The Needle Arts of Greece

Design and Techniques

Graphs and maps by Martha Pangakis

Line drawings by Margery Nichols

The Needle Arts
of Greece

Design and Techniques

Joan Petrakis

Charles Scribner's Sons · **New York**

Acknowledgment is made to the following sources for permission to reproduce patterns: Benaki Museum, The Folk and Ethnological Museum of Macedonia, Scala Fine Arts Publishers, Inc., Photographie Giraudon, Jay Gluck for a drawing on page 2130 of A SURVEY OF PERSIAN ART, Vogue Patterns, The Metropolitan Museum of Art, Aristi Antoniadou, Margarita Falari, Helen Wace. A selection from *A History of the Crusades* is reprinted with the permission of Cambridge University Press.

Library of Congress Cataloging in Publication Data

Petrakis, Joan.

 The needle arts of Greece: design and techniques
 Bibliography: p. 169
 Includes index.
 1. Embroidery—Greece, Modern. 2. Embroidery—
Patterns. I. Title.
NK9151.A1P48 746.4′4 76-49654
ISBN 0-684-14863-3

Printed in the United States of America

Acknowledgments

It took the combined efforts, inspiration, encouragement, and enthusiasm of many people to produce this work on Greek design. To name all of them individually would necessitate writing another volume. I would like, however, to express my thanks to some of them publicly at this time.

I am most deeply grateful to my friend Margarita Falari and her sister Aglaia, who, through their own collection of embroideries worked over the years, opened up a whole new world of Greek study to me; to my friend and teacher Anne Norton, who has always been so generous with her time and creative suggestions; to Muriel Baker, who said, "You have a plethora of material for a book!"; to Ruth Wolcott, who read and discussed my manuscript with me; to my husband, who, from the first afternoon I mentioned my decision to write a "small" book on the subject, received the idea with great enthusiasm and has encouraged me through all the difficulties and discouragements; and to my parents, who not only worked projects but also helped in so many other ways.

My thanks go to Dr. Basil Tsatsas of Athens, Evangelos Falaris, and Athanasios Trilianos for assistance with translations; to Martha Pangakis and Margery Nichols for their fine art work; to Ellen Agritelley, my typist, whose fingers fly over the keys; to John Malechinsky, K. Konstantopoulos, and M. Skiandaresis for the photography here and in Athens; to Harrold de Groff for his many artistic suggestions as well as all the materials used in constructing the projects; to Sandra Fitz Gerald, who constructed them;

v

to Jean Mailey, Barbara Teague, and Mary Doherty of
the Metropolitan Museum of Art; to Eleni Kalogeropoulou
and Constantine Kefalas, director of the Folk and Ethnological
Museum of Thessalonike; to the librarians of the Benaki
Museum in Athens, and especially to its director, Angelos
Delivorrias, whose vision and foresight made it possible to
bring this beautiful collection of design to the American
public; to April Ferris, who answered so many questions; and
to my editor, Elinor Parker, who patiently answered the
myriad questions this neophyte had to ask and in her own
quiet way expressed an interest and enthusiasm that was
so encouraging.

To my stitchers I owe a debt of gratitude for giving me
so many hours of their precious time as well as their expertise
as needlewomen.

To my students, who have always received the Greek
embroidery workshops with such enthusiasm, to my many
friends, who contributed in so many ways, and to Johanna
and her little friends, who keep asking for more "broideries"
to do, what can I say but thank you from the bottom
of my heart.

Joan Petrakis

For Greece . . .

and her people

Contents

As you read through the pages of this book, you will find continual reference to the works of Mr. Alan J. B. Wace.

Mr. Wace of the British School of Archaeology spent much of his life in Greece. He had gone to Greece as a very young man and purchased his embroidery collection from the grandmothers who had embroidered them. Because of this, he was able to accumulate accurate information on stitchery, design, color, etc. This collection was made jointly by Mr. Wace and Mr. R. M. Dawkins and was divided equally between them.

Upon retirement from his archaeological work, Mr. Wace became professor at Cambridge University and later Curator of Textiles at the Victoria and Albert Museum in London. During this time he contributed several pieces of his collection to the museum.

Upon his death, Mr. R. M. Dawkins left his complete collection of Greek embroideries to the Victoria and Albert. Mr. Wace, while still alive, contributed his collection to the Liverpool City Museum.

I am grateful to Mrs. Helen Wace for the above information.

A thing of beauty is a joy forever:
Its loveliness increases; it will never
Pass into nothingness.

<div align="right">John Keats, *Endymion*</div>

Introduction

For most of us the story of Greece ends with the Classical period of ancient history. For many of us a trip to Greece means viewing the architecture and artistic accomplishments of the people who lived before Christ. But what of modern Greece and her people? Who are they? What are they like? What are their artistic talents and abilities? What of their lives?

One way in which we may learn about the life and national spirit of a people is through their folk art, for in their handwork we find the true expression of their character and culture. Through their use of color and design we can appreciate their aesthetic sense, imagination, inherent taste, personality, local traditions, and historical experiences as well as their geographical surroundings.

The examples of Greek embroidery that exist today in museum collections date primarily from the eighteenth and nineteenth centuries. Although few remain from the seventeenth century and none from before that time, it is safe to assume, since the Greek people are traditionalists by nature, that patterns developed during previous centuries have remained more or less unchanged.

The history of modern Greece is filled with intrigue and excitement, wars, conquerors, and heroes, and it would be impossible and quite unnecessary to record all these events in this volume. However, if we are to appreciate and understand fully the folk art of that nation, some historical background is necessary.

Modern Greece has been influenced by three main periods: the Byzantine, which extended from the third to the fifteenth

century; the time of the Crusades, which took place from the eleventh through the thirteenth century; and the period of Ottoman rule, which lasted from the fifteenth to the late nineteenth century. It would seem that Greece has always been a crossroads of the known world.

Mountains and sea isolated the people of Greece from one another. Thus, we find each village and town, each province, and each island developing its own folklore and customs, its own handwork, even its own dialect and its own way of thinking. It is this strong individualism of the people of Greece, in combination with the influences from the East and the West, that has resulted in the interesting and unique type of design work recorded in this book.

Two excellent collections of embroideries, textiles, and costumes can be found at the Benaki and Folk Art museums in Athens. The Folk and Ethnological Museum of Thessalonike also houses a fine smaller collection. Other excellent collections can be found in the Liverpool Museum and Victoria and Albert Museum in England, the Art Institute in Chicago, the Textile Museum in Washington, D.C., the Metropolitan Museum of Art in New York, and the Museum of Fine Arts in Boston.

Needlework has become an important means of creative expression for American women. Because of the very unusual designs and colors of Greek embroideries, as well as the versatility and adaptability with which the designs may be handled in different media, I hope that this book may open a whole new world of stitchery design for women in America and familiarize the serious embroideress and costume historian with the museums of Greece that hold such treasure for them. It is my sincere hope that as you study the materials presented here you will gain a greater appreciation and understanding of modern Greece, the nation and its people.

Résumé of the History of Greece

The textile arts have been a part of the Greek world since Byzantium became the Eastern capital of the Roman Empire. Byzantium, a small trading town situated in a strategic place on the Sea of Marmara, was chosen by Constantine, the emperor of Rome, to be the capital of New Rome. This change was necessitated by the fact that Rome had become the scene of much decadence and corruption and the empire had begun its decline. Little did Constantine realize that his choice of Byzantium, later to be known by his own name, was to be one of the most momentous decisions in the story of Western civilization, for a new empire was being born—the Byzantine—which was to have a life span of some eleven hundred years. This bright new civilization had its roots in the Classical traditions of Greece and Rome, but it was a Christian civilization.

The tale of the founding of the little town of Byzantium is a short but very interesting one. In the year 657 B.C.,[1] nearly a thousand years before Constantine made his choice, a Greek sailor named Byzas sailed across the Aegean from his home in Megara, on mainland Greece, through the Dardanelles, and across the Sea of Marmara. Before setting sail, Byzas had asked the Delphic oracle where he should found his new city. The oracle had answered, "Opposite the blind."[2] When he reached the Bosporus Byzas understood what the oracle had meant, for on the Asiatic shore Greek colonists had already founded the city of Chalcedon. These settlers must have been blind for not observing that only half a mile away on the European shore was a far superior site. It was here that Byzas founded the city that took his name, which it retained until

1

Constantine made it his capital and called it New Rome. Later it became Constantinopolis, or "City of Constantine."

Constantinople was situated on a land bridge between the East and the West and a sea channel from north to south. So, through and to Constantinople came ivory, porcelain, raw silks, damasks, cinnamon, sugar, and other spices from far-away places like Ceylon, India, and China. West of the city were fertile lands where grapes and grains flourished, and the waters of the Bosporus and the Sea of Marmara teemed with fish. From the north, from the southern parts of Russia and the area of the Danube, ships carried furs, corn, gold, caviar, honey, and slaves, and the rich soil of Anatolia and Egypt to the south supplied food for Constantinople's growing population.[3]

Constantine laid great emphasis on Hellenism in settling his new city, which was to become a center for art and learning, in the Greek-speaking world. The libraries were filled with Greek manuscripts and the museums with Greek art treasures. Everywhere in the city were reminders of the Hellenic heritage. But Byzantium was to be a Roman city, too, and to attract a Roman population Constantine offered free bread and games to the common people, and to the upper classes the gift of palaces that were exact replicas of their homes in Rome.[4] From Rome the new empire also inherited theories of administration, military tradition, and law.

The third factor in the settling of Constantinople was the influence of the Christian East, for Constantinople was to be a Christian city. Eastern Christianity had been developed, by Greek philosophy, into a form that was readily accepted in Europe. The citizens of Constantinople were cognizant of their Greek and Roman heritage, but their basic philosophy of life was different in that they dwelled more on the spiritual and took less joy in worldly things. This made them more responsive to ideas from the East than to those from the West. Eastern mysticism invaded the Roman world and taught it to revere its monarch as divine. In the center of his city Constantine set up a great column of Apollo and replaced the head with his own. He then placed a scepter in one hand and a globe representing the world in the other, and there he was worshiped by pagans and Christians alike. On May 11, 330 A.D., Constan-

tine dedicated his city to the Holy Trinity and to the Mother of God, and the emperor reigned in autocratic majesty.[5]

At the same time Christian relics were brought to Constantinople from all parts of the world—the linen worn by the infant Jesus, the crown of thorns, the stone of Christ's tomb—to be placed in the churches and shrines. Often these relics were encased in gold and silver and decorated with precious stones or wrapped in fine silken cloth.

Constantine is credited with the erection of many churches throughout his realm, among them the basilicas of St. Peter and of the Lateran in Rome, in Jerusalem the Church of the Holy Sepulchre where Christ was buried, and in Bethlehem the Church of the Nativity.[6] In Constantinople he built the Church of the Holy Apostles and of St. Irene.[7] Constantine also began the plans for the great church of Hagia Sophia (Holy Wisdom) that was later built by his son and successor, Constantius II. The "Great Church," as it was called, was dedicated on February 15, 360 A.D. At a later time it was consecrated to the Holy Wisdom of Christ.[8] The new emperor enriched its treasures: "Many tissues adorned with gold thread and stones for the sanctuary; for the doors of the church different curtains of gold; and for the outside gateways many others of gold thread."[9] In the year 532, during the early part of Emperor Justinian's reign, a great fire that burned for five days razed half the city, including Hagia Sophia.

Justinian, perhaps the most famous of the Byzantine emperors, was an enlightened patron of the arts, and the greatest changes in the physical appearance of Constantinople took place during the sixth century under his rule. He personally supervised the rebuilding of Hagia Sophia, which was in itself a unique architectural creation and became, in fact, Byzantium's main contribution to architecture—the solution to the problem of balancing a dome over a square.

But Justinian's strength as emperor manifested itself in other ways as well. He expanded his empire westward by freeing Africa from the Vandals, Spain from the Visigoths, and Italy from the Ostrogoths. Many cities became very important to Byzantium during this period: in Italy, Ravenna, Rome, Amalfi, and Milan; in Sicily, Palermo and Syracuse; in Spain, Cartagena, Malaga, and Cordoba; in Africa, Carthage

3

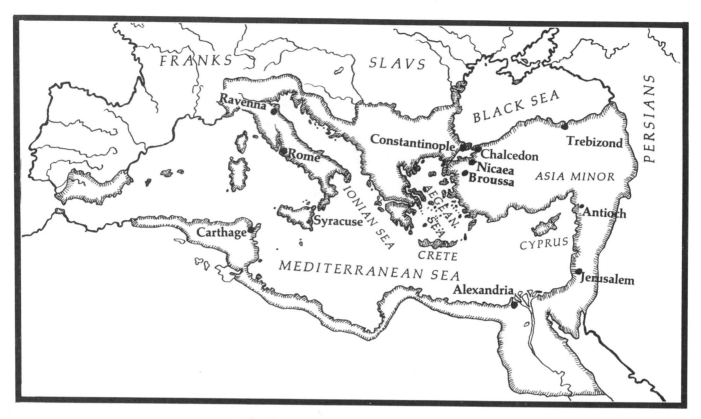

The Byzantine Empire under Justinian I

and Tripoli. Throughout the old Roman Western world, which had fallen to the barbarians, Justinian was able to establish Byzantine power. While he expanded his empire westward, he also was involved with wars on the eastern side with Persia.

Among the Western cities conquered by the Byzantines Ravenna was probably the most important, because in 544 it became the seat of the magistrate for Italy, thus uniting the Eastern and Western empires. Two of the most beautiful basilicas of Ravenna were built after the Byzantine conquest: in 549, St. Apollinare in Classe and San Vitale, which houses the famous mosaics of Justinian and his empress, Theodora.[10]

During the rule of Justinian the dress of the courtiers was very elaborate; it was this style which later was incorporated into liturgical vesture when it came into use between the fourth and ninth centuries. In studying the mosaics of San Vitale, we find that, at least in part, the decoration of the garments was done by embroidery as well as by weaving; however, there are no surviving examples of this. One author of the time wrote

4

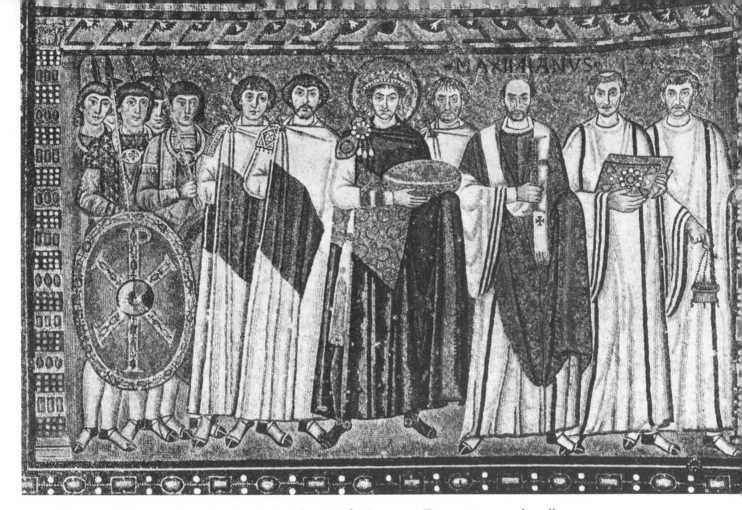

Mosaic of Emperor Justinian (center) at San Vitale, Ravenna. Decorations on the silk garments were woven and embroidered. *Alinari-Scala.*

that Justinian's garments were decorated by the use of a needle in such a fine way that it appeared to have been done with a paintbrush.[11]

It was not uncommon for the emperor's representatives to take fine silks with them into the Western world as gifts to other ruling dignitaries, nor was it uncommon for the emperor of Constantinople to present gifts of fine silken fabrics to those who came to pay their homage to him.

Silk, which was imported into the empire from China and had to come by land through Persia, was usually confiscated by the Persians, who in turn imposed a high tariff on it for importation to Constantinople. The wars between Persia and Byzantium interfered even more with the importation of this fine commodity upon which the economy of Byzantium depended. Justinian tried in vain to establish a new direct route from China. It so happened that in the year 550 two Nestorian

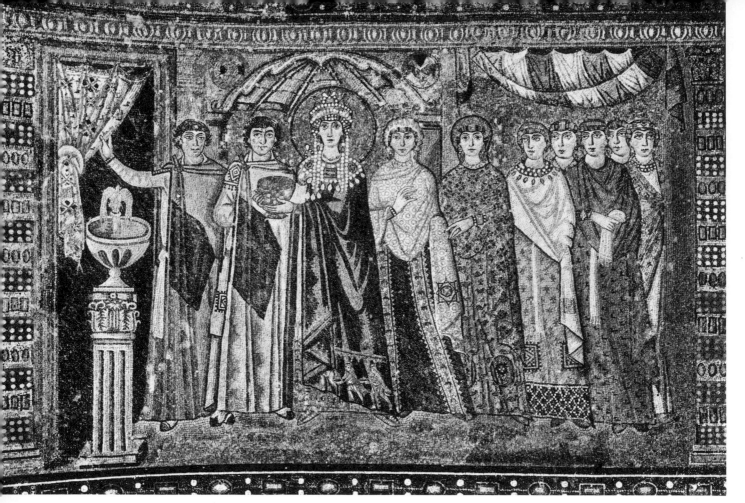

Mosaic of Empress Theodora and the ladies of her court, dressed in elaborate silk fabrics of both embroidered and woven design. San Vitale, Ravenna. *Alinari-Scala.*

monks arrived in Constantinople carrying silkworm eggs in their hollow staves. In a short time sericulture became widespread in the empire and the necessity to import silk from the East declined.

The silk industry continued to spread throughout mainland Greece, in Thebes and Corinth. Syria and Alexandria in Egypt also had flourishing industries. By the time of Constantine V (740–755) the imperial factory at Constantinople had a world monopoly of precious woven silks. The Arabs from the east, the Chazars from the north, as well as the Western nations, all clamored to purchase these highly prized silks, brocades, and cloths of gold which had no counterparts in the West. By the eleventh century Thebes and Corinth had become the silk centers on mainland Greece. The Peloponnese developed a successful carpet industry, and Sparta, by the tenth century, was exporting carpets to Italy.

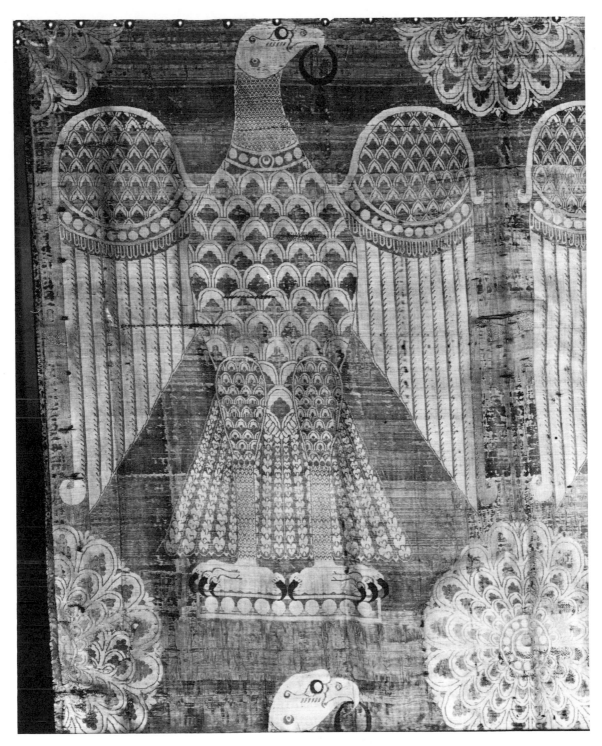

Constantinopolitan silk, eighth or ninth century, now in the Church of St. Eusebius at Auxerre. It is originally the shroud of St. Germaine and is probably one of the finest existing Byzantine silks. *Giraudon.*

Toward the end of the tenth century, after Byzantium had lost a good portion of Asia Minor to the Seljuk Turks, the empire had begun its commercial decline. Norman invaders in 1147, during the Second Crusade, headed by Roger II of Sicily, captured Thebes and Corinth and carried off men and women highly skilled in sericulture to Palermo, breaking the silk monopoly of the empire—and thus began the growth of the silk industry in the West.

The Crusades to the East were to complete the destruction of the Eastern empire. They had begun as an answer to the appeals made by the eastern emperor Alexius Comnenus (1081–1118) to Pope Urban III for assistance in fighting off the Seljuk Turks.[12] The Fourth Crusade (1199–1204), which had been launched to save Jerusalem from the Infidel, was diverted by personal greed to the capture of Constantinople. The Flemings, the French, and the Venetians participated in this assault, which resulted in the downfall of the Eastern capital in the year 1204. The great city of Constantinople was pillaged for three days. This Fourth Crusade precipitated the decline and fall of the Byzantine Empire and it permanently weakened its defense against future enemies. According to Steven Runciman:

> The Sack of Constantinople is unparalleled in history. For nine centuries the great city had been the capital of Christian civilisation. It was filled with works of art that had survived from Ancient Greece, and with masterpieces of its own exquisite craftsmen. The Venetians indeed knew the value of such things. Wherever they could, they seized treasures and carried them off to adorn the squares and churches and palaces of their towns. But the Frenchmen and Flemings were filled with a lust for destruction. They rushed in a howling mob, down the streets and through the houses, snatching up everything that glittered and destroying whatever they could not carry, pausing only to murder or to rape, or to break open the wine cellars for their refreshment. Neither monasteries nor churches nor libraries were spared. . . . For three days the ghastly scene of pillage and bloodshed continued till the huge and beautiful city was a shambles.[13]

In the years that followed the city was practically denuded of all Christian relics and art work. Many of these objects still survive in the treasury of St. Mark's in Venice, among them thirty-two Byzantine chalices made of semiprecious stones. The doors of Hagia Sophia became the doors of St. Mark's. Enamels and precious stones from Hagia Sophia were added

to the gold-paneled altarpiece at St. Mark's which had originally been made in Constantinople in the tenth century. The four bronze horses that had adorned the Hippodrome of Constantinople found their way to a place above the central entrance of St. Mark's, and numerous columns, capitals, carvings, and panels of marble that were looted from Constantinople in 1204 are presently incorporated into St. Mark's.[14]

Having gained control of Constantinople, the Crusaders and their Venetian allies proceeded to partition the Byzantine Empire. This new Latin Empire, however, never amounted to more than a collection of weak states that failed to remain united because of animosities and jealousies among leaders. The Crusaders actually did not inherit the Byzantine Empire, they just broke it up.[15]

Three sections of the empire did, however, remain under legitimate Greek rulers, namely, Trebizond, Nicaea, and the Despotat of Epirus. The Serbs and the Bulgars were encroaching on the north and the Seljuk Turks on the east. These pressures, compounded with problems from within, made it

The Gradual Fall of the Byzantine Empire

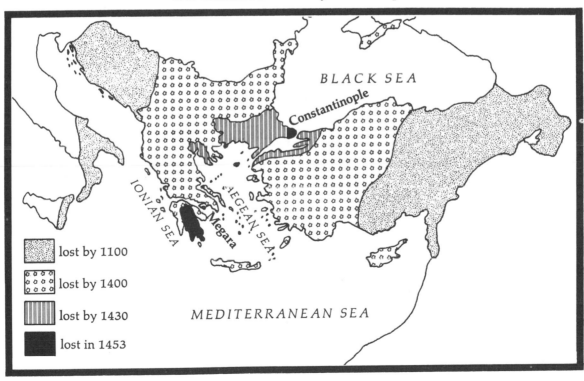

lost by 1100

lost by 1400

lost by 1430

lost in 1453

impossible for this new Latin Empire to survive, and so, in 1261, Paleologus of Nicaea, with the help of the Genoese, recaptured a very weakened Constantinople.[16]

The prognosis for this new Byzantine Empire was not a favorable one. The Turks of Asia Minor had captured more of its lands; it had been politically divided by disputes; and economically the empire had been bankrupt. Although churches were rebuilt and redecorated, and there was a new impetus for intellectual and artistic growth, the Byzantine Empire never was able to return to its previous greatness, nor did it recover the power necessary to overcome the continuous invasions of the Turks, Serbs, Bulgars, and Latins. By the fifteenth century Constantinople was a sparsely populated and sadly diminished city. On May 29, 1453, after seven weeks of attack, Constantinople fell to the Ottoman Turks.

With the fall of Constantinople came a mass exodus of scholars, who found refuge for themselves in and became a part of Renaissance Europe. But peace was yet to come to the part of Greece that remained free of Turkish rule. The Venetian Duchy of Athens fell to the Ottomans in 1460; Lesbos, in 1462; Euboea, in 1470. In 1479 the Turks seized the Ionian Islands from the Venetians and in 1682 returned them to Venice, under whose rule they remained until the eighteenth century, when they became British possessions. Rhodes fell to Turkey in 1522. Nearly half a century elapsed before Naxos, Chios, and Cyprus fell in 1571. Venetian Crete fell to the Turks in 1669.[17]

During this long span of Turko-Venetian wars the emigration of Greeks soared. Places like Dalmatia, Corsica, Malta, and Sicily assimilated these people. Other Greeks went to cities on mainland Italy and founded communities that later made cultural and economic contributions to Greece. With the growth of trade during the seventeenth and eighteenth centuries, thousands of Greek merchants settled in the urban centers of the northern Balkans, central Europe, and southern Russia. These people later made great contributions to the Greek revolution against the Turks that began in 1821.[18] Before the end of the eighteenth century, prosperous Greek trading communities had grown up in Vienna, Buda, Bucharest, Venice, and other foreign cities.

For the conquered people of Greece, the first period of subjugation to the Turks was almost a respite. The Venetians (and Genoese in the Aegean) had treated them worse than slaves.[19] They had levied unmerciful taxes, controlled commerce, allowed no self-government, and encouraged proselytizing.

The Turks, on the other hand, organized their government administration in an ad hoc manner, and governing varied in all sections of their newly conquered lands. Each area had its own Turkish governor, so to speak, and was allowed to function freely. Some villages were completely exempt from taxation because of the amount of the valuable commodities they produced and sent to Constantinople; other villages were allowed to govern themselves and were exempt from taxes as well for their contributions to the armed forces.[20] In general, the taxes levied on the people conquered by the Turks were lighter than those levied by the Venetians.

Since the Koran teaches that people of any religion who worship by the Book should be allowed freedom of religion, Christianity survived Ottoman rule. However, two sultans, Selim I and Murad III, did consider mass extermination of Christians but decided against it because of counsel from their religious advisers in addition to the fact that it would result in a great loss of revenue from per capita taxes.[21]

A great contribution made by the Orthodox Church during this period was that it preserved not only the religion and culture of the people but their national identity as well. Since the scholars had fled, the priests became the teachers, but as funds decreased, schools closed and the level of learning by the end of the sixteenth century was very low. With the scholars gone and the native Byzantine aristocracies exterminated, the people lived as one peasant mass.

By the middle of the 1600s the Turkish empire had begun its disintegration. With its deterioration the government lost its original efficiency and discipline and instead was characterized by plunder and seizure by force, violence, and exploitation of its subjects as well as of its own people. Slowly the Turks became as tyrannical as their Venetian and Genoese predecessors. Periodic peasant revolts began to spread and become more frequent, and this beginning of national spirit finally culminated in the Revolution of 1821.

BLACK SEA

Constantinople

THRACE

SEA OF MARMARA

THRACE

SMYRNA

MACEDONIA

LESBOS

AEGEAN SEA

CHIOS

CYCLADES

DODECANESE

THESSALY

EPIRUS

CRETE

Athens

PELEPONNESE

CORFU

LEFKAS

IONIAN ISLANDS

The Formation of the Greek Kingdom

Several other factors were important in the development of this national feeling, however. One was the growth of a middle class that resulted from the development of commerce and industry. Greek merchants brought back with them from their journeys new ideas of security and enlightenment that contrasted with the deplorable conditions that now existed in their homeland. Another influence was the return of students who had been educated in the West and who began making Greek translations of the works of Voltaire and Rousseau. These men turned the poverty-stricken, church-controlled educational system into a secular one teaching new ideas and thoughts. Other Balkan countries, subjects of Turkish rule, took advantage of Greece's educational opportunities and slowly a strong spirit of nationalism spurred them on to fight for their independence.

The struggle for independence, which spanned the period from 1821 to 1832, was neither brief nor easy. In 1833, the Great Powers—England, France, and Russia—who had become involved with Greece in its fight for freedom, enthroned Prince Otho of Bavaria as its first king, to the strong objection of the Greek people.

Greece in 1832 consisted of only the lower portion of the mainland, with a few surrounding islands in the Aegean. It took the alliance of Greece with the other Balkan countries to fight against Turkey in 1912 and 1913 in order to add part of the north. A portion of Thrace was ceded in 1923, and the Dodecanese Islands, given to Italy as a result of the Turko-Italian war, were returned to Greece in 1948.

Modern Greece, as an organized country and as we know it today, is a new nation only a few decades old—a surprising fact to all of us who know and think of Greece as dating from antiquity. It is a nation that has been able to survive and keep its own culture in spite of the ravages of wars that have introduced many foreign elements during the epochs of its history. The very nature of the people of Greece, their strength and determination, their pride, their individualism, their passion for beauty, their traditionalism—all have combined to create the designs shown in the pages that follow. Perhaps through this study of history and design in the needle arts we will gain a greater appreciation and understanding for a country and its people.

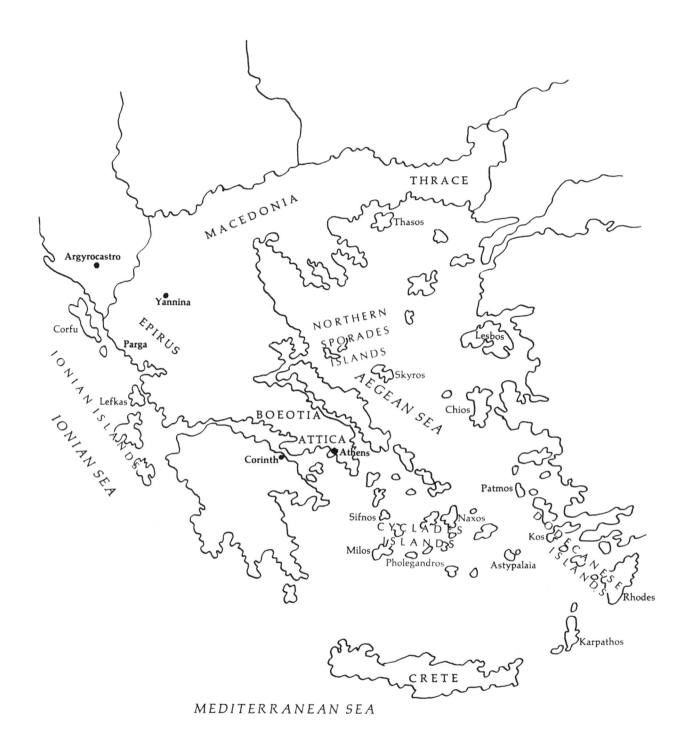

Location of the Sources of Embroideries

General Background of Greek Embroidery

The earliest dated piece of Greek embroidery, a Cretan skirt border dated 1697, is in the Seager Collection of the Metropolitan Museum of Art. Although most museum collections are comprised of pieces dating from the eighteenth and nineteenth centuries, we know from marriage contracts, dowry inventories, and records of travelers that embroideries were in existence from earlier dates. One French traveler who visited Chios, Rhodes, and Cyprus in 1550 wrote of the very fine embroideries of those islands, especially the bed tents of Rhodes, which are truly outstanding pieces in all collections.[1]

Little is known about Byzantine needlework before the fourteenth century, when very fine ecclesiastical embroideries were made throughout the Orthodox world.[2] According to tradition, young Greek girls, as soon as they were able to hold a needle in their hands, were taught to copy the embroideries of their mothers and grandmothers in order to prepare their dowries. The pieces were utilitarian and included valances, pillows, bed tents, and sheets as well as two dresses. One dress was to be worn at the wedding and then for feast days and festival occasions, and the other dress was for everyday wear. A girl's worth was determined by the delicacy and number of the embroidered articles included in her dowry.

It might well be noted here that embroideries for the home were used mainly on the islands; on mainland Greece, they were found only in Epirus. The simple island homes, usually with only one window, were designed and situated in a way that provided defense against pirates. The fine embroideries, along with any colorful ceramics that were available, were the only adornments for these single-room homes.[3]

The materials used for these embroideries were almost always the same: silk on linen, silk on silk, and occasionally silk on coarse cotton. The people raised flax and cotton, which they wove into fabrics. The silk was raised for exportation, but leftover silk stuffs were used for embroideries; thus it was economical to create and adorn fabrics with lovely designs. Up until the end of the eighteenth century silk was the primary export product of Greece.[4] With the coming of the Industrial Revolution the silk industry eventually died out, leaving only rare traces today. Silkworms are raised, and fabric is woven in the small town of Souflion in Thrace; some silkworms are raised on Crete and some are raised in the Peleponnese. The silk industry of today is carried on in Greece as a cottage industry with weaving done in the homes.

Wool was used for both fabrics and embroidery in the northern provinces, primarily Macedonia and Thessaly, and also used by the nomad groups known as the Sarakatsani.

Vegetable dyes were the only types used, and each area seemed to have its own sources for different colors. Herbs, roots, leaves, and fruit rinds were the primary sources. In order to make the colors fast, the newly dyed threads, after they were dried, were washed in seawater.

In 1794 a physiologist from France, Guillaume Antoine Olivier, spent a good deal of his time on the island of Chios observing the dyeing preparations and methods of the women. He noted that for dark green they boiled the leaves of a peach tree; for light green, the wood of a peach tree; for flesh colors, the wood of the wild quince tree; for rose, the roots of apple trees; for yellow, the wood of the oriental nettle tree or henna leaves; for orange, red peelings of onions which had been soaked in water for five days and then boiled with alum; for red, the red peelings of onions boiled with alum with the addition of cochineal.[5]

On the island of Skiathos, red dyes were obtained from four sources: the root of the plane tree; the root of arbutus; the root of the madder plant, also known to the ancient Greeks; and the gall formed by the insect *Coccus ilicis* on the holm oak tree. Blue was obtained from imported indigo. Yellow came from the flowers of oxalis and the wood of the fustic tree. Green was obtained from fleabane; purple, from blackberries and myrtle berries. Brown was obtained from the acorn cup of the valonia

oak tree; black, by first dyeing the fabric or threads in valonia and then in vitriol.[6] The length of time the threads remained in the dye bath determined the shades of the colors.

The stitches used in Greek embroideries were those that are universally known: split, outline, back, long-armed cross,[7] flat, darning, double darning, chain, cross (also referred to as the Phrygian stitch[8]), herringbone, fishbone, Cretan feather, Roumanian couching, satin, etc. The isolation of small Greek villages and the individualism of the people is demonstrated by the fact that in nine villages on the island of Chios the cross-stitch is known by fourteen different names.[9] This is an example of the problems resulting from the lack of communication among the villages of Greece. Each existed as an isolated unit within the larger community to which it belonged, and each developed its own dialect as well as its own means of artistic expression.

Satin or darning stitch, which was the most commonly used stitch in Cyclades counted-thread work, was eventually replaced by the cross-stitch, and on the Ionian Islands darning and split stitch were abandoned for cross-stitch. This seems to be so because those specimens of embroideries done in cross-stitch appear to be newer.[10]

There are two main categories in Greek embroideries: counted-thread, which is self-explanatory, described by the Greek terms *xobliasta* and *metrita*; and surface, described by the Greek term *grafta*, in which the design is drawn on the surface of the fabric. According to Greek tradition, counted-thread work is done holding the embroidery over the index finger of the left hand, and surface work is done with the aid of a hoop.[11]

The most decorative pieces of clothing worn by the men and women of Greece were the cloaks. For the women, the apron (not to be confused with our utilitarian apron of today) and the shift were most heavily adorned.

The apron, made with fabrics ranging from fine silk to heavy wool, was a decorative accessory in women's dress. Decor was applied by weaving; by appliquéing twisted silk braid, which was done by highly skilled craftsmen; or by embroidering designs.

On the shifts, embroidery was used at the necklines, on the sleeves, both down the length as well as around the bottom

circumference, and at the bottom of the skirts, making a border. Embroidery motifs on mainland garments were usually geometric; if flowers were used at all, they were stylized. On the islands, however, animal and human forms as well as plant life were well represented, but again in stylized forms.

The cloaks were decorated by the application of highly twisted silk, either monochrome or multicolored, or gold cords.

Of the articles embroidered for the home, only those sheets that had embroidery designs running along all four sides were considered to be of good quality. A sheet embroidered only along the long sides was considered to be less valuable. Since fabrics woven on the loom were not wide enough to make an adequate sheet, four strips usually had to be pieced together, and it was customary to conceal the joining seams by embroidering over them either a herringbone stitch or some small design, geometric or otherwise.[12] Plant and animal life were well represented in these designs, as well as human forms and shapes.

Pillows were customarily kept piled one on top of the other and so were most often embroidered only along the edges. Since the tops were unseen, it was felt to be a waste to decorate them. Occasionally, however, motifs were placed on a pillow to form a unified composition that covered the whole surface.

Perhaps the most impressive of all the household embroideries were the highly ornamented bed curtains which were draped around the bridal bed. The *sperveri*, as they were called, were of two types, depending on the houses in which they were to be used. In the Cyclades and on the island of Patmos the bed curtain was a large, rectangular, embroidered fabric that hung from a transverse rod and isolated the bedstead. In Kos and Rhodes the *sperveri* were quite complex in construction. They were often made of as many as twenty strips of linen that were sewed together, leaving one section undone partway up for an opening, and hung over a wooden frame about two feet in diameter that was suspended from the ceiling.[13] The curtain entirely surrounded the bed, with the opening on the long side. This "doorway" was heavily adorned with design, as was the remainder of that side. Here the Greek fear of leaving empty spaces becomes very obvious; every possible area was covered with embroidery all the way up to the top. No needlework was done on the other three sides of the *sperveri*. These were approximately thirteen feet high.[14]

Motifs

A Sarakatsan skirt border worked on 4° canvas for a carpet design by Mr. and Mrs. Charles Altiparmakis. *Folk and Ethnological Museum of Macedonia.*

Embroideries may be attributed to only a small number of islands, and indeed, some islands produced none at all. Life in the Aegean from the twelfth to the eighteenth century was filled with wars and piracy. Many islands, in fact, were left completely uninhabited from fear of pirates.[1] Piracy, added to the wars between the Franks themselves, the Turks, and the Venetians, compounded with various plagues and alternating with periods of prosperity resulting from trade, all had their effects on the cultural development of the people. Skyros, Rhodes, and Crete, for example, were very prolific in embroideries but islands such as Andros produced none.[2]

A geometric design from the neckline of a shift from Corinth. Worked by Phyllis Manousos. *Benaki Museum.*

A border design from Thrace, expanded to cover the complete surface of a tote bag. Worked by Mrs. Allen Greiner. *Folk and Ethnological Museum of Macedonia.*

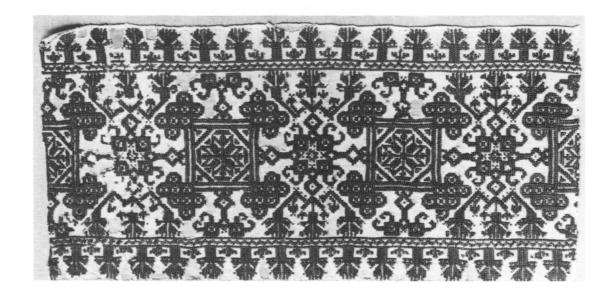

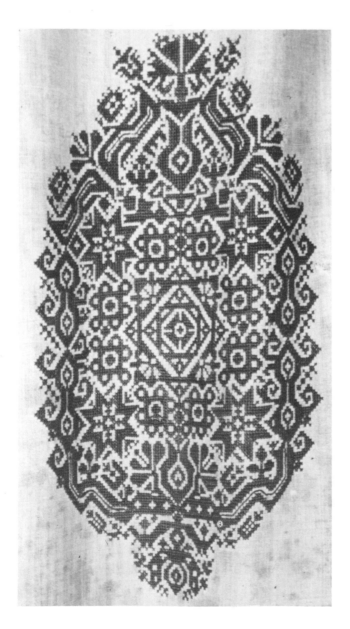

ABOVE A band of natural linen, embroidered in red silk in chain stitch. Sixteenth to seventeenth century. Greek islands, possibly Pholegandros, Cyclades. *Metropolitan Museum of Art, Rogers Fund, 1909.*

LEFT A curtain of natural linen, embroidered in red silk, cross-stitch. Eighteenth century. Kos, Dodecanese. *Benaki Museum.*

Notice the similarities between the design above and the one on the opposite page—both have carnation borders and a central motif connected by other motifs. There is also great similarity between the two designs on this page in the use of the eight-pointed star (found in thirteenth-century carpets from Asia Minor), the circular areas surrounding the center motifs, and the square center motifs. This points out two principles: (1) the passage of motifs through generations and (2) the movement of motifs from one part of Greece to another by marriage dowries, etc.

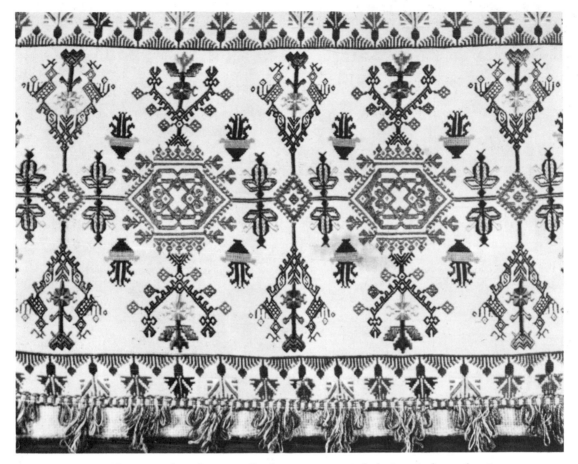

Border, natural linen, embroidery in silk. Satin, cross-, and chain stitch predominate; red, blue, gold, beige, and green. Eighteenth century. Pholegandros, Cyclades. *Benaki Museum.*

Generally speaking, the motifs of continental Greece are strongly influenced by the northern people, and the motifs of insular Greece are influenced by the East and West. It is interesting to observe that the influences in the embroideries of a region or island coincide with the influence on the dialect of the people in that area.

Once a design became traditionally established in a region it was repeated, with very few alterations by succeeding generations. One writer of the eighteenth century wrote that when he commented to the women on an island about what he considered to be the ugliness of their dress, they answered him by telling him that since it pleased their grandmothers to dress in that manner, they were equally happy to dress in the same way.[3]

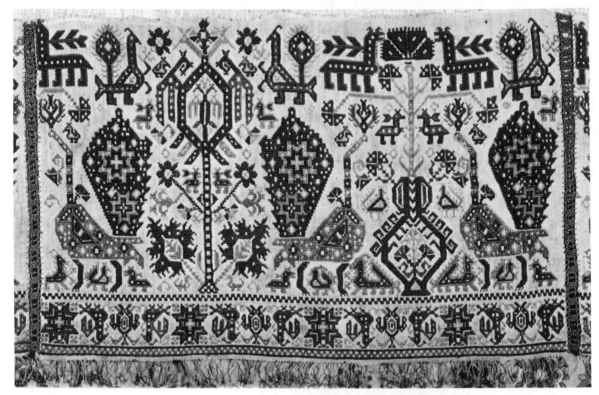

An example of a bed sheet border design expressing the austerity and symmetry of Greek embroideries. The peacocks with tails erect, standing on either side of the vase of flowers, and the other motifs filling in space express *horror vacui*. Embroidered in silk on linen; primary colors, red and blue in cross-stitch. Eighteenth century. Lefkas, Ionian Islands. *Benaki Museum.*

Three artistic principles governed the use of motifs: austerity (rigidity), symmetry, and the fear of empty spaces (*horror vacui*). The first canon is exemplified by the friezelike designs used along the borders of sheets where, for example, a plant would have a large bird on either side of it (the tree of life pattern), and this set of motifs would be repeated all along the border. The fear of leaving empty spaces can be observed very clearly in the Skyros embroidery of the ship where every inch of space on the ship and around it is covered with human, animal, or plant motifs. In some of the Yannina work, for example, a serrated leaf might have other leaves and flowers embroidered within it. The motifs were always used in stylized forms.

To attempt to determine the initiator in the use of individual motifs appears to be a next-to-impossible chore. Such a decision would necessitate many years of thorough scientific study. Therefore, it is my purpose in the following pages to present the interesting facts I have found during my research on the subject.

The plant motifs most commonly used in Greek embroideries—tulips, carnations, hyacinths, serrated leaves, pomegranates or artichokes, and cypress trees—are all horticulturally indigenous to the Levant.[4] It is therefore understandable that the Levantine women would use them in their needlework. Each one of these motifs has its own interesting history.

There seem to be no written records of the tulip before 1554 when it was first seen by a European, the Austrian ambassador to the sultan, who reported seeing the flowers in a garden near Constantinople. The Turkish tulip, however, differed greatly

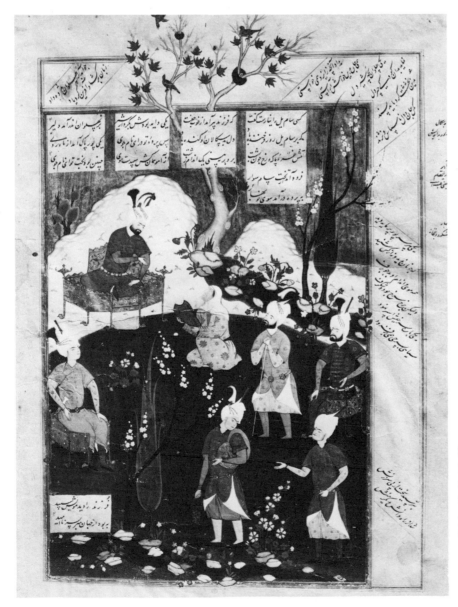

Serrated leaves and cypress trees used in a Persian miniature. Mid-sixteenth century. *Metropolitan Museum of Art, The Harris Brisbane Dick Fund, 1934.*

from the tulip as we know it today. The ideal Turkish flower had six almond-shaped petals with a needlelike tip (Figure 1). The longer the needles, the more highly prized the flower. The flower was taken to Europe in 1572 and through hybridization evolved the round-shaped petal that is more familiar to us today.[5]

The tulip was one of the most frequently used motifs in Turkish velvets. The Turks had continued the strong silk industry already established by the Byzantines. By the fifteenth century they had developed a method of weaving magnificent velvets which made them renowned. By the sixteenth and seventeenth centuries Broussa, in Asia Minor, the first capital of the Ottoman Empire, had become an important center of the textile industry. It flourished there until the nineteenth century. During that century the Turks invented the Turkish towel that we know today by weaving cottons in the pile weave.

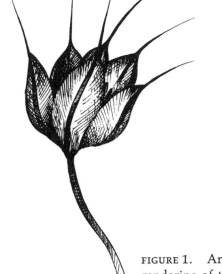

FIGURE 1. An artist's rendering of the ideal Turkish tulip.

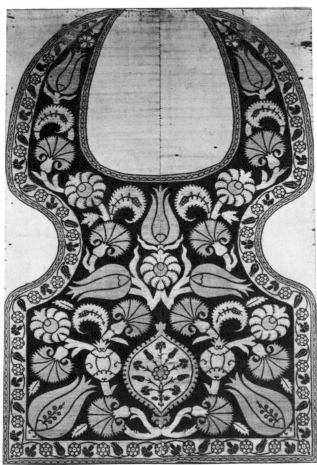

A velvet saddle cover. Gold and silver carnations, tulips, serrated leaves, and pomegranates on a red background. Sixteenth century. Broussa, Turkey. *Benaki Museum.*

24

An inventory of the textiles brought back to Turkey by Selim I from Persia in 1514 indicates that the majority were of Turkish origin. This shows the great esteem in which Turkish textiles were held in the East. Selim I also brought back many Persian craftsmen, but he included no weavers among them. Other documents show that characteristic Turkish patterns had developed long before the fifteenth century, before Selim ever fought against Persia. We might therefore conclude that Turkish textile designs, which included all of the plant motifs named at the beginning of this chapter, were not inspired by Persian craftsmen (Figure 2) but were the designs traditionally used in Asia Minor.[6] It would seem only natural

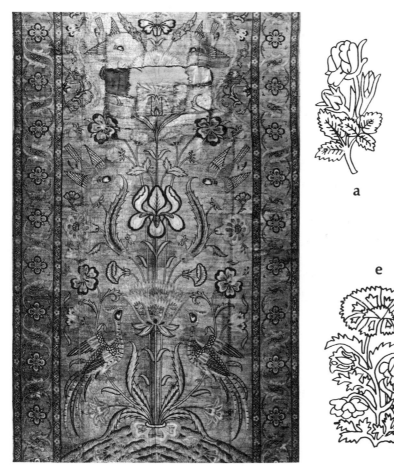

A panel of Persian silk woven in multicolored silks and silver threads on a light green background. Unfortunately the carnation at the top center is worn away; however, part of the outline is still visible. The use of birds and a more realistic style distinguish this from Turkish textile design. Seventeenth century. *Benaki Museum.*

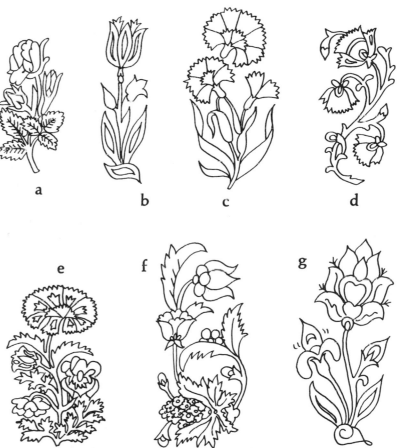

FIGURE 2. Types of floral motifs, brocaded on taffetas and satins, traditionally attributed to Isfahan. Seventeenth century. From *A Survey of Persian Art* by Jay Gluck.

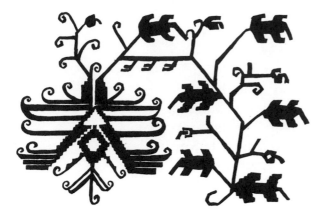

FIGURE 3. The Turkish rose with the hooked stem.

that the women who could not afford to purchase these beautifully designed fabrics would try to emulate them in their needlework.

The carnation has been cultivated for more than two thousand years. Theophrastus, in 300 B.C., gave it the name *Dianthus*, meaning "divine flower," since it was dedicated to Zeus. The carnation was shown in the frescoes on the walls of the throne room of King Minos at the Palace of Knossos in Crete, which was in existence in the year 2000 B.C.[7] The carnation is indigenous to Greece and Asia Minor, and it seems only natural that it would be used so frequently in the embroideries.

The Turkish rose was used in two different forms. In one it was centered between two serrated leaves, and in the other the stem was bent at a right angle with a blossom at the end of the stem and often a smaller blossom under the leaves. The stem always had a characteristic hook on the end of it (Figure 3).[8]

The serrated leaf was used as early as the sixth and seventh centuries in Coptic weavings.[9] Its use during that era was not limited to textiles, however; it was also used in architecture, and both a pilaster and a frieze showing it are now in the Louvre Museum.[10] The serrated leaf flanking the artichoke or pomegranate was commonly used in fifteenth-century Turkish fabrics. It is interesting to note that the pomegranate has always played a part in the folk customs of weddings in Greek villages; in ancient Greece it was a sign of fertility.[11]

The pomegranate was often used in fifteenth-century Turkish textiles as part of a composition with the ogival pattern. This ogival pattern also appeared in Byzantine silks of the tenth century with a motif resembling a pomegranate. There is an indication here that this pomegranate-ogival pattern,

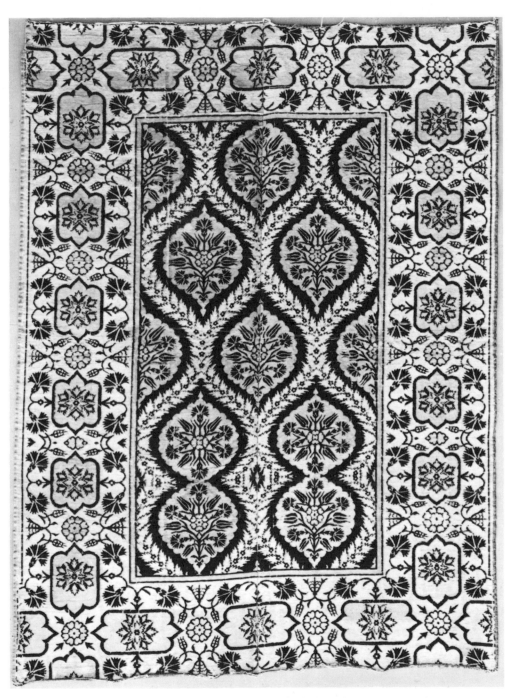

The tulip, rose, and carnation are all included in this seventeenth-century Turkish velvet. The ogival pattern is formed by serrated leaves.
Metropolitan Museum of Art, Rogers Fund, 1909.

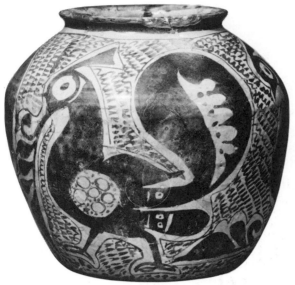

A stylized bird used on Persian ceramics. Ninth century. *Metropolitan Museum of Art, Rogers Fund, 1950.*

which is so prominent in Turkish textiles, was known in Byzantine textile design before the fall of Constantinople.[12]

The animals that appear most frequently in Greek embroidery motifs include the stag, peacock, double-headed eagle, gazelle, lion, and cock. Again these appear in stylized form.

The stag, with its antlers placed horizontally along its back, is commonly used in the embroideries of the Dodecanese and Ionian islands. It appeared in designs in Anatolia (Asia Minor) and Mycenae in the third millennium B.C.[13] but in a very naturalistic style, sometimes with the antlers horizontal along its back and sometimes with the antlers erect. The Scythians, nomad tribes of Russia, whose civilization spread from 3000 B.C. to 100 B.C., used the stag with antlers in horizontal position. Greek goldsmiths were commissioned to do carvings for the Scythians and they designed the stag in a more realistic style, displaying its natural body curves.[14]

The peacock has always appeared throughout the Middle East in designs. It was used in early Christian catacombs and in Byzantine church art. Many examples may be found on sarcophagi at St. Apollinare in Classe and St. Apollinare Nuovo in Ravenna dating from the sixth century. Very often two peacocks were depicted drinking from a vase of water, which to the church symbolized drinking the waters of life.[15] The legend of the incorruptibility of the peacock's flesh made it a sign of

immortality in the church. This might explain its use in the tree of life design. This design was used in Greece as a stylized plant with a peacock on either side, always with its tail erect.

The double-headed eagle, which appears constantly throughout eighteenth- and nineteenth-century Greek embroideries in both naturalistic (from Crete) and geometric forms, has a most fascinating history throughout the Levant. It seems to have been a part of every culture that ever existed in that area. It appears in carvings of the Babylonians, Hittites, Assyrians, Mycenaeans, and the Minoans of Crete. It was used as a seal and on coins.

After Constantinople fell to the Venetians in 1204, the Laskaris dynasty of Byzantium set up a new capital in Nicaea and the double-headed eagle came into use as a symbol of Byzantium.[16] During the Paleologan dynasty (1261–1453) it became the official emblem of the Byzantine Empire. This Byzantine eagle, during the long period of Turkish occupation of Greece, became a symbol of the hopes of the Greek people for their freedom.

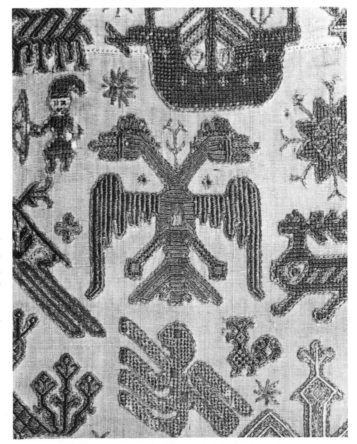

The double-headed eagle, commonly used on Greek embroideries, became a symbol of the hopes for freedom of the Greek people. Worked in blue silk on linen in chain, satin, and backstitch. Eighteenth-century *sperver*. Patmos, Dodecanese. *Benaki Museum.*

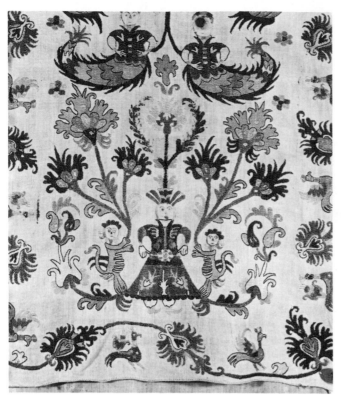

Human faces applied to animal bodies as well as to stylized human bodies are quite common in embroideries from Skyros in the northern Sporades. Worked in red, blue, and gold silk on linen in darning and outline stitch. Cushion cover. *Benaki Museum.*

Human forms in line drawings used in embroideries from Sifnos in the Cyclades. Worked in satin stitches in shades of green, blue, and beige. Silk on linen border. *Benaki Museum.*

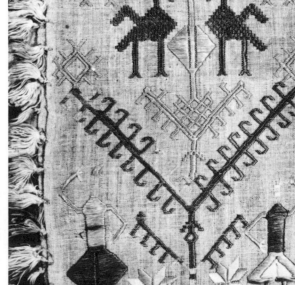

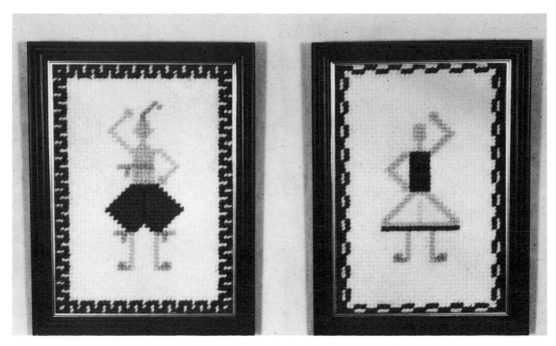

A shepherd worked by Leslie-Rae Tribelhorn, age 14, and a shepherdess worked by Kristin Tribelhorn, age 11. The design is from Sifnos. Both girls designed their own borders. *Benaki Museum.*

Human forms used in Greek embroideries were usually found on the northern Sporades and the Cyclades. The most realistic forms are found in the Ionian Island embroideries. Those of the Sporades show great imagination. Sometimes human heads are used on animal bodies. At other times the humans have a very oriental look. On the island of Siphnos in the Cyclades the human body is used in its very simplest stylized form as a straight-line figure.

All of these motifs were indigenous to the area of Asia Minor and Greece for centuries, and the artists used for their inspirations the designs with which they were surrounded. The Levant was always a crossroads for armies and trade. This resulted in a constant interchange of ideas and cultures and makes the tracing of sources of design in detail an impossibility. The embroideresses of Greece took existing motifs and by applying their own imagination and creative abilities adapted them to their immediate uses.

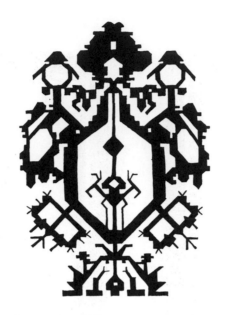

FIGURE 4. The *Glastra*
pattern.

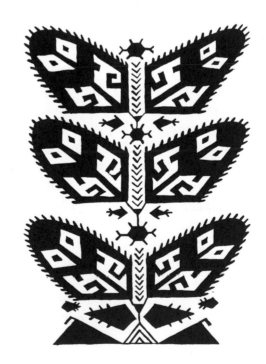

FIGURE 5. The King
pattern (*platyphellenio*).

Patterns and Designs

THE DODECANESE

The main characteristic of the embroideries of the Dodecanese Islands is the use of individual patterns in horizontal or vertical rows to form adornments. As noted in an earlier section, the bed tents, or *sperveri*, of the Dodecanese were particularly outstanding articles in home decoration.

Although Rhodes was captured from Byzantium in 1313 by the Knights of St. John and remained in their possession until 1523, when it was lost to the Turks, there is no visible Italian influence in embroideries from there. Three patterns are outstanding in the designs: *Glastra*[1] (Figure 4), the Greek word for flowerpot; King pattern[2] (Figure 5), known by its Greek name, *platyphellenio*, meaning "broad leaf";[3] and Queen pattern[4] (Figure 6), known by its Greek name, *spitha*, meaning "spark."[5]

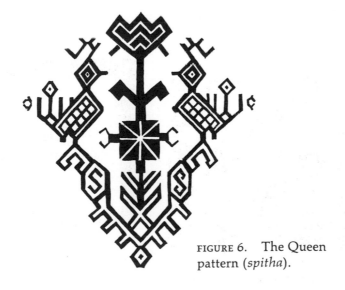

FIGURE 6. The Queen pattern (*spitha*).

33

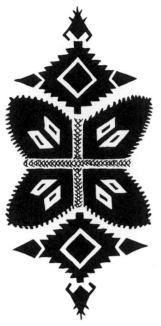

FIGURE 7. Variation of the King pattern.

FIGURE 8. Variation of the King pattern. It is interesting to see how the star variation was derived. In his explanation A. J. B. Wace points out that the stem of the leaves was eliminated to accomplish this design.

On carefully examining the *Glastra* pattern, with the use of a bit of imagination we can see a base shaped like a flowerpot, with a stylized floral design appearing to grow out of it.

The King pattern is very versatile. It may appear horizontally or vertically as two leaves placed at a forty-five-degree angle on either side of a stem; it may appear in a group of four with the bases of the leaves facing each other (Figure 7); or these groups of four leaves may be used side by side to form a star pattern; in this case, however, the stem is eliminated (Figure 8).[6]

The Queen pattern is basically the bottom half of a diamond that is filled with geometric forms and also usually contains cypress trees or peacocks.

The stitchery in Rhodes was done with a very heavy silk thread, much like the Pearsall silk that is used today, but it was a coarser variety and had more strands. This gave the Rhodian embroideries that were often worked in cross-stitch an embossed look. They were bulky in appearance and stood out from the fabric. Since the cross-stitches were not always crossed in the same direction, the patterns were shaded because of the different light reflections. Red and green were the predominant colors.

Embroideries from the island of Karpathos, a part of the Dodecanese, also had very heavy, solidly filled designs, much like the *Glastra* of Rhodes. On this island, however, the base of the *Glastra* is not clearly discernible nor are the shapes as clearly delineated as those of Rhodes, resulting in a rather uninteresting appearance.

An adaptation of a simple leaf pattern from Rhodes, arranged to form a diaper pattern. Worked by Mrs. Charles Altiparmakis. *Benaki Museum.*

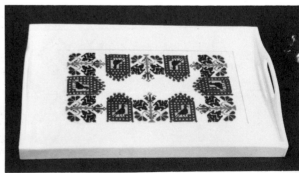

A design from a cushion in Karpathos. Worked by Mrs. William Upson. *Benaki Museum.*

On Astypalaia, another Dodecanese island, closest to the Cyclades, appeared a pattern identified as *Dixos*, or "disk"[7] (Figure 9). This is also a stylized flowerpot, like that of Rhodes. Here, however, it is designed and worked in a more delicate style. The silk floss used for embroidery was much finer and therefore the embroidery remained close to the surface of the fabric without creating the appearance of relief work as in embroidery from Rhodes. This *Dixos* pattern often appeared down the sides of a sleeve on Astypalaia garments.

Astypalaia was ruled by the Venetians from the early 1200s until it fell to the Ottomans toward the mid-1500s. Whitework combined with drawn-thread work (*fil-tiré*)[8] was used. In this type of needlework threads were drawn together and overcast to make an openwork background, or what appears to be a very fine canvas. The pattern was worked on areas in which the threads had not been drawn.

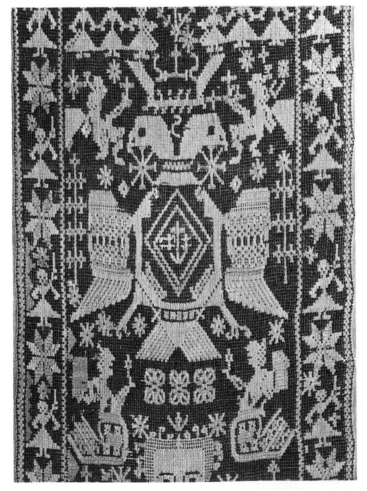

FIGURE 9. The *Dixos* (disk) pattern.

Whitework combined with drawn-thread work, in which threads are first removed and those remaining are overcast together in a color to make a meshlike background. The linen from which no threads have been drawn is then either worked in patterns or filled in with satin stitch. Astypalaia, Dodecanese. *Benaki Museum.*

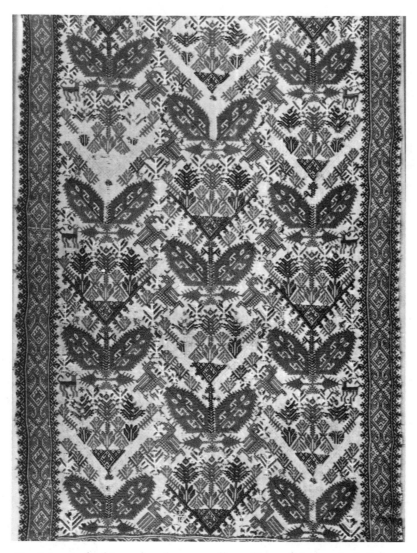

Curtain worked in red and green silk on linen. Stitches include
satin and darning. The King pattern is used as a base for the
Queen pattern. *Benaki Museum.*

The island of Kos used basically the same patterns as Rhodes
with red and green as basic colors. Because fine silk thread
was used, however, the work was much more refined. Cross-,
darning, and satin stitches were predominant.

The island of Patmos used the same King and Queen pat-
terns, often in combination. The King pattern appears to serve
as the base for the Queen pattern. The stitches used on this
island, however, were satin and pattern darning. This might
have been an influence from the Cyclades since both Venetians
and Turks allowed the monks from the monastery of St. John
the Divine to use their fleet of ships in trading activities.

THE CYCLADES

The King pattern which was prominently used in the embroideries of the Dodecanese Islands is found often in the southeasternmost of the Cyclades Islands, Naxos and Amorgos. Needlework from Siphnos, Melos, and Pholegandros, the islands of the western Cyclades, made more use of the Queen pattern. Unlike in the Dodecanese, where cross-stitch was used most frequently, in the Cyclades satin, darning, and long-armed cross-stitches were most common. However, toward the end of the eighteenth century, cross-stitch replaced satin and darning on the island of Anaphe;[9] but on Patmos, in the Dodecanese group, because of its proximity to the Cyclades, darning and satin stitch continued to be used.

Naxos, in the Cyclades, became a Venetian duchy in 1204 and remained so until it fell to the Turks in 1580. The embroidery designs of this island are different from those of any other part of Greece. The greater number of them are made up of interlocking geometric patterns that cover the whole surface of the fabric, giving the appearance of a rich damask. Most of their geometric patterns were based on the stylized leaf-star[10] (Figure 8). These embroideries, almost always worked in monochrome red, were done in darning stitch and

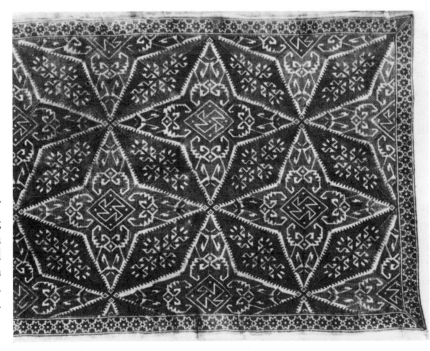

The "leaf and star" variation of the King pattern, worked in monochrome red darning stitch. From a bedspread, Naxos. *Benaki Museum.*

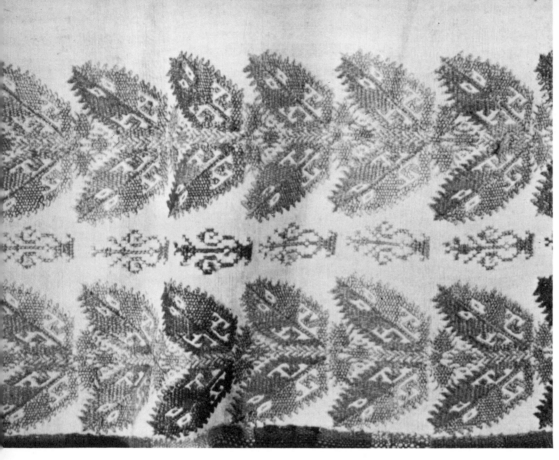

The King pattern, worked in darning vertically along a central stem. Colors include dull gold and green. *Benaki Museum.*

were worked from the wrong side of the fabric. Silk was the medium in which they were worked, and by changing the direction of the stitch, the embroideress was able to achieve interesting shading effects due to light reflection. Naxos produced more embroideries than any other island in the Cyclades. It is said that although there was Venetian influence in the customs of the people, the architecture, and the family names of the capital city, Naxos, there was no foreign influence in the designs used by the villagers because these people would not associate with their captors.[11]

The other western island that made use of the King pattern was Amorgos. It was used on bed curtains in vertical rows and was worked in darning stitch. Dull golds and greens were the most common colors. Although Amorgos was famous for its exportation of red lichen,[12] used in making dye, its own embroideries were not predominantly red. In the Cyclades, embroideresses of Melos used a soft rose; of Naxos, a burnished red; and in the Dodecanese, the women of Patmos used a true red.

On Melos, the Queen pattern was used in combination with a hexagon that had a diamond pattern within it.[13] Quite often the bed curtain was decorated along the bottom with a row of the hexagon diamond with a Queen pattern above and below it, the points of the Vs of the Queen pattern meeting the hexagon. Along the side borders, the Queen patterns telescoped within each other. Up the center of each panel ran another hexagon-diamond series with Queen patterns all on their sides. Satin stitch was used predominantly in this work.

On the island of Pholegandros the Queen pattern was used in combination with hexagons and flowers represented in geometric forms. These pieces were worked on fine linens in polychrome silks. The most common stitches were satin and cross.

Embroideries from the island of Siphnos made use of human forms as little line figures, always worked in satin stitch. The Queen pattern was used in a simplified form along with geometric, stylized birds.

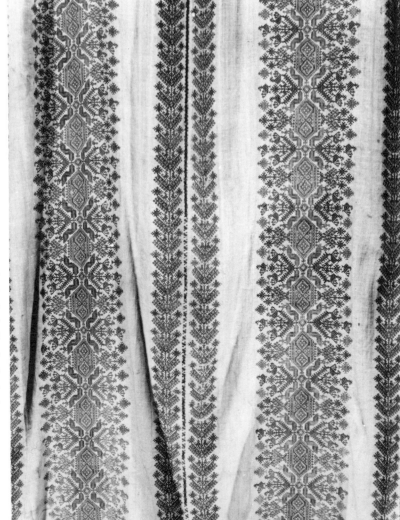

A bed curtain embroidered with the hexagon diamond pattern and the Queen pattern. The Queen patterns along the edge telescope into each other. Worked in red silk on linen in satin stitch. Melos, Cyclades. *Benaki Museum.*

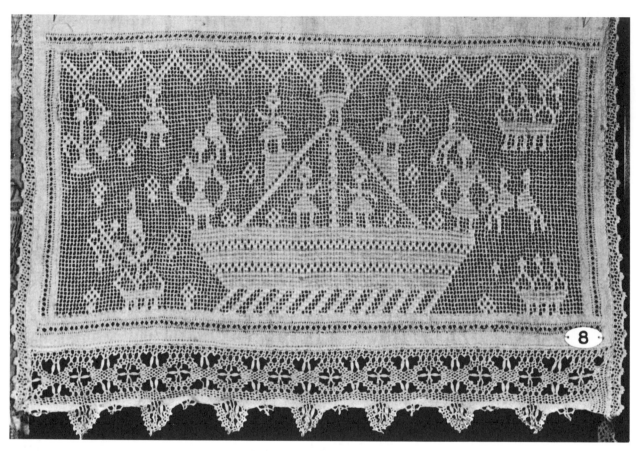

Drawn-thread work done completely in white on a towel from the Cyclades. *Benaki Museum.*

On Ios, plants and animals in geometric shapes were worked in cross-stitch in bright colors. The peacock, again with tail erect, is commonly found in the tree of life design.

Smaller embroidered articles for the home, such as pillow-cases, were usually worked in cross-stitch geometric designs in multicolors.

Whitework in a style similar to that of the Dodecanese, with its drawn-thread background and surface darning, again an Italian influence, was also done in the Cyclades.

CRETE

Crete was under Venetian rule from 1204 until 1669, when it fell to Turkey. The influences of both East and West are very strongly combined in creating a freer type of design outstandingly different from the work in other parts of Greece. Embroideries from Crete are the only ones that were signed and dated, the oldest of which, from 1697, is in the Metropolitan Museum of Art as part of the Seager Collection.

Embroideries were used for home decoration as well as for garments on Crete; however, the most outstanding embroideries are those that were used on the borders of chemises.

Byzantine double-headed eagles, sometimes sprouting car-

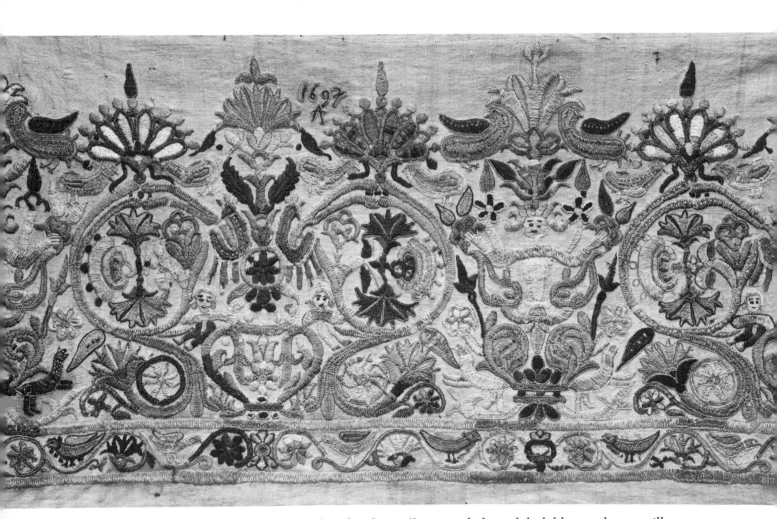

Cretan dress border, dated 1697. Embroidered in yellow, tan, light and dark blue, and green silk on linen. Stitches include Cretan feather, herringbone, outline. *Metropolitan Museum of Art, Bequest of Richard B. Seager, 1926.*

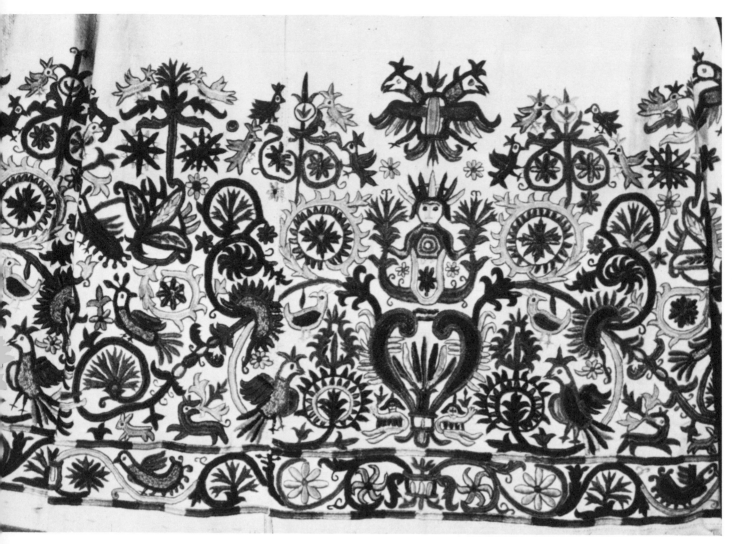

A nineteenth-century Cretan border of a camisole showing a great resemblance to the seventeenth-century design on the preceding page. An example of Greek traditionalism. Worked in red, gold, and green silk on linen. Stitches include Cretan feather, satin, herringbone, and outline. *Benaki Museum.*

nations from their mouths; vases of carnations with birds on either side forming the Eastern tree of life; mermaids holding flowers rather than tails in their hands—all these, combined with arabesque designs commonly used in sixteenth-century Venetian textiles, were united to create the unusual surface embroideries of Crete. These borders usually measured around thirteen inches in depth and had a narrow border of arabesque designs, about two and one-half inches wide, beneath them.

Most of these borders were worked in bright polychrome silks, but monochrome red or dark blue can also be found. The fabric was usually linen, sometimes linen and cotton combined.

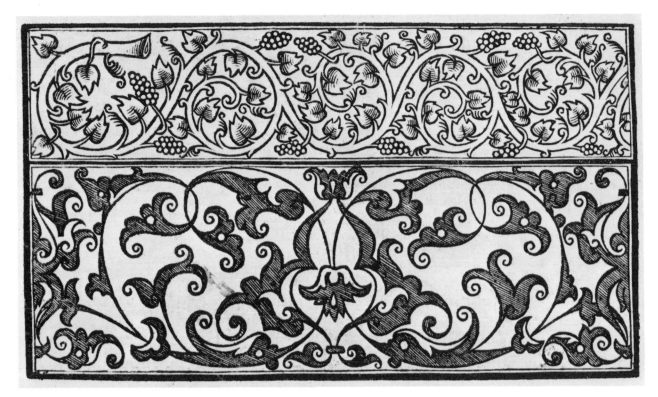

Arabesque lace design from *Opera Nuova Universale Inititilata Corona di Recammi* by Giovanni Andrea Valrassore, ca. 1530, plate 30. *Metropolitan Museum of Art, Harris Brisbane Dick Fund, 1932.*

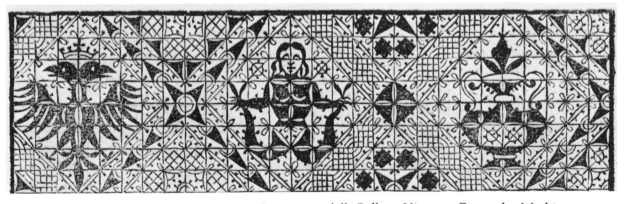

Detail of an embroidery design. From *Ornamente delle Belle et Virtuoso Donne* by Mathio Pagano, Venice, 1554, plate A-8. *Metropolitan Museum of Art, Rogers Fund, 1921.*
Note the resemblance between the Cretan designs on pages 41 and 42, and the Venetian embroidery designs on page 43.

Of all of the Greek embroideries, the Cretan ones used the most stitches. Designs were worked in herringbone, satin, Cretan feather, chain, stem, and split stitch.

Unfortunately, there are no pieces of other parts of Cretan dress remaining besides these chemises. The only sources of information on what other garments looked like are written descriptions.[14] Very often, these skirt borders which usually included five widths of fabric were donated to churches to be used as altar frontals.[15]

The same bright silk motifs used on skirt borders also appeared on cushion covers in Crete. Usually they were designed as roundels with mermaids or double-headed eagles in the center and other roundels in each corner, or a roundel was placed in the center and an arabesque border was used along the edge and floral motifs were placed on the inner corners of the borders.

EPIRUS

The Despotat of Epirus remained under Frankish rule from the twelfth century until 1431 when it fell to the Ottomans. It remained under their control until 1912 when it was united with the Kingdom of Greece.

In the eighteenth century a powerful, ambitious, and ruthless Turkish Albanian named Ali Pasha became ruler of Yannina, the capital of Epirus, which extended beyond its present borders. During his reign, Yannina became a modern urban center and had the largest population of any town in Greece before the war for freedom from the Turks. Ali was intensely interested in developing trade and handcrafts, and under his rule Yannina became the center of commerce and a city of great opulence and sophistication.

Epirus was the only part of the mainland to use embroideries on items for the home as well as on garments. Pillowcases, curtains, and bedspreads were the main articles of decoration.

The embroideries of Yannina are Turkish in inspiration. The hyacinth, carnation, rose, and tulip were the motifs most

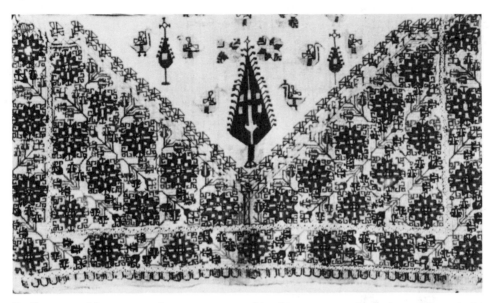

Dull tones of browns and greens are used in these geometric designs. The stitch in which they are worked is identical on both sides of the fabric. Epirus, Argyrocastro. *Benaki Museum.*

often used. The embroideries identified with Yannina were primarily designed with the Turkish rose having a bent stem, which was sometimes encircled by two serrated leaves, as in the ogival pattern. These embroideries were worked in bright as well as dark colors and are excellent examples of the *horror vacui* for which the Greeks were known. Herringbone and outline stitch were used throughout. It is said that these designs were inspired by Turkish covers. When used for pillowcases, the whole surface was covered, and when used for bedspreads, the four borders were embroidered, leaving the centers with no design.

In northern Epirus, in the town of Argyrocastro, now a part of southern Albania, a type of work was done that was completely different from any previously described. The stitch was identical on both wrong and right sides of the fabric and the motifs were geometrical. The colors, greens, browns, and beiges, were duller in comparison to the other work in the area.

The influence of the Venetians from the Ionian Islands on Epirot embroideries can be seen in the embroideries of the coastal town of Parga, where drawn thread and satin stitch were used in creating geometric motifs.

45

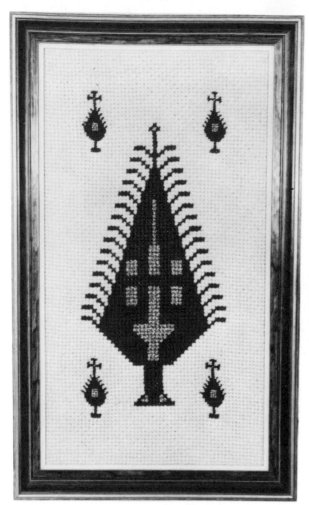

An adaptation of the cypress tree, from Argyrocastro, now a part of Albania, is worked in wool and gold metallic threads. Worked by Anne Steinwedell, age 13. *Benaki Museum.*

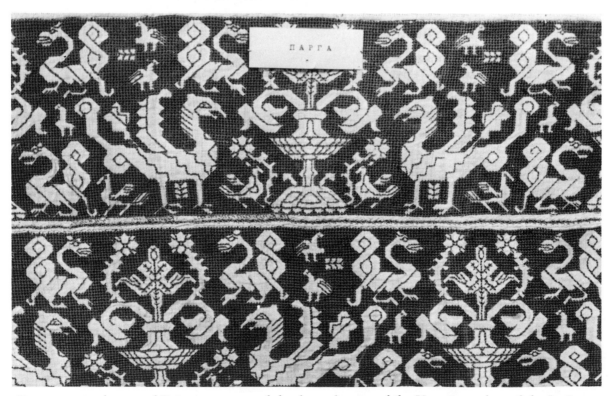

Parga, a coastal town of Epirus, was one of the dependencies of the Venetian rulers of the Ionian Islands. A border worked in red silk on natural linen in drawn-thread work, using backstitch to define detail. Eighteenth century. *Benaki Museum.*

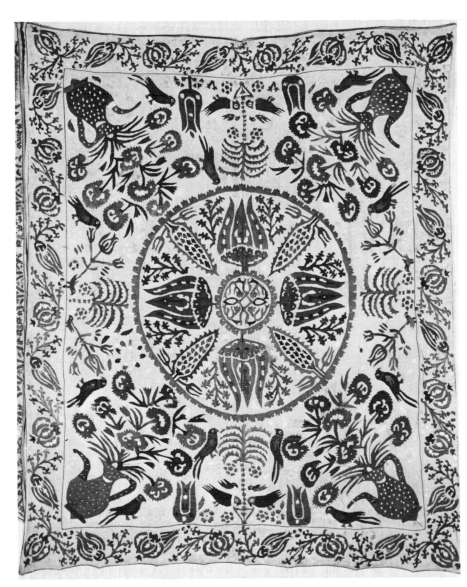

Cushion cover from the Ionian Islands. Worked in silk on linen in red, blue, green, and cream. The tree of life this time is shown with small birds on either side of the stylized plant. Worked in darning stitch. Eighteenth century. *Benaki Museum.*

IONIAN ISLANDS

The Ionian Islands have an interesting history. They came under Venetian rule in the middle of the fourteenth century, French rule in the eighteenth century, and British rule in 1816. In 1864 Britain returned the islands to the Kingdom of Greece.

In the Ionian Islands embroideries were worked in silks in cross-, satin, and darning stitch on linen. The peacock, with tail erect on either side of the plant, much like the designs used

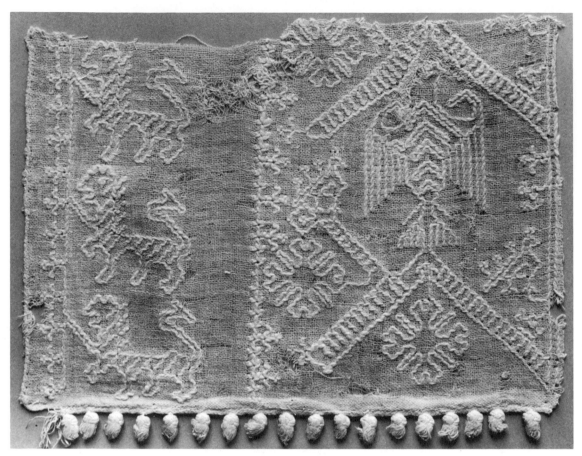

A sixteenth-century Italian piece of whitework embroidered in *punto scritto*. Compare the stylized animals, eagle, and flowers used in this piece with the Venetian work opposite. *Metropolitan Museum of Art, Gift of Marian Hague, 1938.*

in the Cyclades, was commonly used. Other Ionian Island work was done in drawn-thread background called *maglia quadrata* (an Italian influence) with details on the motifs worked in split and darning stitch.[16] Trees, peacocks, and double-headed eagles were among the motifs used. Bright reds, blues, and greens were the dominant colors.

In the Ionian Islands human forms were used to show action taking place: a bridal procession, a hunting scene, etc. Although there are some Turkish elements in these designs—the flowers

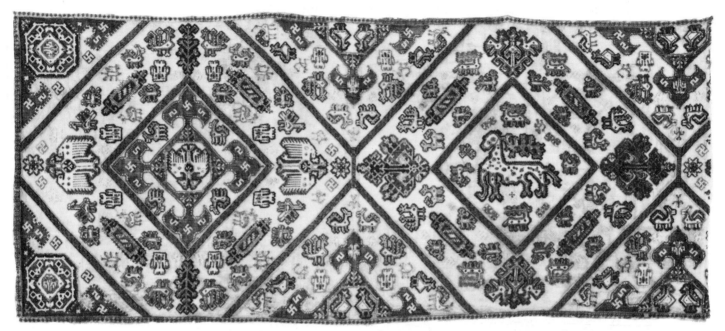

Drawn-thread work, *maglia quadrata*, of Venetian influence, was commonly used in the embroideries of the Ionian Islands. Stylized flowers and animals were used. Satin stitch is primarily used in green, red, blue, and gold. Eighteenth century. Ionian Islands.
Helen Wace Collection.

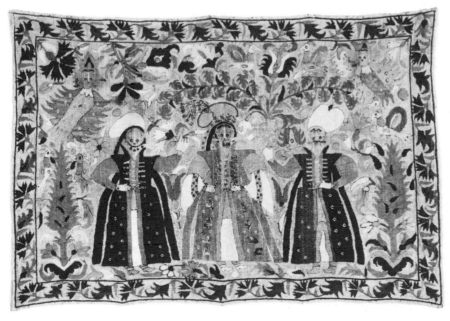

A wedding cushion worked in darning and outline stitch. Human forms were most realistically represented in embroideries of the Ionian Islands. Garments are those typically worn on the islands during the eighteenth century. Colors included red, blue, pink, green, gold, and white, with black used for the outlines. Ionian Islands.
Helen Wace Collection.

and headdresses, for example—the garments worn are not Turkish. The frog, which was the common closure for Turkish garments of this period,[17] was also commonly used in Venice, Poland, and Hungary at the same time.[18] The type of dress itself is not Turkish, as the garments of Turkish men at that time were the long, loose kaftans.[19] The tight knee trousers were worn by Ionian Island men, and in frescoes of Cretan churches from the fourteenth to the sixteenth century we find Cretan men similarly dressed. Men on the island of Chios also wore garments of this type.[20] Colors usually included bright blues, reds, and greens.

Whitework, another Italian influence, was also worked in the Ionian Islands.

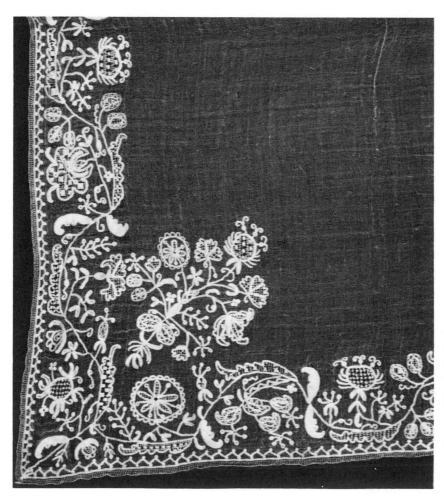

A bridal veil made of fine, gauzelike fabric and worked in white chain stitch and drawn-thread. Lefkas, Ionian Islands. *Benaki Museum.*

THE NORTHERN SPORADES

Of the northern Sporades Islands, Skyros is the only one that produced embroideries. The Venetians occupied the islands in 1453, and they remained there until 1538,[21] when the Ottomans defeated them. After this, the islands of Skopelos and Skiathos were depopulated.[22]

Bright, colorful, gay, and oriental-looking are the most descriptive words one can use when talking about the embroideries of Skyros. There is in them an obvious freedom and lack of the austerity that is so prominent in the designs of the other islands of Greece.

Subjects of everyday life were used in designs, sometimes naturalistically and sometimes in fantastic forms. Flowers, ships, humans, beasts with human heads, roosters, birds, horsemen carrying scimitars—any variety of subjects was used to decorate these fabrics.

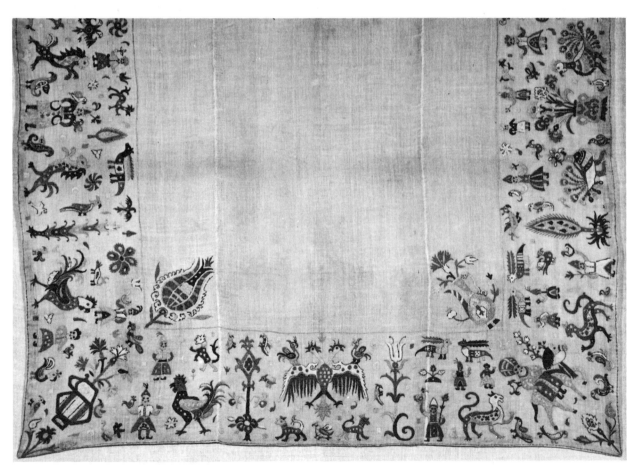

A sheet from Skyros using a variety of animal, plant, and human motifs. Worked in polychrome silk on linen. *Benaki Museum.*

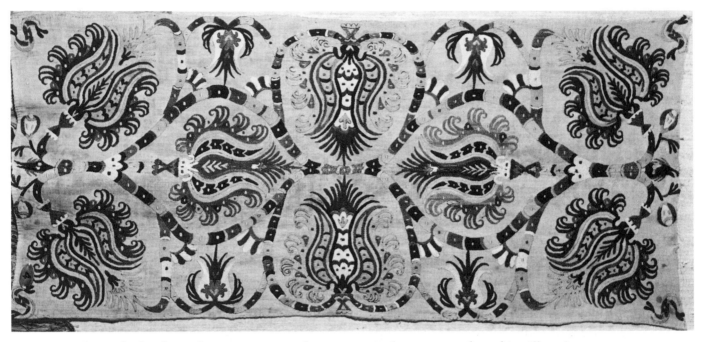

The Turkish tulip and pomegranate make up an ogival pattern used on this pillow from Skyros. Worked in darning and outline stitch. Colors include red, gold, light and medium blue, and black. *Benaki Museum.*

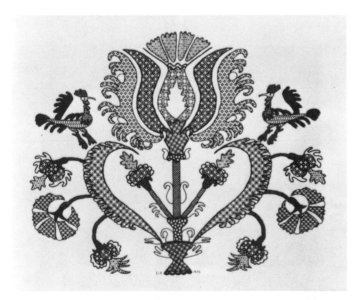

A Skyrian flower arrangement (see Plates 25 and 26) adapted for use in blackwork. Worked by Elizabeth L. Kidder.

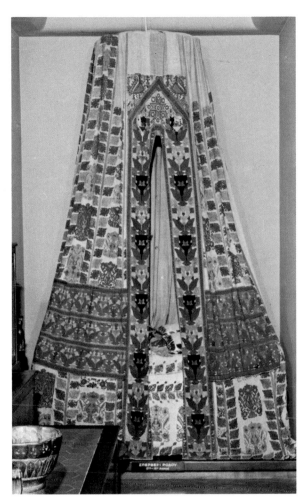

PLATE 1. A bed tent (*sperver*) of Rhodes measured 13 feet in height and was draped over a disk 2 feet in diameter that was suspended from the ceiling. Designs, worked in silk on linen in cross-stitch, include the King, Queen, and *Glastra* patterns, along with alternating rows of simple leaves.
Benaki Museum, The Helen Stathatos Collection.

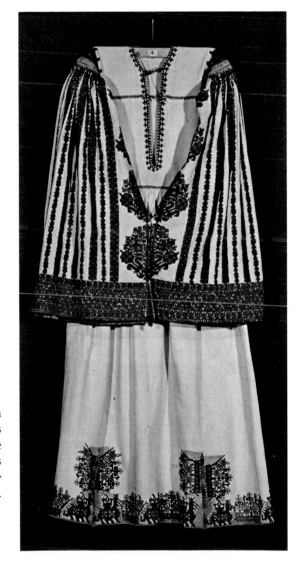

PLATE 2. An Astypalaian shift worked in polychrome silks. The *Dixos* pattern is surrounded by stripes called centipede designs. Worked in counted-thread. This was one of the most formal shifts worn by the women of Astypalaia. *Benaki Museum.*

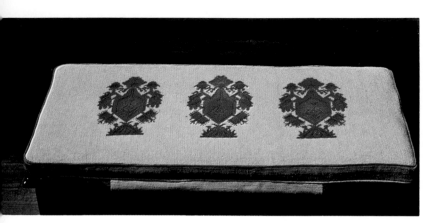

PLATE 3. Adapted from the Rhodian *Glastra* pattern. Worked by Mrs. Stavros Manousos. *Benaki Museum.*

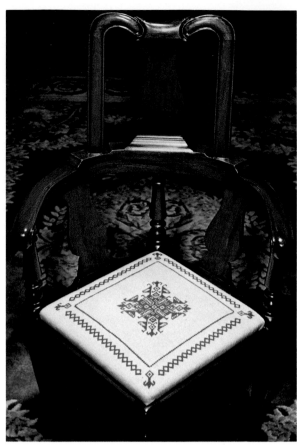

PLATE 5. An adaptation of a motif from a Naxian pillow used for the center of a chair seat, with a border made up of segments within the design. Worked by Mrs. E. Gerard Keen. *Benaki Museum.*

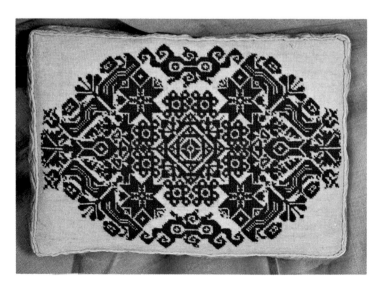

PLATE 4. An adaptation of a bed curtain design from Kos. Worked by Ruth Wolcott. *Benaki Museum.*

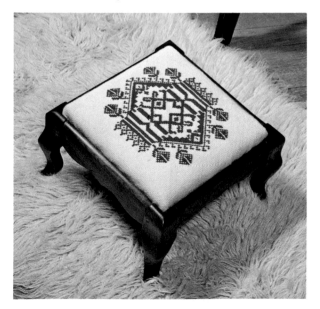

PLATE 6. A hexagon motif from Pholegandros used on a footstool. Worked by Marjorie Ramage. *Benaki Museum.*

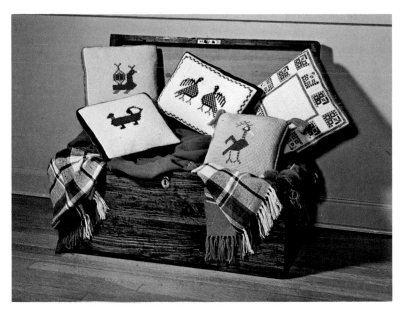

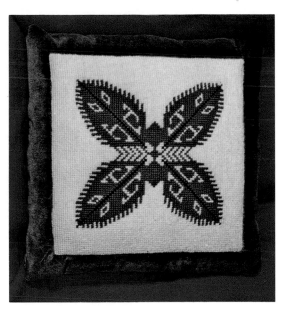

PLATE 7. A treasure chest of pillows. From left to right: Dog by Sylvia Perdikis, age 4½. Source: Lefkas. Peacock by Mary Elizabeth Keen, age 9. Source: Corfu. Two eagles by Holly Bishop, age 12. Source: Ionian Islands. Floral border by Susan Marie Keen, age 13. Source: Macedonia (*design from Folk and Ethnology Museum of Macedonia*). Bird by Patricia Ellen Keen, age 7. Source: Sifnos. *All designs unless otherwise noted are from the Benaki Museum.*

PLATE 8. Adapted from the King pattern. Worked by Mrs. Sebastian Bugella. *Benaki Museum.*

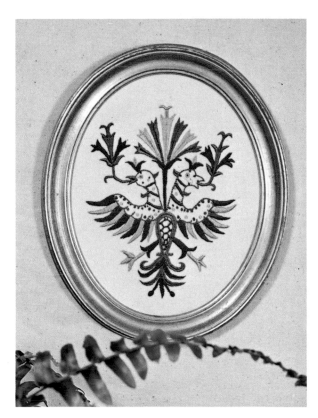

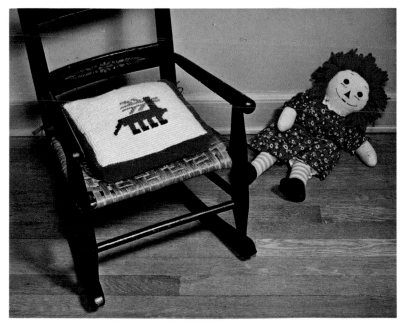

PLATE 9. The reindeer from Lefkas made into a cushion. Worked by Johanna Kristina Petrakis, age 4½. *Benaki Museum.*

PLATE 10. The double-headed eagle sprouting flowers, taken from a Cretan border, is worked in Pearsall silk on velvet, using chain, flat, Cretan feather, satin stitch, and French knots. Worked by Mrs. Herbert Gutterson. *Benaki Museum.*

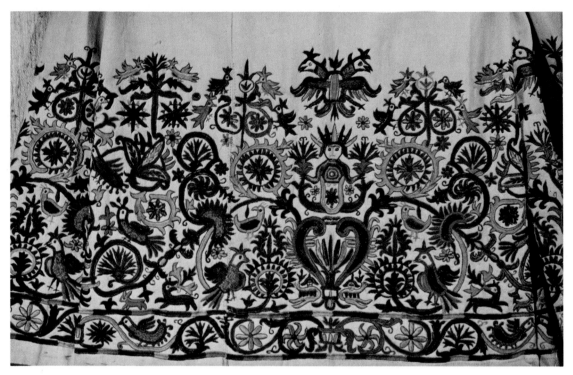

PLATE 11. The embroidered border of a Cretan chemise. The double-headed eagle, mermaid, and arabesque designs are used. *Benaki Museum*.

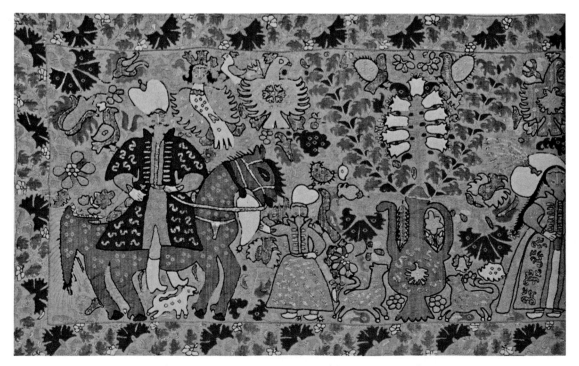

PLATE 12. A segment of an eighteenth-century wedding cushion depicts the groom, with interesting headdress, on horseback and animals on either side of a vase of flowers. Worked in silk on linen in darning stitch. Ionian Islands. *Benaki Museum*.

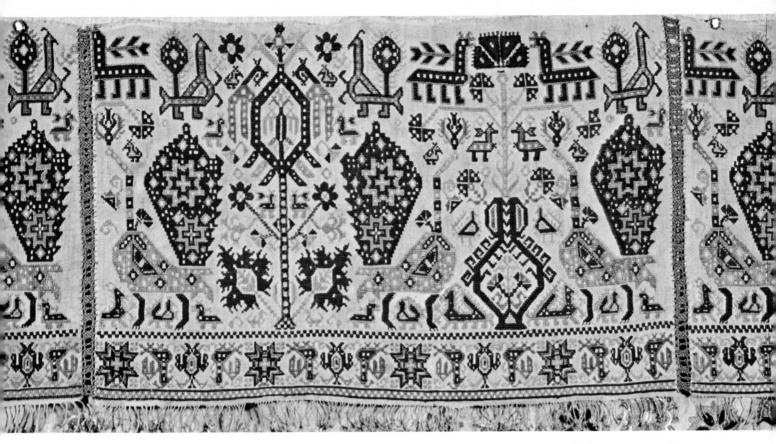

PLATE 13. The "tree of life," animals on either side of a vase of flowers. Worked in cross- and darning stitches. Ionian Islands. *Benaki Museum.*

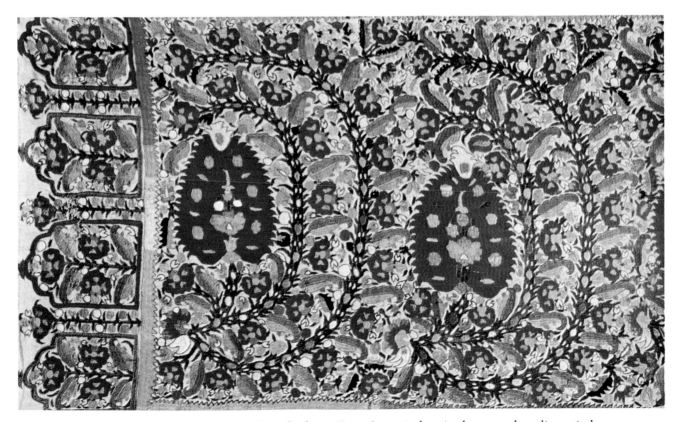

PLATE 14. Section of a bedspread worked in silk on linen in herringbone and outline stitch, characteristic of Yannina embroidery. Red, green, and gold predominate as colors. Epirus, Yannina. *Benaki Museum.*

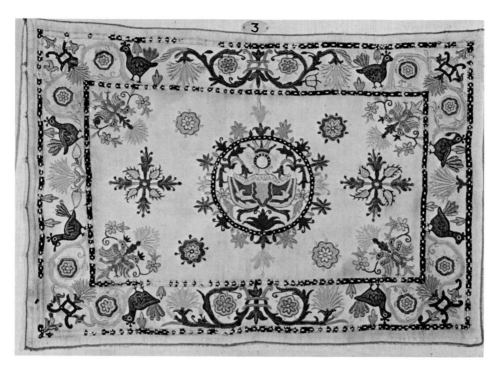

PLATE 15. A Cretan cushion with a roundel centered with a mermaid sprouting flowers. A border of birds, roses, and carnations goes around the edge of the pillow. On the four inner corners are double-headed eagles, sprouting carnations between them. Silk on linen. Satin, Cretan feather, herringbone, outline, and chain stitches are used. *Benaki Museum*.

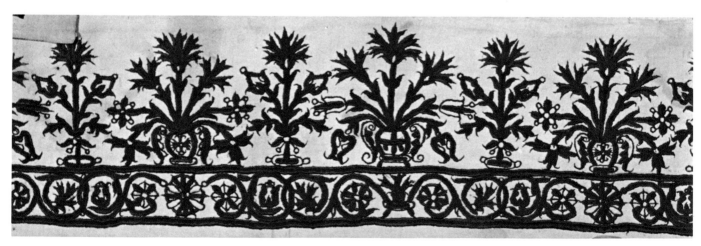

PLATE 16. A red monochrome Cretan border of carnations with a lower arabesque border. *Benaki Museum*.

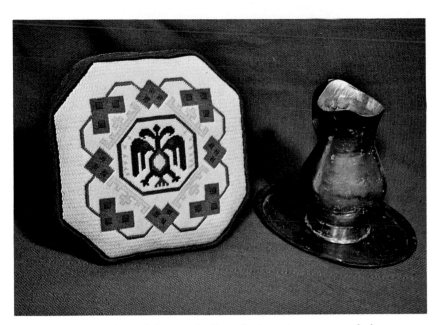

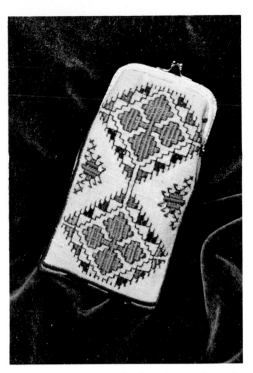

PLATE 17. Adapted from a Lefkas design. An octagonal shape centered with the double-headed eagle. Worked by Marion Lewis. *Benaki Museum.*

PLATE 18. A motif taken from the side of a sleeve and worked on handwoven Greek counted-thread fabric, into an eyeglass case. Worked by the author. *Folk and Ethnological Museum of Macedonia.*

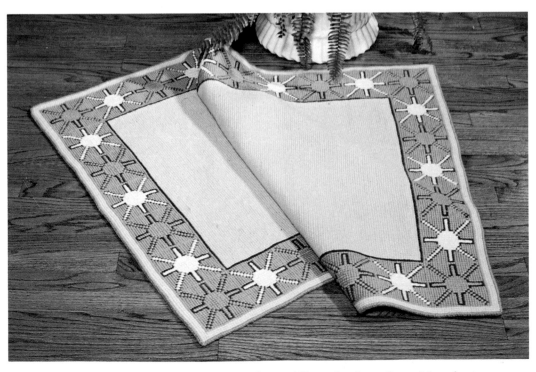

PLATE 19. A border adapted from the neckline of a dress from Macedonia and made into a carpet. Worked by Mr. and Mrs. Costas Capsalors. *The Folk and Ethnological Museum of Macedonia.*

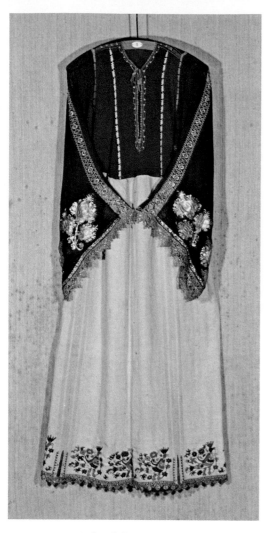

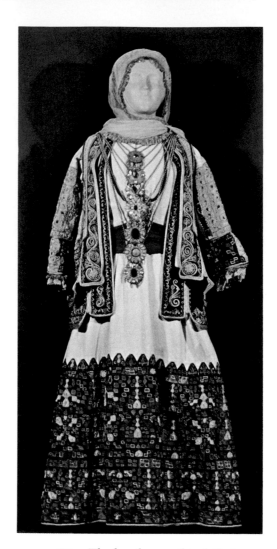

PLATE 20. A bridal dress from Skyros with a bodice made of fine colored linen with gold embroidery. *Benaki Museum.*

PLATE 22. The border on the shift from Attica, very colorful and mosaiclike, has no specific motif or representations. Worked in polychrome silks and gold metallic threads. *Benaki Museum.*

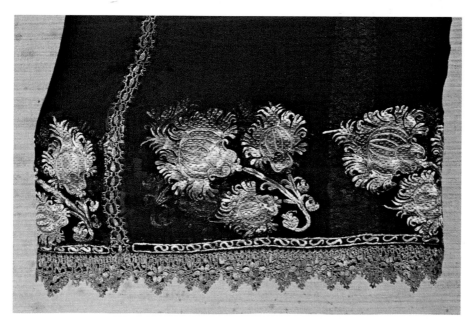

PLATE 21. Detail. Embroidery on sleeve worked with fine gold thread in a stitch that is perfect on both sides of the fabric. *Benaki Museum.*

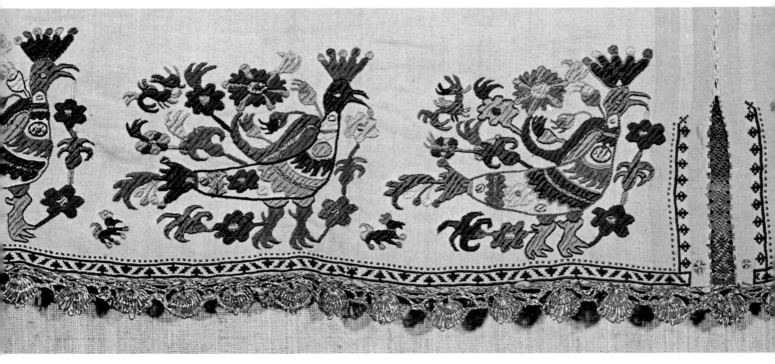

PLATE 23. Detail. Embroidery along the bottom of the cotton skirt was done in polychrome silk. *Benaki Museum.* (Plate 20)

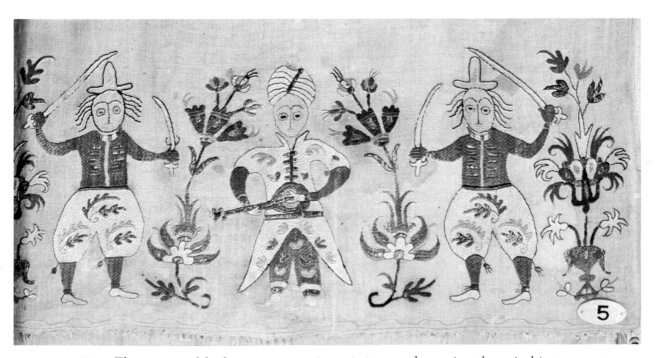

PLATE 24. Three oriental-looking men, carrying scimitars and an oriental musical instrument. The flowers have typical Turkish "hooked" stems. Worked in silk on linen in darning, outline, and chain stitches. *Benaki Museum.*

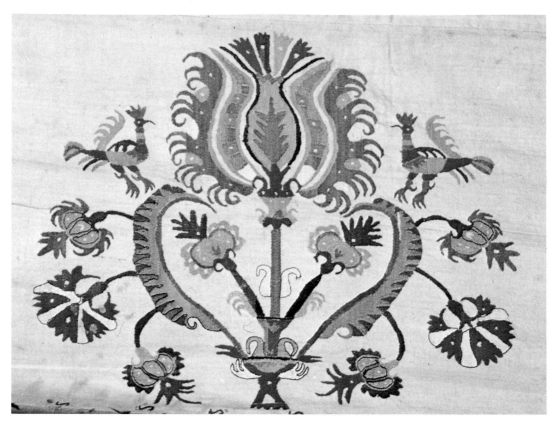

PLATE 25. Eighteenth-century Skyrian flower arrangement including tulip, carnation, pomegranate, from an embroidered sheet worked in silk in darning, outline, and chain stitches. *Benaki Museum.*

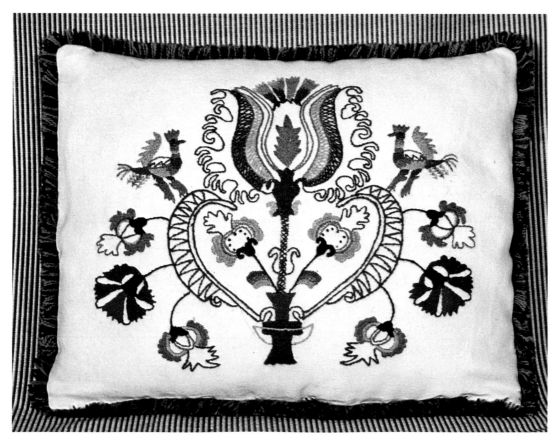

PLATE 26. An adaptation of the same floral arrangement worked in eighteenth-century American crewel stitches by Muriel Baker.

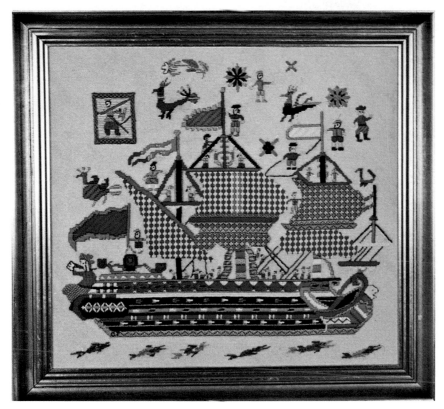

PLATE 27. A Skyrian boat, adapted from surface embroidery to canvas work and done in an interesting combination of techniques (i.e., appliqué), materials (wool, D.M.C. mouline, cotton perle, etc.), canvases (ranging from 18° to 32°), and stitches. Worked by Mrs. Raymond Tribelhorn. *Benaki Museum.*

PLATE 28. A famous bird of Skyros adapted to canvas work and worked in polychrome D.M.C. mouline, completely in tent stitch. Worked by Mrs. John H. Brown, Jr. *Benaki Museum.*

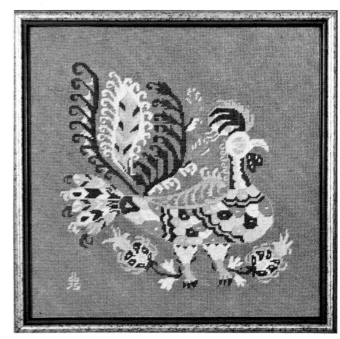

PLATE 29. A geometric design from Attica. Worked by the author on handwoven Greek counted-thread fabric. *From the private collection of Margarita Falari, Thessalonike, Greece.*

PLATE 30. A geometric sleeve border from Boeotia makes an interesting design for a tray center. Worked by Mrs. Emanuel Perdikis. *Benaki Museum.*

PLATE 31. A Boeotian geometric, again from a sleeve, is worked in an interesting carpet. Worked by Mrs. Harold Norton. *Benaki Museum.*

PLATE 32. A border from a shift of Corinth shown worked in three different techniques:
1. Bottom, bench: crewel wool on 18° canvas; background canvas left unworked. Worked by the author. Bench courtesy of Harrold de Groff Interiors.
2. Top left, pillow: worked using the technique of basting canvas on fabric and then raveling canvas out after embroidery is completed. Worked by the author.
3. Top right, table cover: worked in D.M.C. mouline on handwoven Greek counted-thread fabric. Worked by Aglaia Kyriazi. *The Folk and Ethnological Museum of Macedonia.*

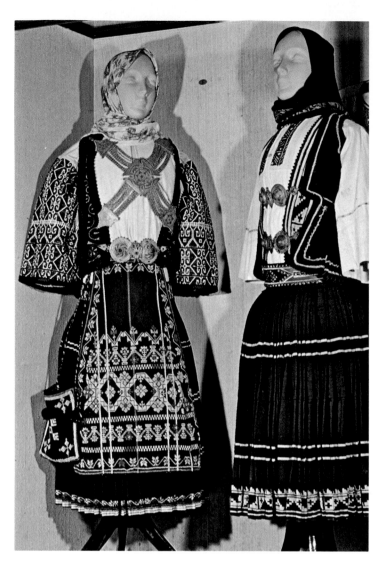

PLATE 33. Sarakatsan dress. These nomad shepherds traveled from the mountains to the plains of Greece and were completely self-sufficient. The austerity of their lives is well represented in their embroideries, which are often in black and white with a slight accent of color. The large silver ornament was worn across the newly married woman's chest until her first child was born. *Benaki Museum.*

PLATE 34. The original colors of a Sarakatsan sleeve border are used in the center project worked in tent stitch on 14° canvas. Long crosses are vertical. Worked by Mrs. Peter Steinwedell. *Left:* The purse worked in navy blue tent stitch on 18° canvas with long crosses going horizontally. Worked by Mrs. G. Barry McMennamin. *Right:* The purse worked in light blue cross-stitch (the original stitch) on etamine (a counted-thread fabric from Greece), 36°. Worked by Margarita Falari.

PLATE 35. The same Sarakatsan design, worked on 5° canvas in a contemporary color scheme for a handsome carpet by Dr. Gregory M. Petrakis. Chair and plant stand courtesy of Harrold de Groff Interiors. *Benaki Museum.*

PLATE 36. A Sarakatsan sleeve border design used for a carpet on 5° canvas. Worked by Mr. and Mrs. G. Anthony Westbrook. *Benaki Museum.*

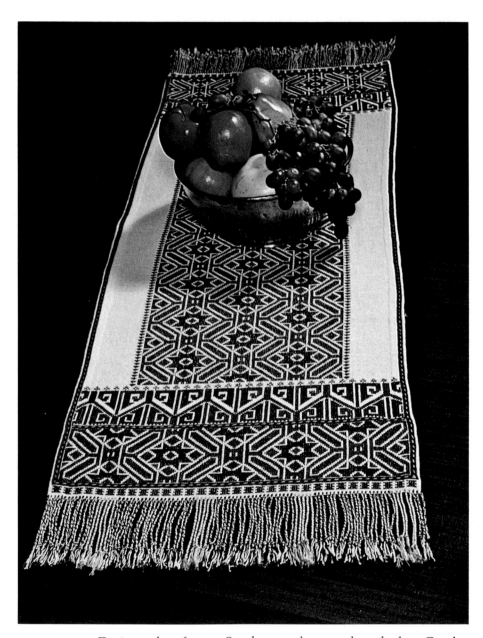

PLATE 37. Design, taken from a Sarakatsan sleeve and worked on Greek handwoven counted-thread fabric. Notice the similarity of this design to the tray from Boeotia (Plate 30). Worked by Margarita Falari. *From the private collection of Mrs. Aristi Antoniadou, Thessalonike, Greece.*

The humans showed Persian and Turkish influences in their turbaned heads, scimitars, and the musical instruments they often carried; the flowers, invariably tulips, hyacinths, and carnations, had the Turkish curve at the end of the stem; cocks with bright, full, fantastic tails; boats and oriental ships filled to more than capacity with human forms—all this in contrast to the practice of Islam which forbade the depiction of human forms. The people of Skyros were not sailors, but they used and named every different type of boat available in their embroideries. Embroidered bedspreads had motifs on all four sides. A great number of stitches were used, including split, satin, darning, outline, and running.

Needleworkers from Skyros, one of the few places in Greece where colored fabrics were used for embroidery, usually did so for the bodices of their bridal dresses. The necklines were embroidered in fine flowers of gold metallic thread. The bottoms of the full sleeves were embroidered with gold metallic flowers, *laledes* or poppies, along the circumference.[23] The embroidery was done with such accuracy that the stitchery was perfect on both wrong and right sides. The edges of the sleeves were trimmed with gold lace. The skirts were made of cotton and embroidered in polychrome silks, usually in a flower or bird motif.

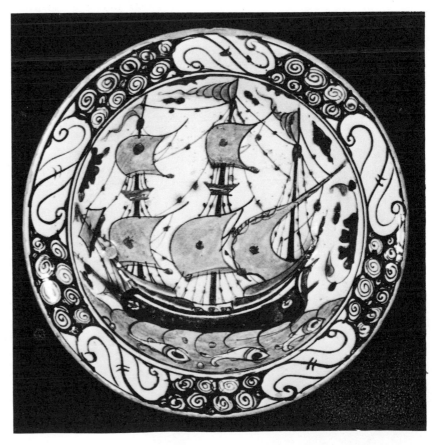

Isnik (Nicaea) ceramic plate, ca. 1600. Polychrome with red. Notice the lack of any human forms because Islam did not allow it. *Benaki Museum.*

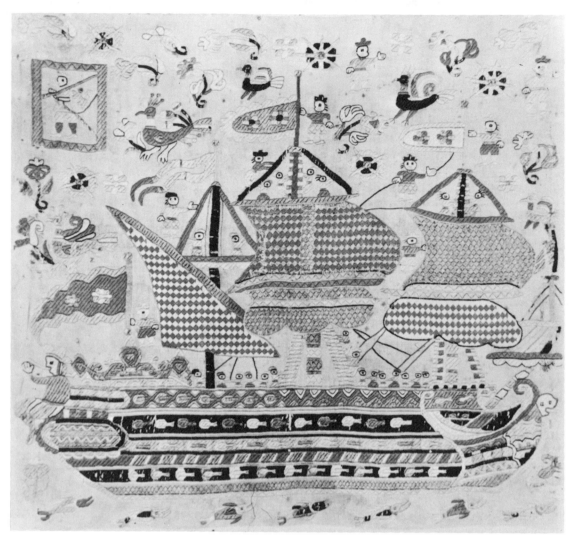

Cushion cover from Skyros (see Plate 27 and page 128) worked in polychrome silk on linen. An overabundance of human and animal forms fills the ship and its environs. Darning, satin, and outline stitches. Seventeenth to eighteenth century. *Benaki Museum.*

A simplified Skyrian ship. Worked by Laurie Keen, age 11.

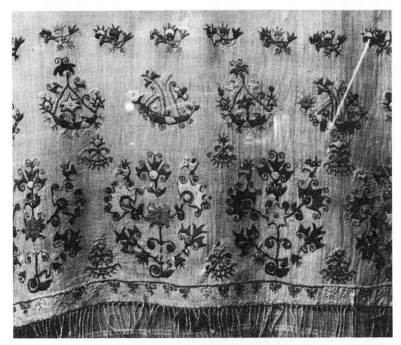

The Turkish rose with the hooked stem worked in darning, outline, chain, and backstitch. Polychrome silk on linen. Lesbos. *Benaki Museum.*

Satin stitch, pulled-thread, and hemstitching in white, worked in geometric shapes on a fine linen towel. Lesbos. *Benaki Museum.*

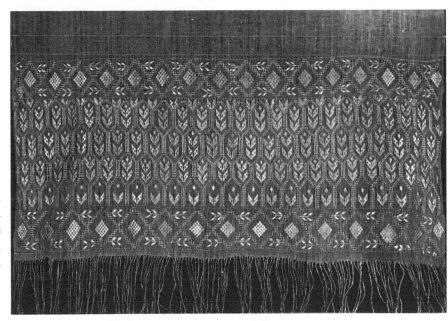

CHIOS AND LESBOS

These two islands in the northern Aegean have similar histories that include wars with Venetians and Frankish invaders and conquest by the Genoese, who remained there until defeated by the Turks. The islands were returned to Greece in the early 1900s.

A whitework placemat adapted from a design of Lesbos. Worked by Peg Lunt (Mrs. R. Gilman Lunt). *Benaki Museum.*

The colored embroideries of Lesbos very often include the Turkish rose with the crooked end of the stem. Whitework, with Turkish motifs as well as geometrics, was commonly done on the island.

Because the people of Chios not only produced silk but also wove and exported it to the mainland from the fourteenth to the nineteenth century, they did not produce a large number of embroideries. Most pieces worked were square scarves worn by the women.

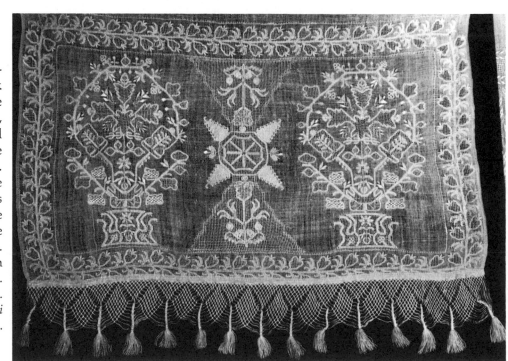

Drawn-thread work in white done in satin, chain, and buttonhole stitches. Netting edge and tassels finish the edge of the towel. Worked on fine linen. Lesbos. *Benaki Museum.*

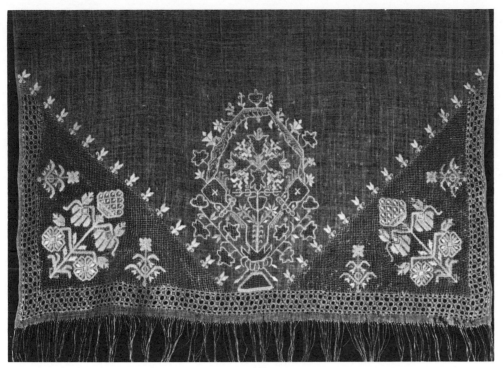

A number of interesting drawn-thread patterns, combined with satin, chain, and buttonhole stitch in white on a fine linen towel. Lesbos. *Benaki Museum.*

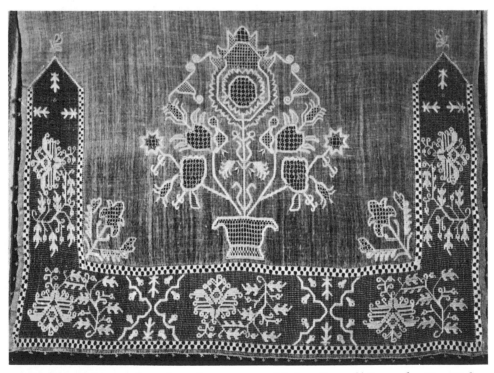

A variety of drawn-thread work patterns, with fagoting, chain, and satin stitch, worked in white on a fine white linen towel. The Turkish rose with its hooked stem appears in the border. Lesbos. *Benaki Museum.*

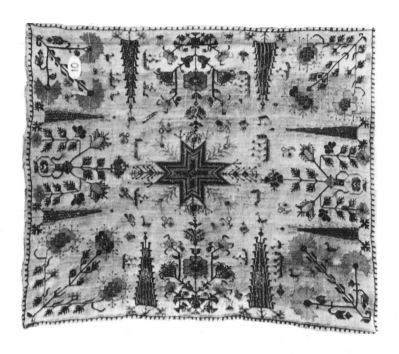

Embroideries from Chios were sparse and usually used for women's scarves. *Benaki Museum.*

Borders from different parts of Greece. From lower left: Thasos, Chios, Skyros, Thrace, Chios, Thrace, Sarakatsan (three-sided), Ionian Islands. Worked by the author. *Benaki Museum.*

Foreign motifs became integrated with the indigenous ones and have given distinct character to the embroideries of each region of Greece with the result that each area did produce an original and almost completely individual art.

Projects for Construction

CANVAS ON FABRIC TECHNIQUE

This is an excellent technique to use on any fabric upon which you wish to embroider, such as velvet or knits, to which you cannot transfer designs by the usual methods of painting, carbon, etc. Disposable canvas may be used; however, if regular canvas is used, the embroidery will have an embossed look after the canvas threads are removed.

1. Mark the center on the lengthwise and crosswise grain of the fabric upon which you wish to embroider your design.

2. Cut the canvas the same size as the fabric and tape the edges. Place the canvas on the fabric, keeping the edges together, and pin the canvas in place. Baste through the canvas, on the established fabric basting lines, with stitches no longer than ½″, so that both are fastened together on the straight of grain.

3. Baste, starting from the center crosswise line out to the edge of the fabric (arrows in the diagram indicate direction) at 2" intervals.

Although it is not shown in the diagram, this same basting procedure may be carried on across the fabric as well to ensure that the grain remains in place.

4. Treat both layers, canvas and fabric, as if they were one and baste them onto the tapes of the roller frame. Embroider your design.

5. After the embroidery is completed, carefully remove all basting and ravel out the canvas.

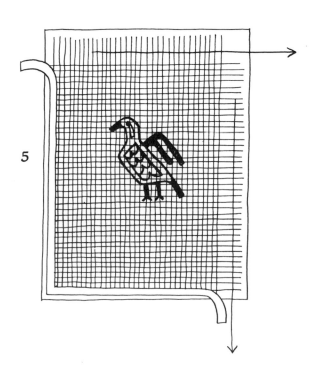

MAKING A KNIFE-EDGE PILLOW

One of the important characteristics of a square or rectangular pillow is that it be just that: a geometric configuration without convex lines ending in "pointed ears" at the corners. To achieve this you must take accurate measurements that allow for the curve of the pillow and then apply a few simple rules of construction.

Although this method was basically devised for making pillows out of fabrics, it can be applied to all types of canvaswork pillows, always, of course, centering motifs and designs, with the exception of those that have a border design. It is best to construct those pillows with boxing.

This method was used to make all the knife-edge pillows that appear in this book.

1. Measure the pillow lengthwise and crosswise from seam to seam over the center curve. These are the only two figures needed to construct the perfect pillow.

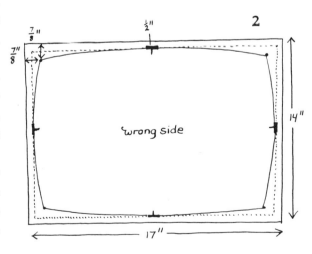

2. Cut the fabric to be used (remembering to center any motif) 1" larger than the pillow measurements to allow for the seam allowance. At the halfway point, both vertically and horizontally, and on the wrong side of the fabric, measure in and mark, preferably with tailor's chalk, the ½" seam allowance. Make this mark extend ½" beyond the center mark on all four sides. At the corners mark in a ⅞" seam allowance, and then join these points with tailor's chalk. Your shape will be a gradual curve in to the corners. Machine baste on this seam line, making sharp points at the corners.

 Cut a second piece of fabric to these measurements, mark in the exact same manner, and machine baste the seam allowance as a guide. If you are not adding cording, fringe, etc., you may now proceed with step 12.

3

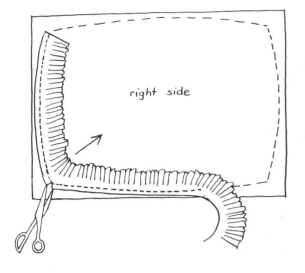

right side

3. Having machine basted your seam allowance, you may proceed to add a fringe on the right side of the pillow with the fringe facing the center. Start the fringe at the corner and go around, using your basted seam line as a guide, pinning at 2″ intervals. Snip the fringe in at every corner, being careful *not* to cut the stitch lines. When you have gone completely around the pillow, carry your fringe 1″ around the corner where you started. Stitch the fringe to the pillow and then proceed with step 12.

4. If you are using cording, the construction is basically the same as for the fringed pillow with a few modifications.

5. Leave a 1″ tail of cording beyond the corner seam allowance; mark and pin cording on the seam line.

4

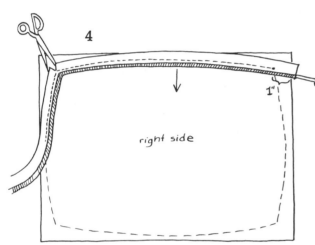

right side

1″

6. Stitch bias, starting 1″ from the corner, onto the pillow and snip in as you go around the corner, being careful not to snip the stitching on the bias. As you near the corner where you started, stop stitching about 1″ away and cut off the cording, leaving approximately 1″ beyond the corner seam allowance.

7. Open bias strips and stitch them together, making sure they will fit exactly to the pillow and at the corner.

8. Trim the seam, press it open with your fingers, and cut the cording ends so that they butt up against each other.

9. Fold the bias over the cord and continue stitching in place. You may now proceed with step 12.

5

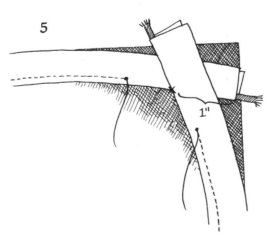

1″

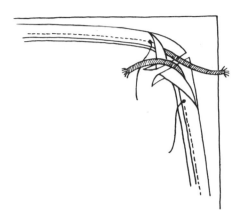

6

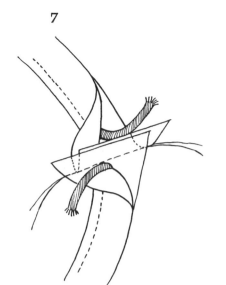

7

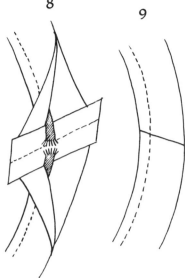

8

9

10

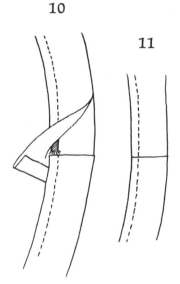

11

10. If steps 7–9 seem too complicated, the bias may be finished according to a simpler method. Open the bias. Cut the cording (*only* the cording) at the corner point on your pillow, about 1″ back, and fold back the bias about ½″ so that the fold is on the corner of the pillow. Bring the ending section of the bias cording up to the cut cord and then trim off the excess cording so that both cords abut on each other.

11. Bring over the folded bias and complete the corner. Stitch in place and continue with step 12.

12. Pin the top and bottom of the pillow, right sides together, matching corners and edges. Starting about 1½″ in from the corner, stitch along the seam line already made by sewing in fringe or cording and go around three sides of the pillow and 1½″ onto the fourth side. This leaves an opening for stuffing. Trim the corner seams and snip in to the seam line, turn the pillow right side out, and insert the muslin-covered pillow. Finish the opening by carefully slip-stitching front and back together.

12

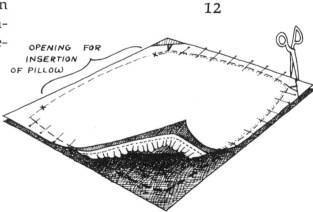

OPENING FOR INSERTION OF PILLOW

EMBROIDERED PURSE

Materials

2 pieces of Greek handwoven fabric 9" x 12"
2 pieces of lightweight Pellon 9" x 10"
2 pieces of lining fabric 9" x 10"

Fabric measurement requirements for making this purse are specifically for the use of Greek handwoven counted-thread fabric with 25 threads per inch. This is important because of the placement of the design.

1. Zigzag the embroidery fabric to prevent raveling.

2. To establish the lengthwise center line of the embroidery fabric, fold it in half lengthwise and with basting cotton, baste *into* the crease, with stitches no longer than ½".

3. Count down 18 threads and baste the fabric on this line to establish the *top* of the small motif, the sides and point of which will be 8 threads away from the center line.

4. Count down 70 threads (approximately 2¾") from the basting line, and you have the location for the top of the large diamond motif.

5. After you have completed your embroidery, press it, face down, on a dry Turkish towel with a steam iron. This will give it an embossed appearance.

Construction of Purse

1. Baste Pellon to the back side of the embroidery, keeping the top edges together. The basting should end ⅜" below the last row of embroidered motifs. There will be approximately 2" of embroidery fabric extending beyond the Pellon. Repeat this for the purse back.

2. Put the front and back sections together, right sides together, and stitch along the basting line. *Do not stitch across the bottom.*

3. Press the seam open. The bag should measure 9⅝" x 7¾".

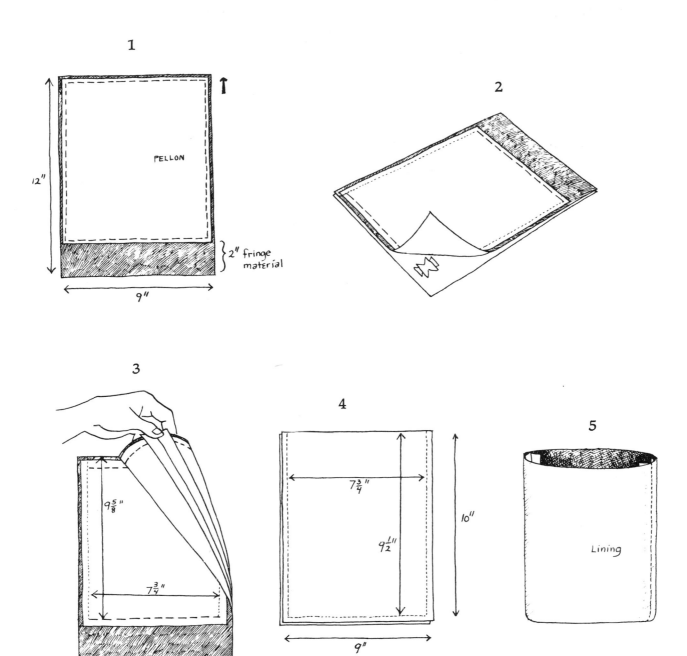

1

PELLON

12"

9"

2" fringe material

2

3

9⅝"

7¾"

4

7¾"

9½"

10"

9"

5

Lining

4. Construct the lining in the same manner, this time stitching across the bottom as well as the sides. Press the side seams open.

5. Turn the lining right side out.

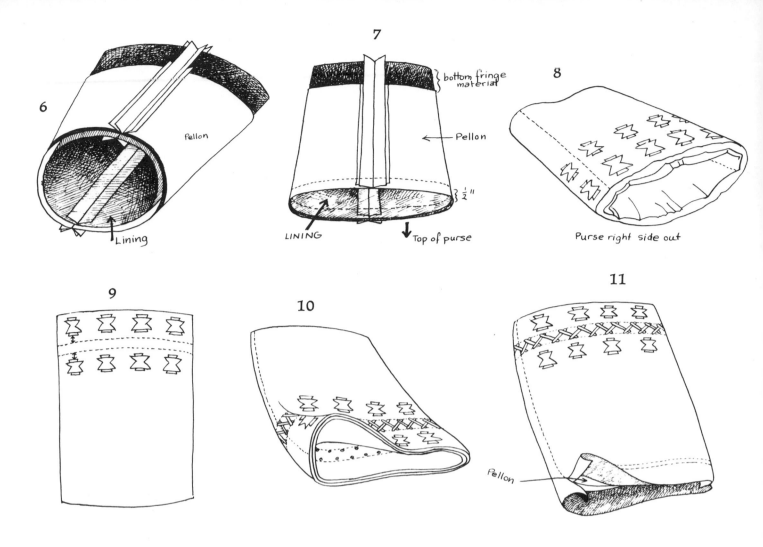

6. Keeping the top edges together, place the right side of the lining against the right side of the purse. Pin around the top, matching the side seams.

7. Seam ½″ from the edge.

8. Turn the bag right side out and press it carefully along the top so as not to press embroidery.

9. Topstitch bag and lining together 3 threads of embroidery fabric down from the bottom of the top motif. Make a second row of topstitching 3 threads up from the second row of the motif.

10. *Using a double thickness of a full skein of 6-strand mouline (12 threads in all), make herringbone stitch casing through all layers of the purse, within the confines of the topstitching.

* Courtesy of Vogue Patterns.

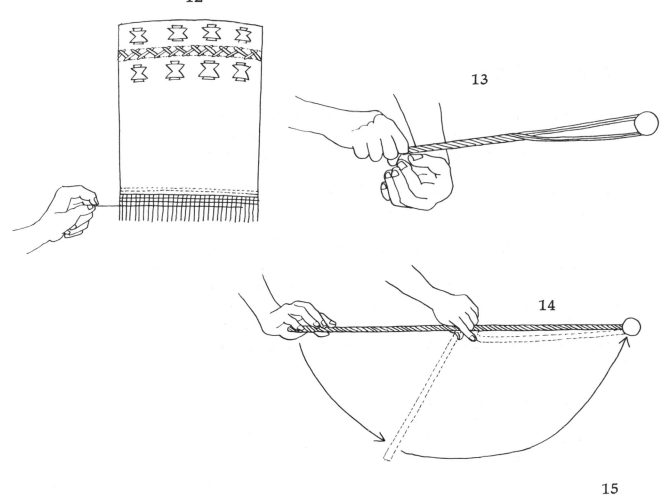

11. Pin the bottom of the purse together, ³⁄₈″ below the last embroidered motif. Do two rows of topstitching or zig-zag, making sure to catch the Pellon but not the lining.

12. Ravel the remaining embroidered fabric at the bottom of the purse.

13. Take a full skein of 758 mouline, fold it in half, and then in half again. Have someone hold one end or attach it to a hook, and then twist it tightly.

14. Place your finger at the halfway mark and fold the yarn in half again. Keep the two ends together and let it twist on itself. Knot both ends. Repeat and thread it through the herringbone casing to form a drawstring.

15. Knot both ends together.

EYEGLASS CASE

Making a purse with a hinged clasp can be done quite easily and effectively by the method that is about to be described. The only measurement of importance is the one taken from one hinge over the top of the clasp to the other hinge. The finished purse or eyeglass case must be twice this measurement in order to be fit properly. Be sure when cutting your fabric to include seam allowances.

The technique described here is not a professional method, nor was it meant to be. It is simple, and it does give successful results. Be sure always to baste in the vertical center line on the front and back of whatever you are making and on the lining.

Press the embroidered piece, embroidered side down, on a Turkish towel with a steam iron. This will give it an embossed look.

Materials
2 pieces of Greek handwoven fabric 7" x 8"
2 pieces of extra-heavy Pellon 7" x 8"
2 pieces of soft lining fabric 7" x 8"
1 spool carpet thread to match eyeglass case fabric
2 heavy sewing needles

Construction of Eyeglass Case

1. Measure the clasp. The eyeglass case clasp measures 6", therefore our fabric must measure 7" to allow for seam allowance.

2. Baste the Pellon onto the back of the embroidered fabric. Do the same for the back section.

3. With embroidery side up, baste (with stitches no larger than ½") along the outer edge of the embroidery. This will act as a stitching guide later on. If you have chosen to embroider the back of your case, repeat these instructions.

4. With right sides together, pin the front and back sections and baste again along the basting line that is closer to the embroidery. Machine stitch as indicated in the diagram. Construct the lining in this same way. Trim the seams to ½".

1

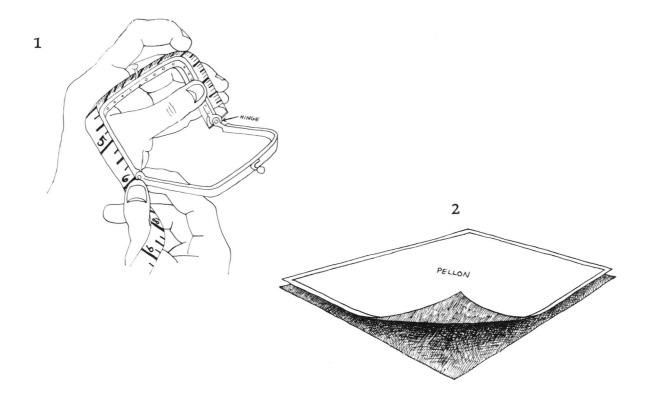

HINGE

2

PELLON

3

7"

PELLON

BASTING

BASTING
ON EDGE OF
EMBROIDERY

8"

½"

4

½"

PELLON

3"

1⅝"

½"

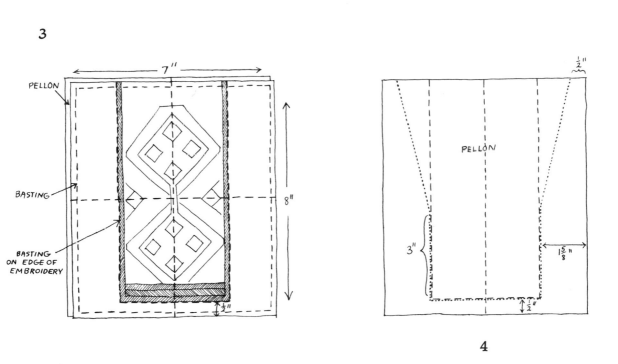

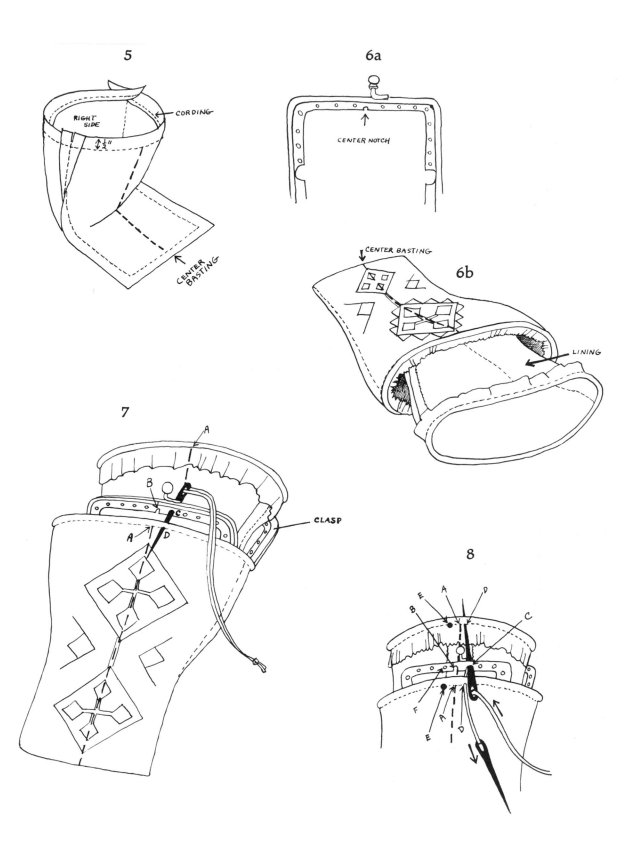

5

RIGHT SIDE

CORDING

½"

CENTER BASTING

6a

CENTER NOTCH

6b

CENTER BASTING

LINING

7

A

B

C

A

D

CLASP

8

B E A D

C

F

E A D

5. Stitch the cording on the right side of the lining and the embroidered fabric, cord side down and raw edges together, and overlap at the side seams to finish.

6. The clasp will have a center notch. This must always match up with the *center basting* on the eyeglass case and lining. Place the lining within the eyeglass case *wrong sides together*.

7. Thread two heavy needles with double strands of carpeting thread. Tie a heavy knot on the ends. Place the clasp between the lining and the eyeglass case, using one needle. Match up A (center basting lines) with B (notch) and push your needle from the inside of the clasp through the hole labeled C. Holding the eyeglass case next to the clasp, push the needle through the point labeled D.

8. Take the second needle and go through hole C from the front of the clasp through the lining at D. Pull both needles so that the eyeglass case and lining are right up against the clasp and the knots are hidden.

9. Now, bring the second needle from the lining through E and F on the clasp and then E on the eyeglass case. Bring the first needle through E in the eyeglass case, F in the clasp, and E in the lining.

10. Continue sewing this way until you reach the hinge; your side seam line should be at the base of it. Knot your threads securely on the lining side and then continue from the center and work to the right side in the same way. Assemble the back in the same way, again starting from the center.

Finishing Techniques

MAKING BIAS CORDING FOR TRIMMINGS

For best results when cording pillows, purses, etc., a true bias should be used. This ensures a smooth, straight edge on the project and a smooth curve, with plenty of stretch when going around curved areas and corners. Other bias cuts such as garment bias will not give the results obtained from a true bias.

It is difficult to state the exact width to cut bias strips in order to make cording because there are so many different widths of cord available. The width of the bias should include the circumference of the cording plus 1" for seams (½" on each side of the cording).

1. The selvage edge is the woven edge of the fabric.

2. Take the selvage edge and make a forty-five-degree angle. The slanted line, indicated at the arrow, is your true bias edge and has the greatest capacity for stretch, which is important for going around corners and curves. Crease that slanted edge and cut along the crease.

3. Proceed to cut as many bias strips as you will need for your cording.

4. To piece bias strips together, lay the strips so that the long cut edges are at right angles to each other and the point of one piece extends beyond the other the depth of the seam allowance. Stitch and press seams open.

5. Place the cording in the center; fold the bias over so that the raw edges meet.

6. Using a cording foot, stitch close to the cord, through the two thicknesses of bias.

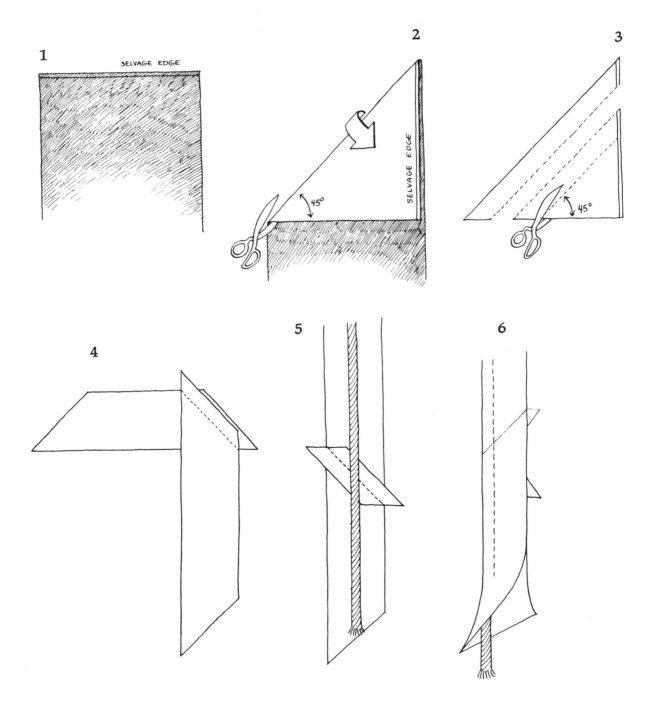

1

SELVAGE EDGE

2

SELVAGE EDGE

45°

3

45°

4

5

6

BRAID FINISH FOR A PILLOW

Braid finish was used to finish the bird pillow in Plate 7. The pillow must first be completely constructed. It is a neat-looking finish and is also easy enough to do so that the child can take part in making it. For our pillow we used only one color, but interest may be added by using many colored yarns together if the child so chooses.

1. Set up three groups of wool, each with 6 strands; in our case, it was crewel wool.

2. Leave a 6″ end and loosely knot all three groups together.

3. Have the child hold the knotted end while you braid the wool to the desired length. Make a loose knot in it. Repeat this for the three other sides of the pillow.

4. Slip-stitch the braid to the pillow, placing the knots at the corners. When all four braids have been slip-stitched in place, go back to each corner and unknot.

5. Then knot both ends together to make a tassel.

1

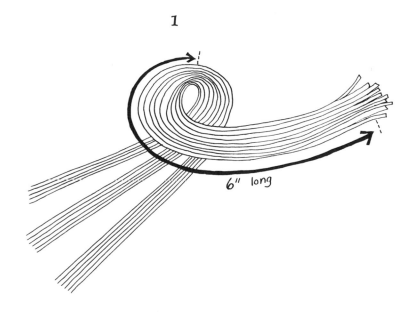

6″ long

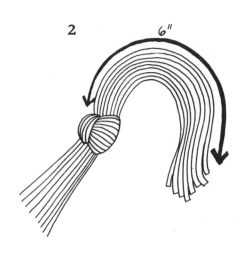

2

6"

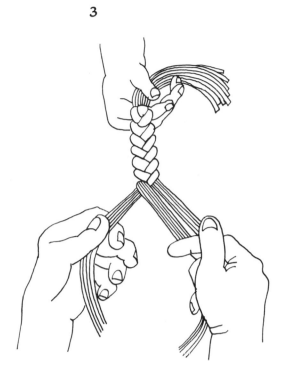

3

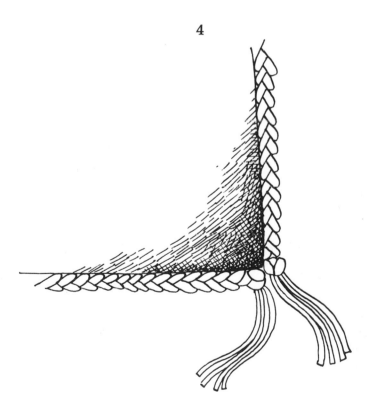

4

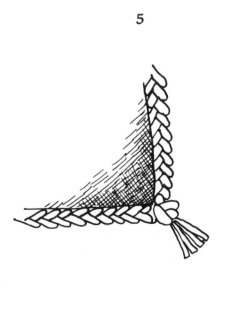

5

STRAIGHT FRINGE

This type of fringe is excellent as a finish in a pillow. Select a blend of colors from the embroidered design, as we did for the pillow in Plate 26, and the result is a custom-made appearance with very little effort.

Determine the width you desire for your finished fringe and add ½" to that. Cut out a piece of Bristol board or oak tag in that width and 2" longer than you need for your completed project.

1. Tape your wool in place on the oak tag and wrap it around, being sure to keep sliding it down toward the taped end—this determines how full or sparse your fringe will be. Continue with this procedure until you have the necessary amount. Tape the ends. Machine stitch ½" from the edge and cut the wool at the opposite edge.

2. Separate both sides of the wool and fold the oak tag back on itself along the stitching line. A good crease will make it easy to tear out.

3. Once you have torn out the oak tag, you are finished. The oak tag remains in the seam allowance; so if you care to, a triple-step zigzag stitch may be done for reinforcement, especially if you will be applying the fringe around corners, where snipping will be necessary.

4. The finished pillow has a straight fringe.

1

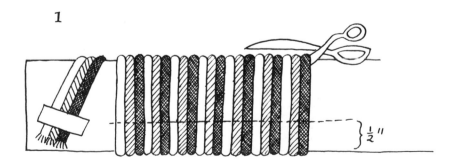

2

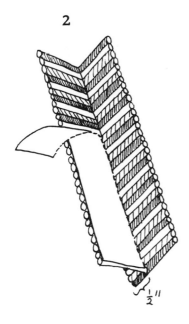

$\frac{1}{2}''$

3

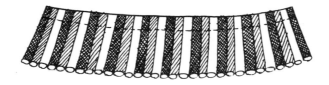

4

TWISTED FRINGE

A fringe of this type may be used on the ends of table runners, scarves, skirts, stoles, or any number of other things.

For our purposes, the insertion in step 2 is mouline; however, any other material may be used. This fringe was used to finish the table runner in Plate 37.

1. Ravel the crosswise threads to the desired length plus 1″ to allow for knotting. Cut embroidery floss twice the length of the loose threads.

2. Separate the third and fourth lengthwise threads and insert, with the use of a crochet hook, a length of embroidery floss, 3 crosswise threads up into the fabric.

3. Make a loop of the floss and pull both ends through.

4. Pull the floss tight and place the ends beside the raveled strands.

5. Twist tightly the left strand of floss and the 3 strands of raveled fabric beside it to the right. Hold it tight while you twist the right strand of floss and the 3 strands of raveled fabric beside it tightly to the right.

6. Place both twisted strands together and twist very tightly to the left.

7. Knot about ½″ up the bottom. Continue all along the remainder of the edge.

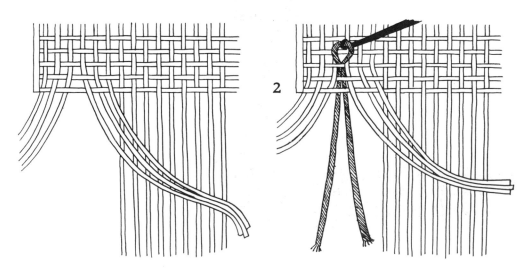

1 2

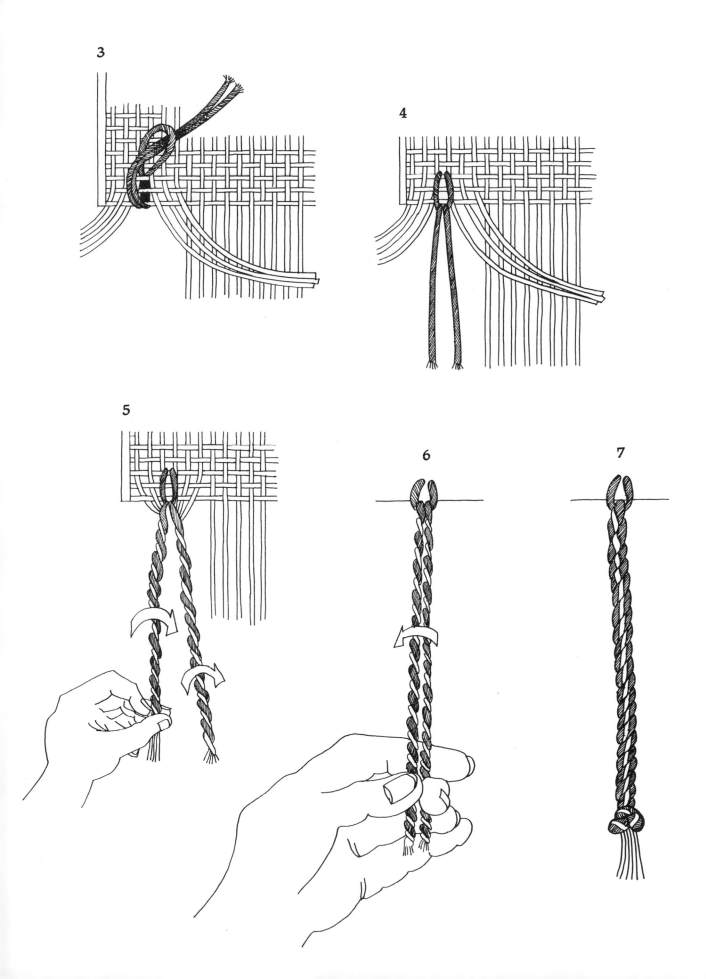

Working with Designs

ENLARGING A DESIGN BY USE OF A SQUARE

To enlarge a design by this method, first establish the longest line in your design; it may be either vertical or horizontal. Once this line is established, draw it through the center of the design both vertically and horizontally. Then, when you complete the exterior lines, you have a square divided in quarters.

Next, determine to what size you wish to enlarge your design. As in the example in Figure 10, it need not be doubled or tripled; it can be enlarged to any size. Once the size is determined, draw the center vertical and horizontal lines, complete the exterior lines, and you have a square again.

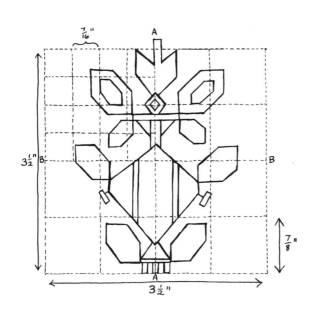
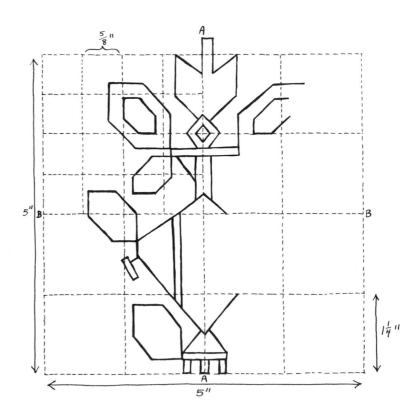

FIGURE 10. Enlarging a design by the use of a square.

At this point it is possible to transfer everything you see in each quarter of the small design to the corresponding quarter of the large square. If this seems too difficult, however, each quarter can be broken down further, as in the example shown (*upper left-hand corner*), simplifying the enlargement of the design (Figure 10).

DESIGN GRAPHS AND LINE DRAWINGS

Several methods were used to graph the designs from the museums shown in this book. All of them are quite commonly used so it will suffice to list them with an occasional note about each. We'll start with the most obvious.

1. Go to the museum, select a design, and graph it. Since cross-stitch and satin stitch are so common in Greek embroidery, this is probably the easiest way, but probably the most time-consuming.

2. A 35-mm color transparency can be projected on a sheet of paper taped to a wall and the design traced. Naturally, this requires further work in correcting lines, shapes, etc.

3. Black-and-white photographs can be enlarged to any size.

4. If there is a detail you wish to graph, in a border, for example, a photo expert can enlarge that area for you.

5. A clear black-and-white photograph can be placed under a high-powered magnifying glass and stitches can be counted.

6. If stitches and design are such that counting is not possible, you can use a freehand drawing and make eye judgments of angles and meeting points.

I am sure others might be able to enumerate many more methods. These, however, were the methods used to graph the designs for this book.

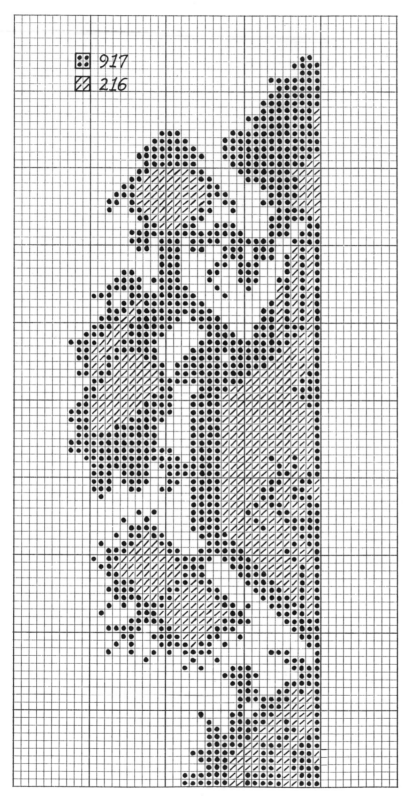

Rhodes. The design itself is worked in cross-stitch with crewel wool.

The Designs

You will notice that some of these designs are given in both graph and line form. This was done to accommodate those people who prefer surface work to counted-thread or canvas work.

In most cases a black-and-white photograph accompanies the graph. This is to facilitate working on the design, should you find the graph difficult to follow.

All designs have been worked in Paternayan wools, crewel, Persian, and rug; Pearsall silk; and D.M.C. mouline.

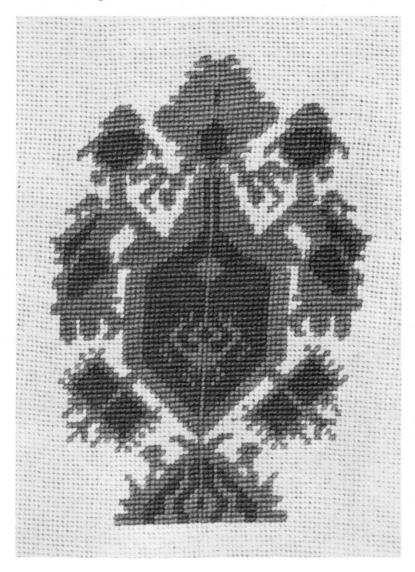

Rhodes. This simple leaf is arranged diagonally in alternating colors to form an interesting design. The leaves are worked in cross-stitch, the background in tent. Worked in Persian wool.

⊞ 242, 540
☐ 593

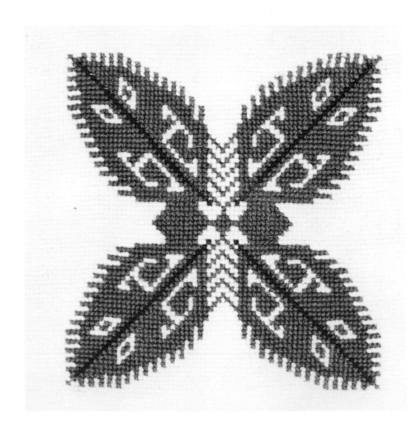

⊞ 439
◩ 010
⊟ 429

Amorgos. The motif is worked in cross-stitch and the background in tent. Worked in crewel wool.

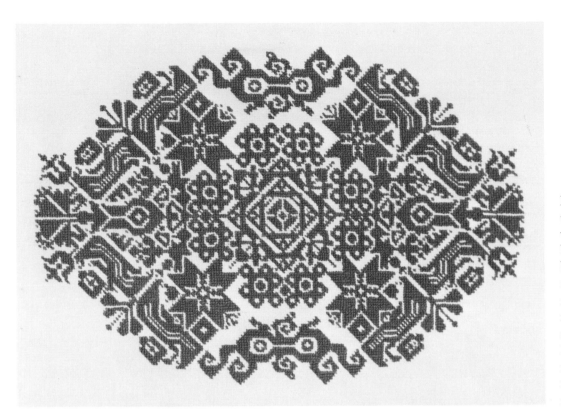

Kos. The arrows show the center. The design was carried on slightly beyond the center point because of a lack of symmetry for those few stitches. The remainder of the design is symmetrical, however. It is worked completely in cross-stitch and in monochrome. Worked in crewel wool.

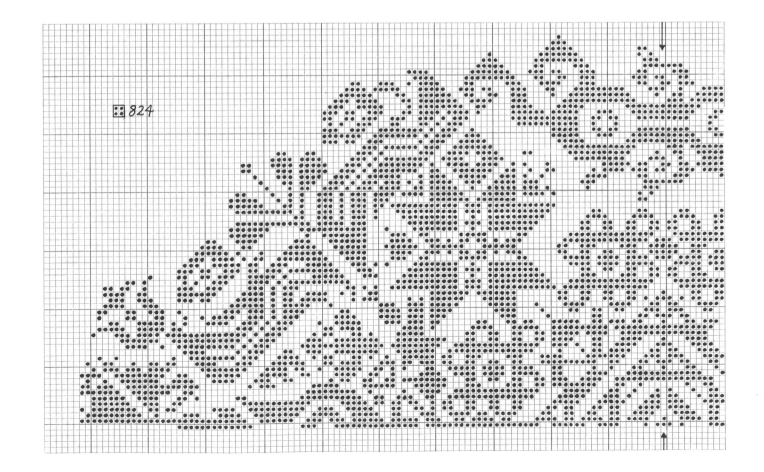

824

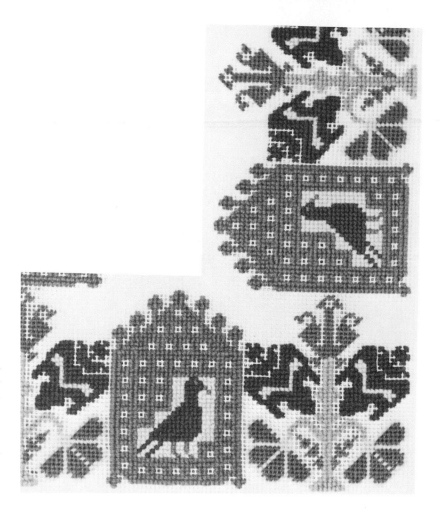

Karpathos. This design lends itself best to cross-stitch in order to get the feeling of the complete design. The background can be filled in with tent. Worked in crewel wool.

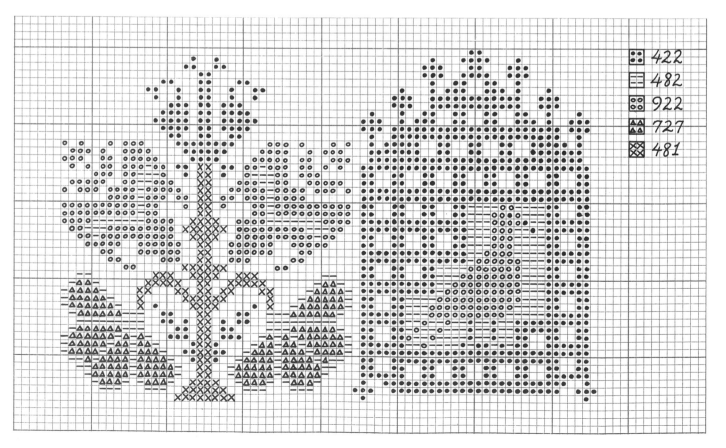

⣿	422
☰	482
◉◉	922
▲▲	727
⊠	481

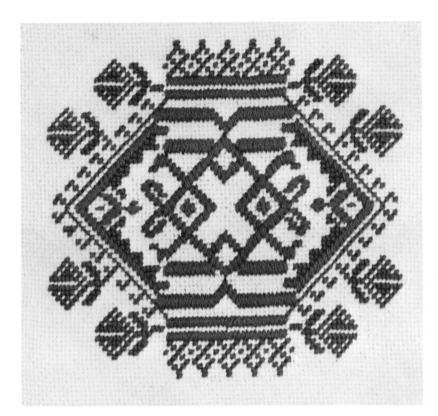

Pholegandros. Worked in monochrome. Since it is worked in cross-stitch and straight stitches, the crosses are placed right on the lines (signifying the mesh) and the straight stitches are between the lines (signifying canvas). In this graph each line on the paper represents one canvas thread. Worked in crewel wool.

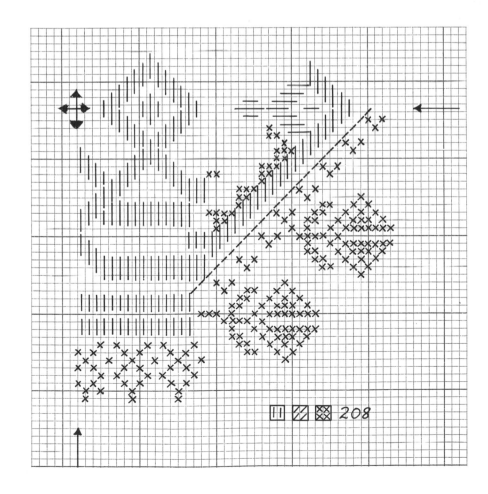

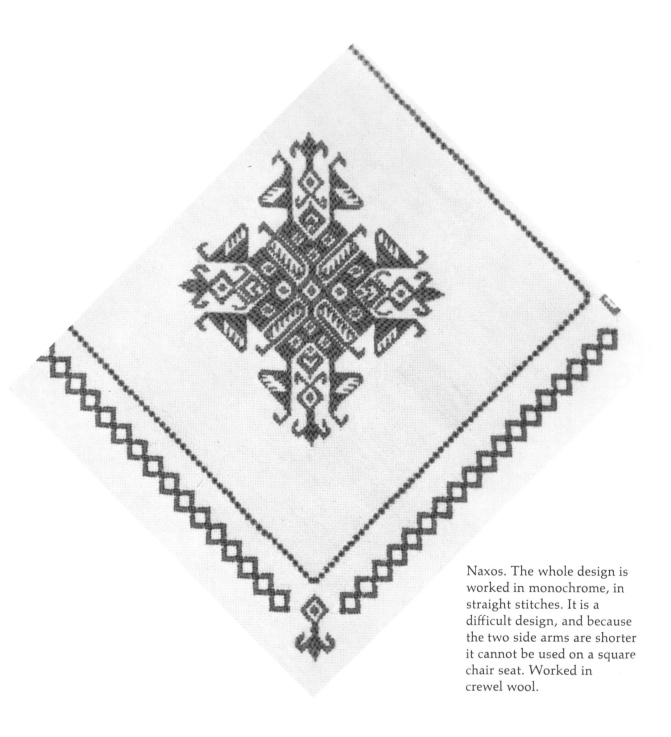

Naxos. The whole design is worked in monochrome, in straight stitches. It is a difficult design, and because the two side arms are shorter it cannot be used on a square chair seat. Worked in crewel wool.

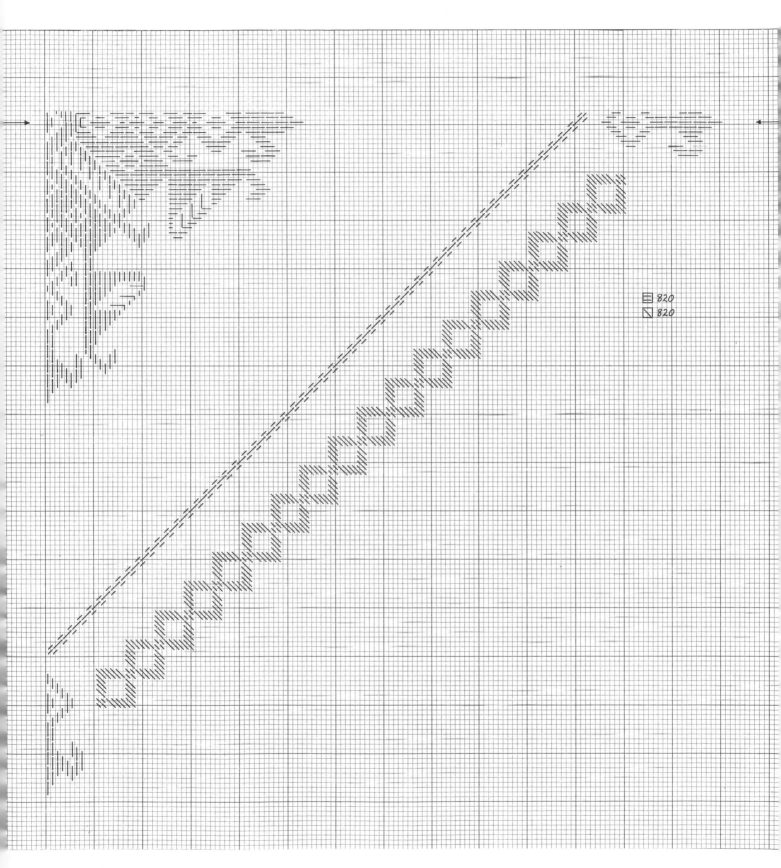

820
820

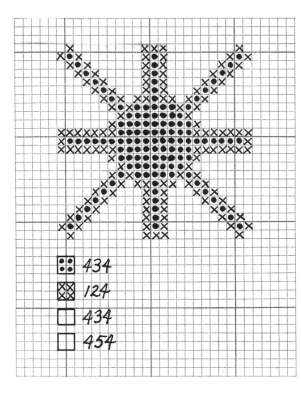

434
124
434
454

Macedonia. The star motif and outline are worked in cross-stitch and the background in tent. The darker center border line is done in cross-stitch. Worked in rug wool with Persian for dark outlines.

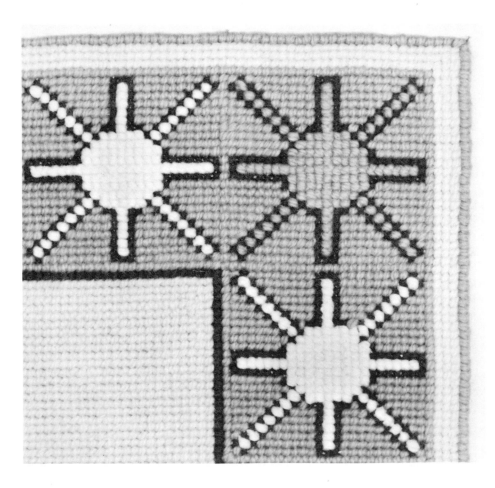

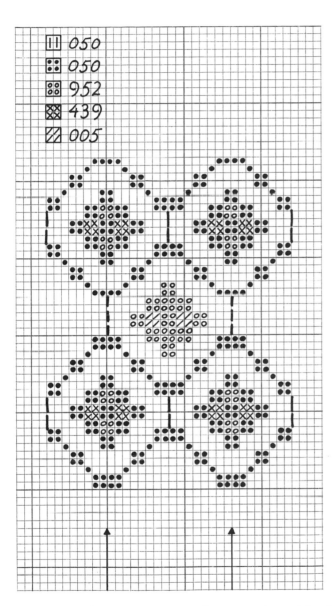

050
050
952
439
005

Thrace. The arrows designate the width of
the border on the dress at the museum.
The design, worked in cross-stitch, has
been expanded into a pattern to cover a
whole surface. The background is done in
tent. Worked in crewel wool.

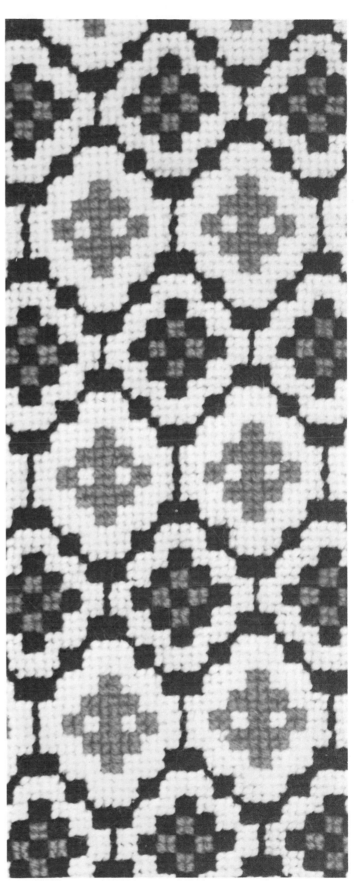

D.M.C. color numbers
In Gobelin stitch: 221 In backstitch: 839
841
924
3685
926
223

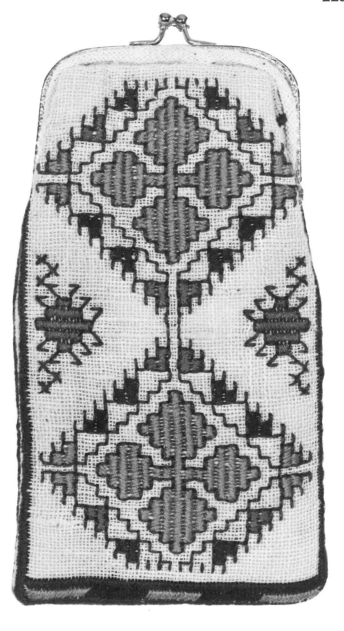 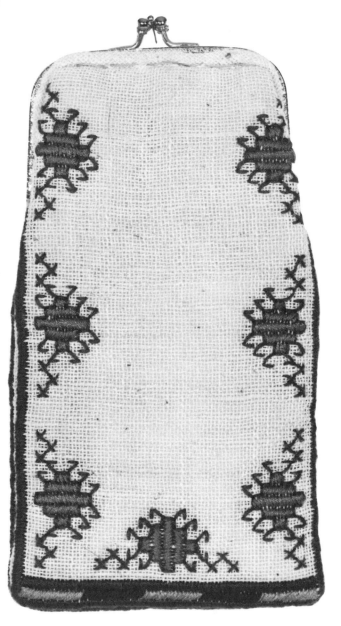

Macedonia. Worked in backstitches for the outline using 839 D.M.C.
Do the outline first and fill in the color. The direction and depth of
the stitches are given in the graph. Outlining is done with two strands
and fillings with three.

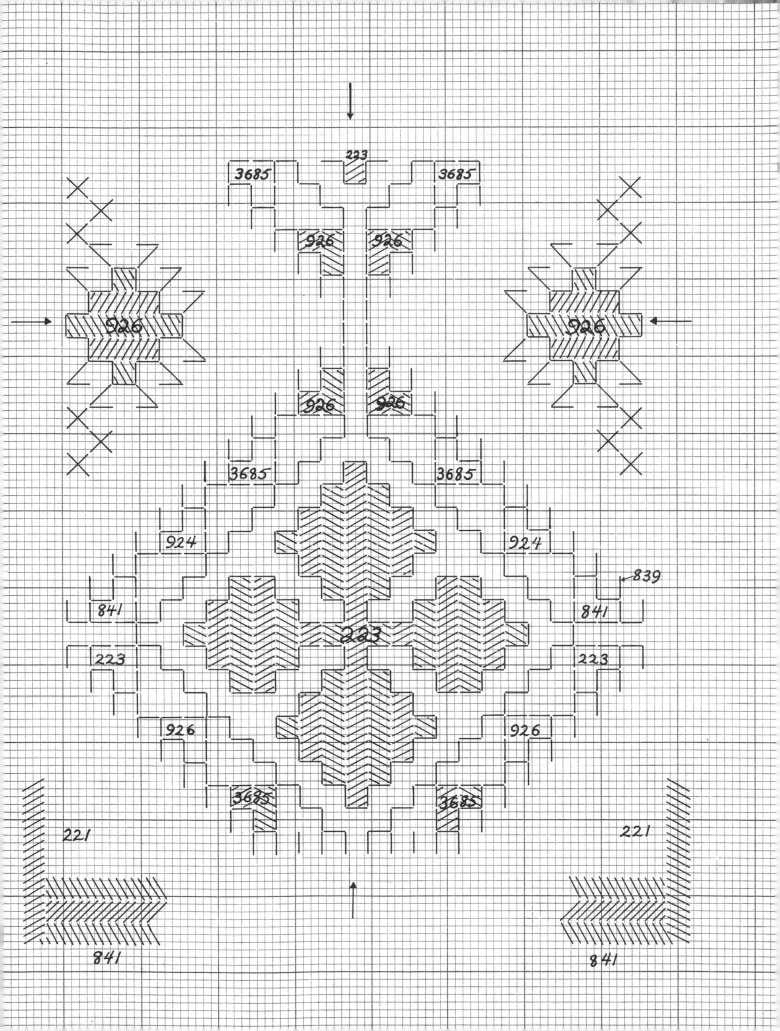

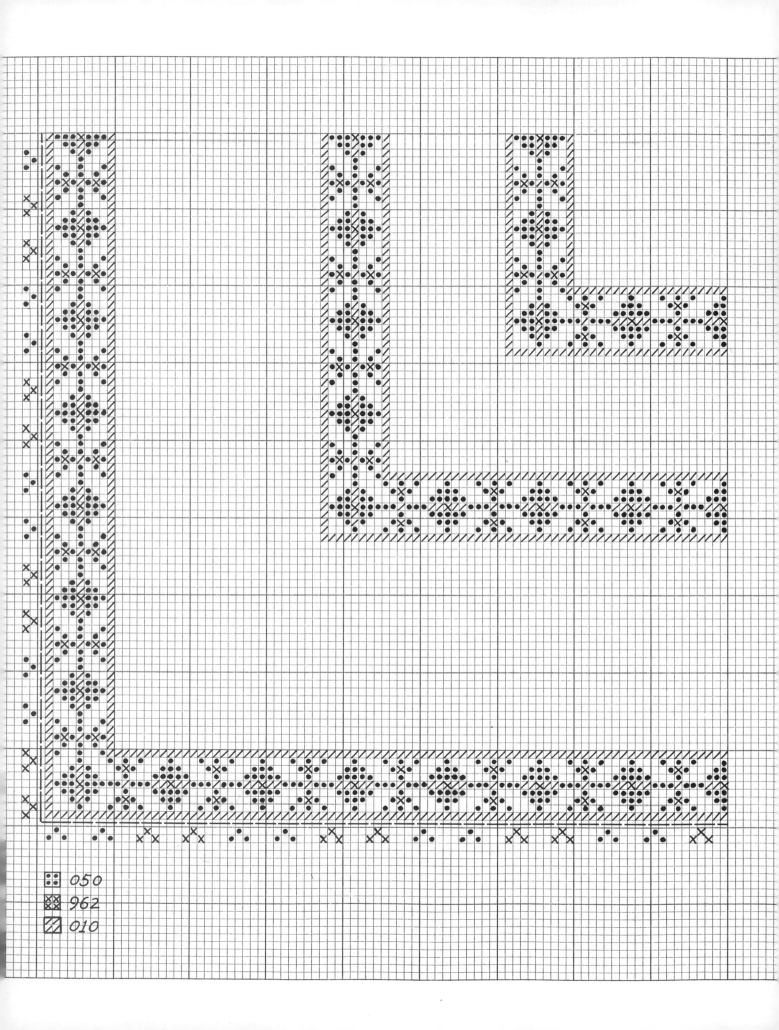

050

962

010

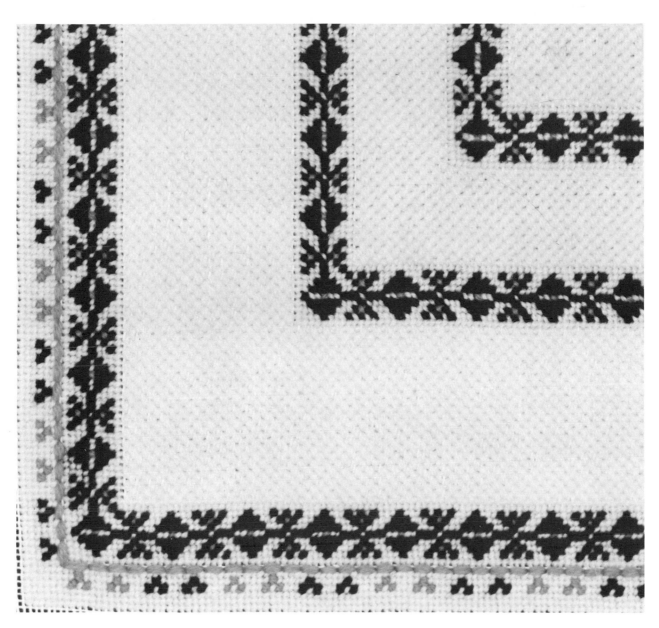

Thrace. Worked in cross-stitch. The background within the confines
of the borders and the one row that outlines the borders are done in
010, tent stitch. The open areas between the rows of borders are
worked in brick stitch. *Caution—keep diamonds and Xs in all rows
parallel to each other and going in the same direction.*
Worked in crewel wool.

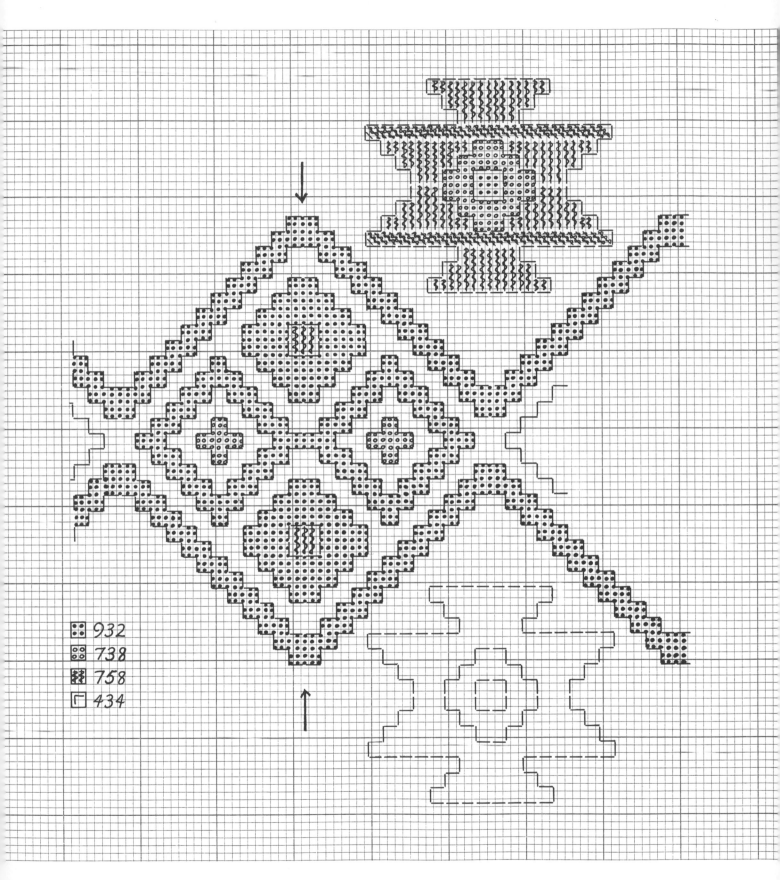

932

738

758

434

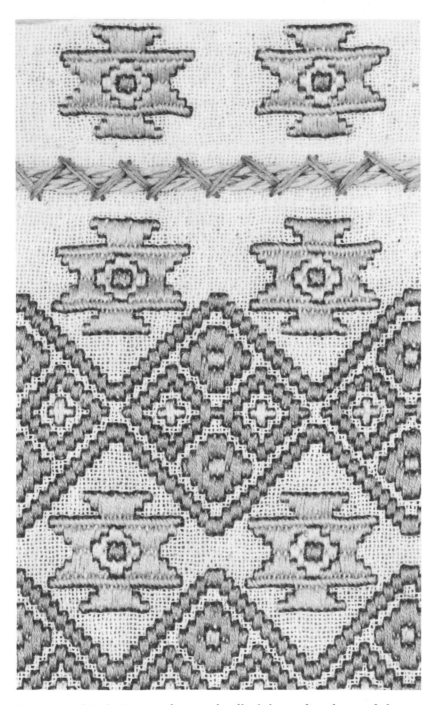

Attica. In this design it is best to do all of the outline first and then fill in with color; this way, the outline becomes just a soft suggestion. Worked in straight and slanting Gobelin with D.M.C. mouline.

Boeotia. Work the whole design in cross-stitch to get the completed
motif, which gives the best effect. Only the center eight-pointed star
is not a solid color; all others are. Worked in crewel wool.

●●	216
◔◔	439
▲▲	460
✕✕	921
☰	459
⫽⫽	475

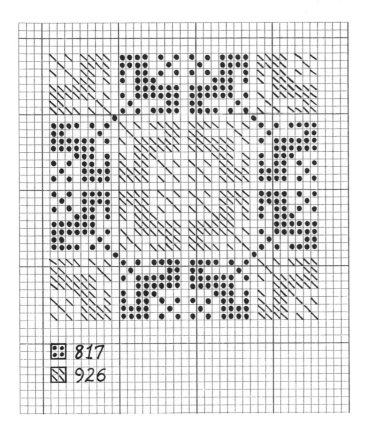

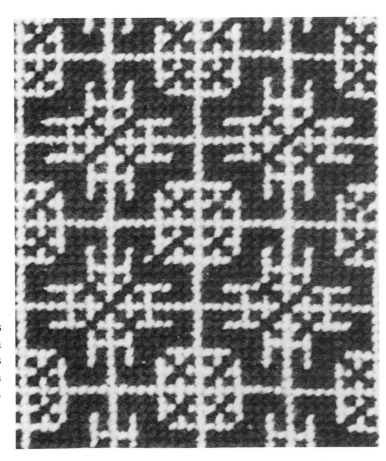

Corinth. The design is worked in cross-stitch with background areas worked in tent in crewel wool.

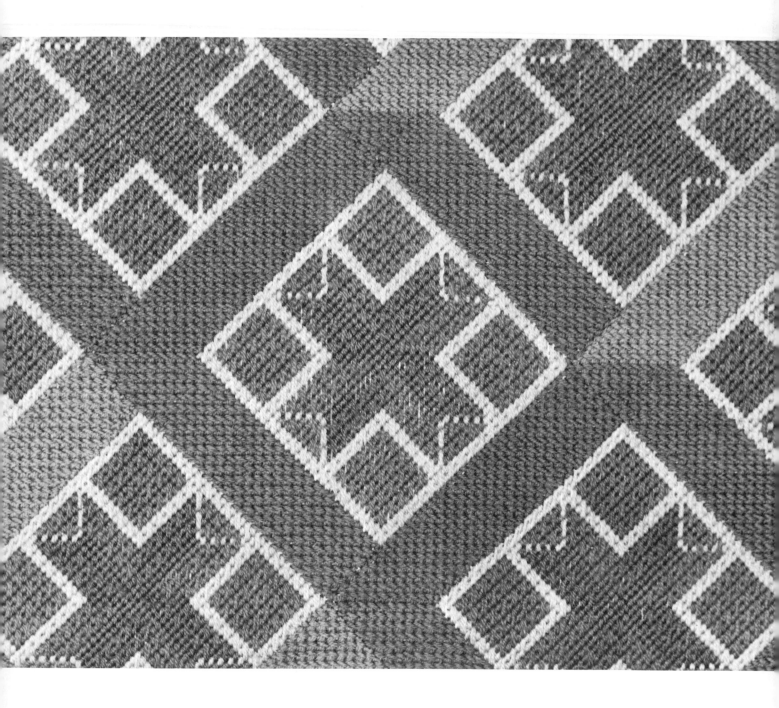

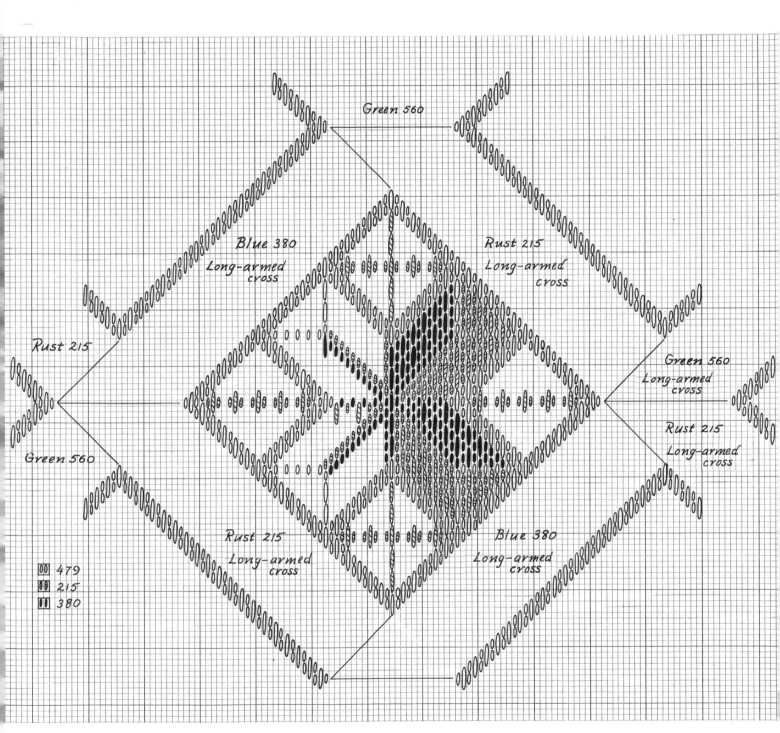

Boeotia. The graph has been worked up showing the Hungarian
stitches in color coding. The colors used for long-armed crosses are
numbered for each area. Worked in Persian wool.

101

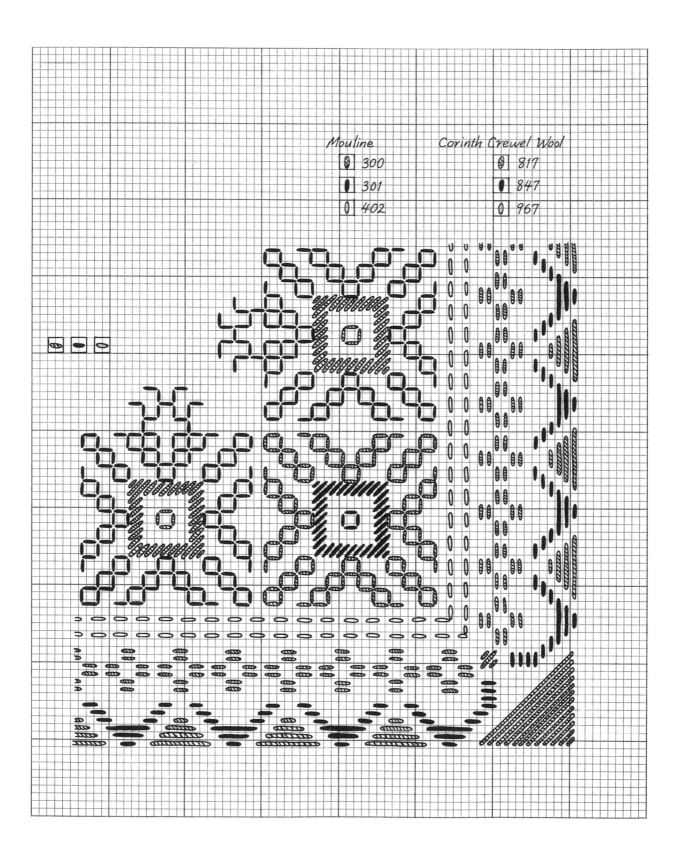

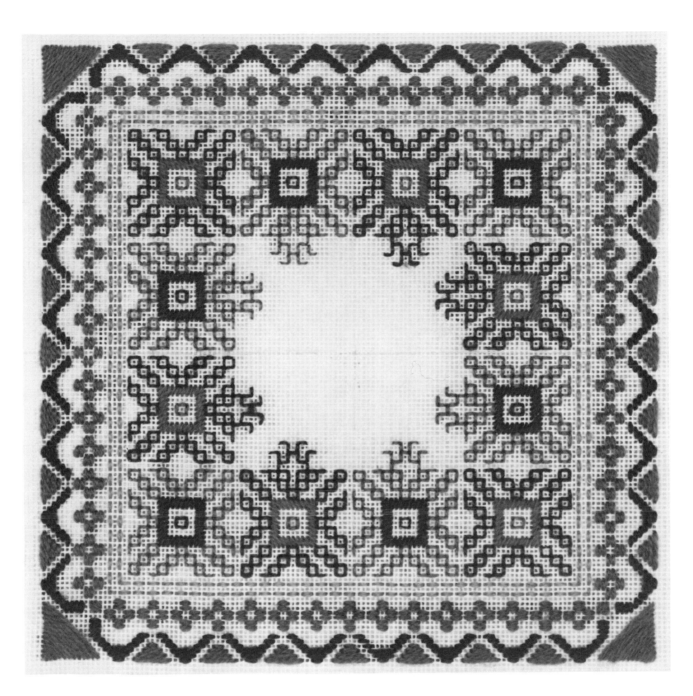

Corinth. Worked as counted-thread in mouline on fabric or in the
canvas basted on fabric technique with crewel wool. It is difficult to
work this design on canvas alone because of the problem of filling in
background colors in the small squares. Worked in crewel wool.

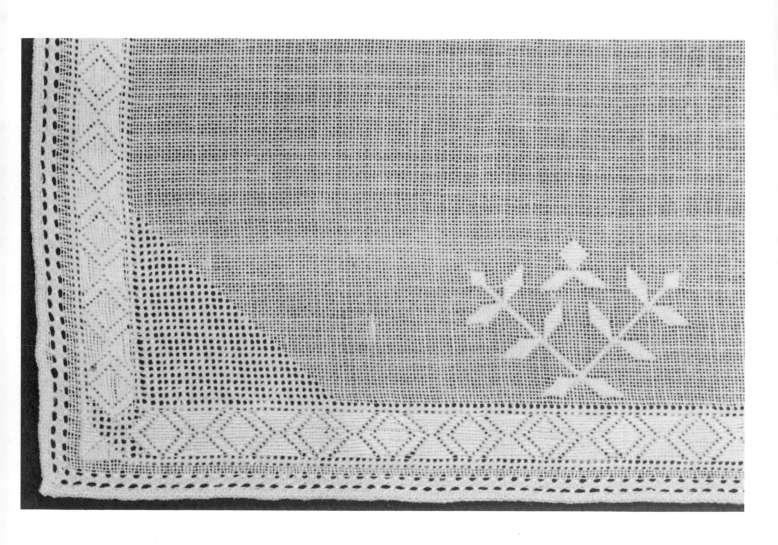

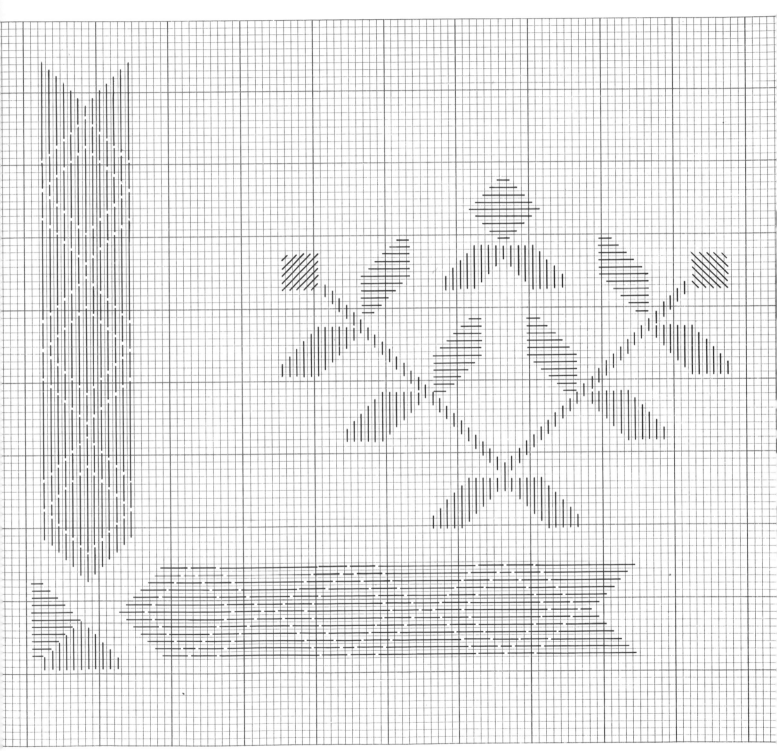

Lesbos. The motif is graphed; however, we have not allowed graphing space for the hemstitching areas.

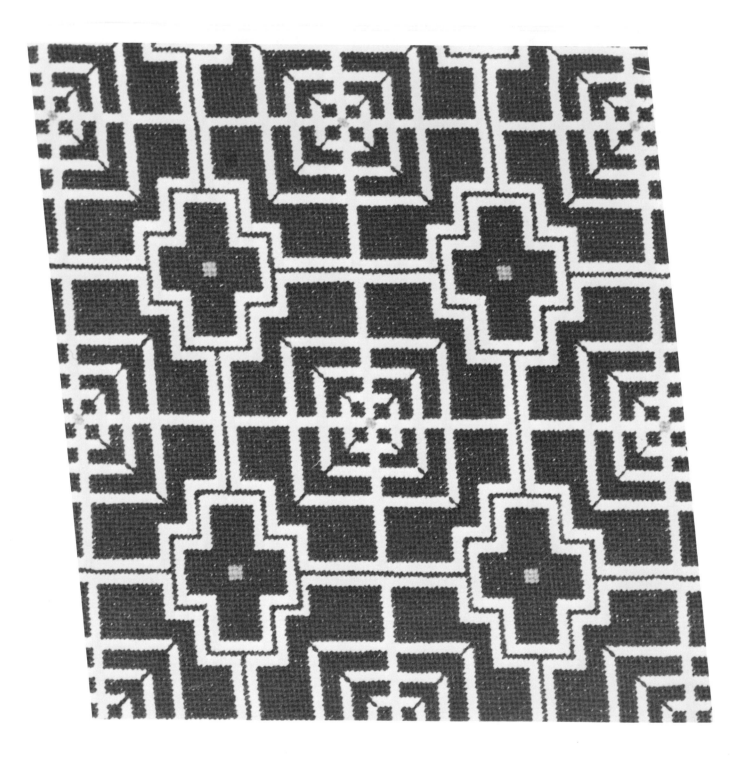

106

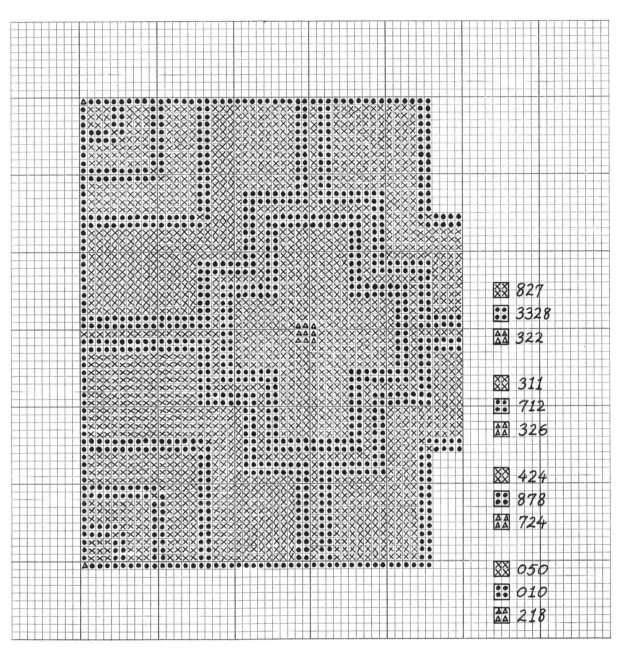

⊠	827
⊡	3328
△△	322
⊠	311
⊡	712
△△	326
⊠	424
⊡	878
△△	724
⊠	050
⊡	010
△△	218

Sarakatsan. By the use of different gauge canvas or by using counted-thread fabric the appearance of the design can be changed. It can also be changed by using unusual color schemes; or, in the design itself, by working it with the long cross placed vertically or horizontally; or by working the corner stitches of the center squares in either the background color or the accent color.

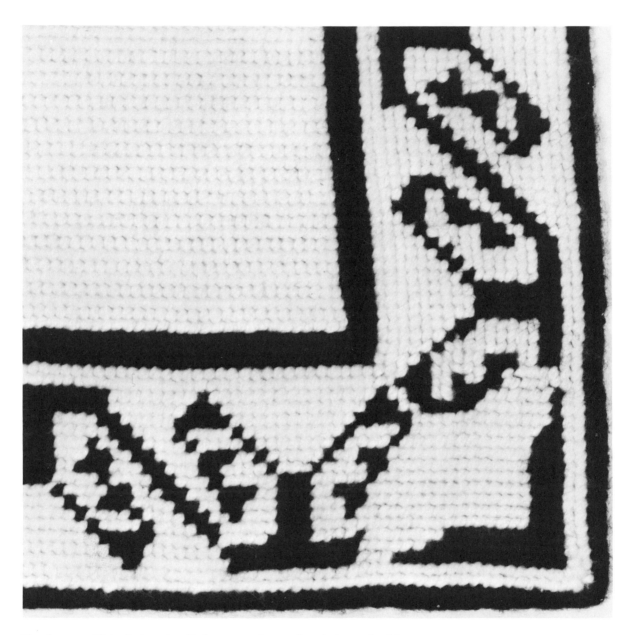

Sarakatsan. This design detail shows up best when it is worked in cross-stitch. The background is tent. Worked in carpet wool.

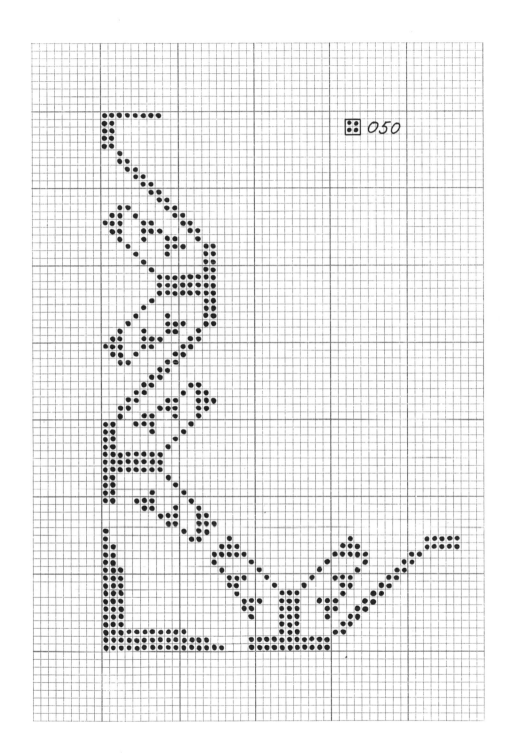

050

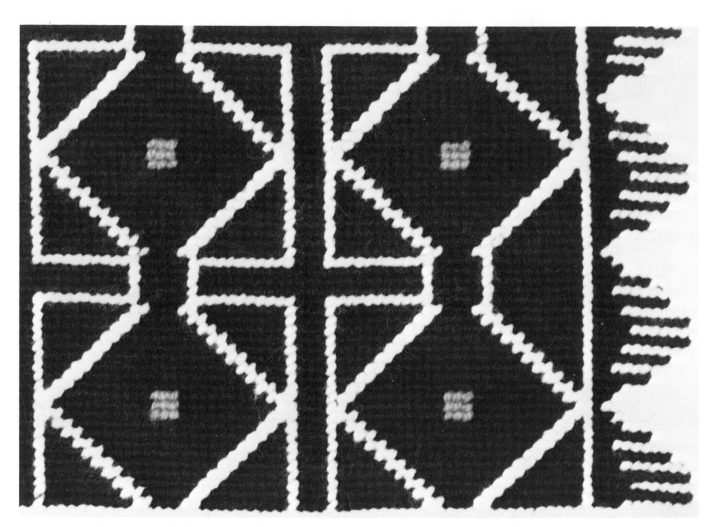

Sarakatsan. Worked in tent stitch in carpet wool.

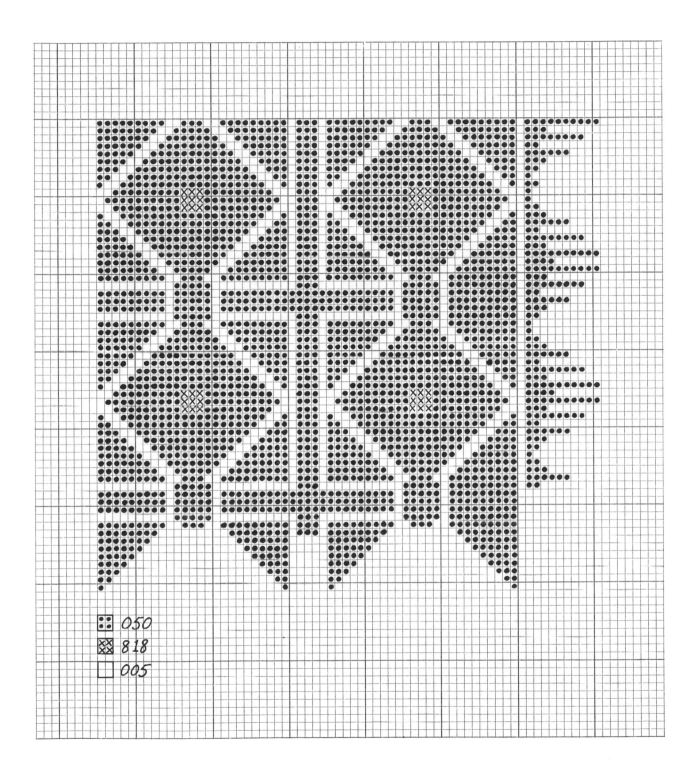

050
818
005

These border graphs are placed in order following the black-and-white photograph. They are all worked in D.M.C. mouline.

322

815

A. *Bottom left.* Thasos. Design detail worked in cross-stitch and background in tent.

597

435

435

599

C. Skyros. One of the Skyrian designs used to embroider the joining seam of the sheet. Worked in cross-stitch.

304

B. *Upper left.* Chios. Worked in combination of cross-stitch and straight stitch. Again, the lines on the graph paper represent the threads of canvas. The background is done in tent.

422

304

762

322

D. *Upper right.* Thrace. May be
effectively worked in tent as well
as cross-stitch.

834

470

E. *Lower right.* Chios. Detail is best when worked in
cross-stitch.

F. Thrace. The diamonds appear best
 when worked in cross-stitch;
 however, the background as well as
 the center lines bisecting the
 diamonds may be worked effectively
 in tent.

⊞ 304

⊠

⊞ 422

☐ 422

⊞ 937

⊞ 304

⊠ 807

H. Ionian Islands. These little motifs are best
 worked in cross-stitch.

G. Sarakatsan. This border is best worked in
 cross-stitch. *Please note*: the corners are not
 alike but the border can be used effectively
 as a frame.

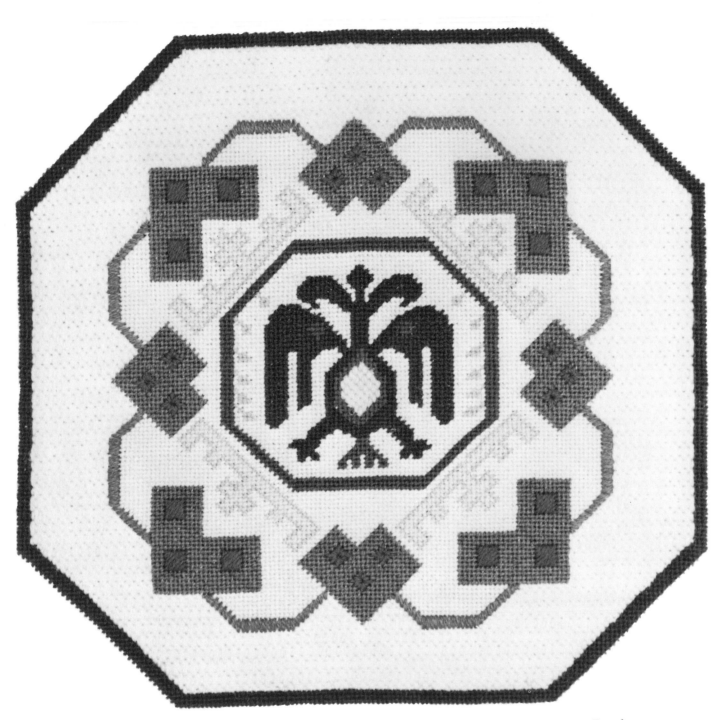

Lefkas. This design *is not symmetrical*. This is why it is drawn out in its entirety. For those who would like to work it out as a piece of surface embroidery, we have included the line drawing for the next design which may be worked in surface stitches in the same colors.

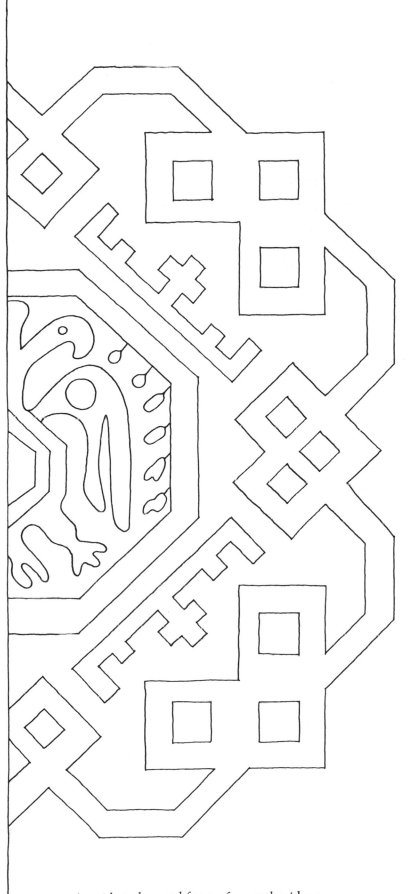

A guide to be used for surface embroidery.

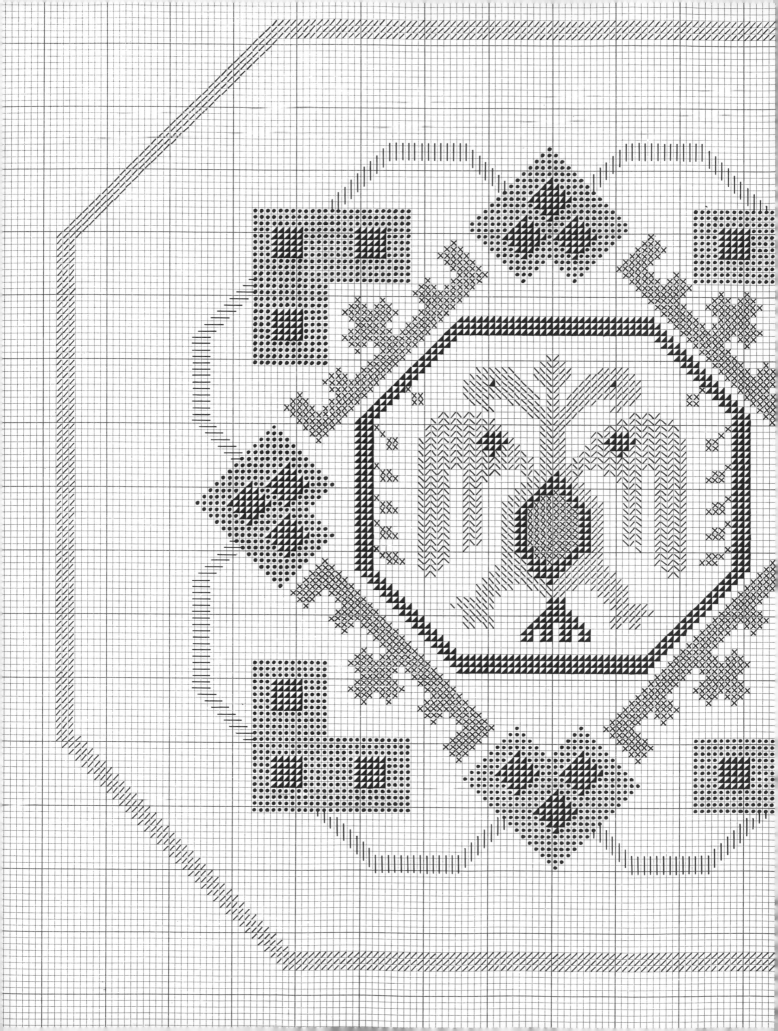

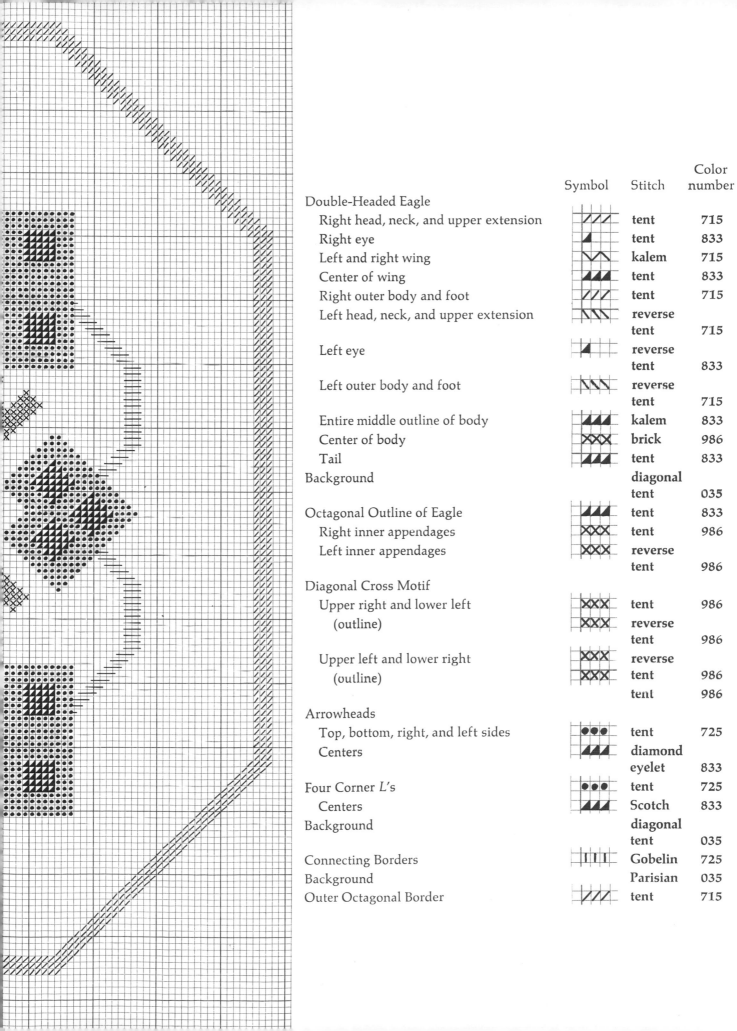

	Symbol	Stitch	Color number

Double-Headed Eagle
- Right head, neck, and upper extension — tent 715
- Right eye — tent 833
- Left and right wing — kalem 715
- Center of wing — tent 833
- Right outer body and foot — tent 715
- Left head, neck, and upper extension — reverse tent 715
- Left eye — reverse tent 833
- Left outer body and foot — reverse tent 715
- Entire middle outline of body — kalem 833
- Center of body — brick 986
- Tail — tent 833

Background — diagonal tent 035

Octagonal Outline of Eagle — tent 833
- Right inner appendages — tent 986
- Left inner appendages — reverse tent 986

Diagonal Cross Motif
- Upper right and lower left (outline) — tent 986 / reverse tent 986
- Upper left and lower right (outline) — reverse tent 986 / tent 986
- tent 986

Arrowheads
- Top, bottom, right, and left sides — tent 725
- Centers — diamond eyelet 833

Four Corner L's — tent 725
- Centers — Scotch 833

Background — diagonal tent 035

Connecting Borders — Gobelin 725

Background — Parisian 035

Outer Octagonal Border — tent 715

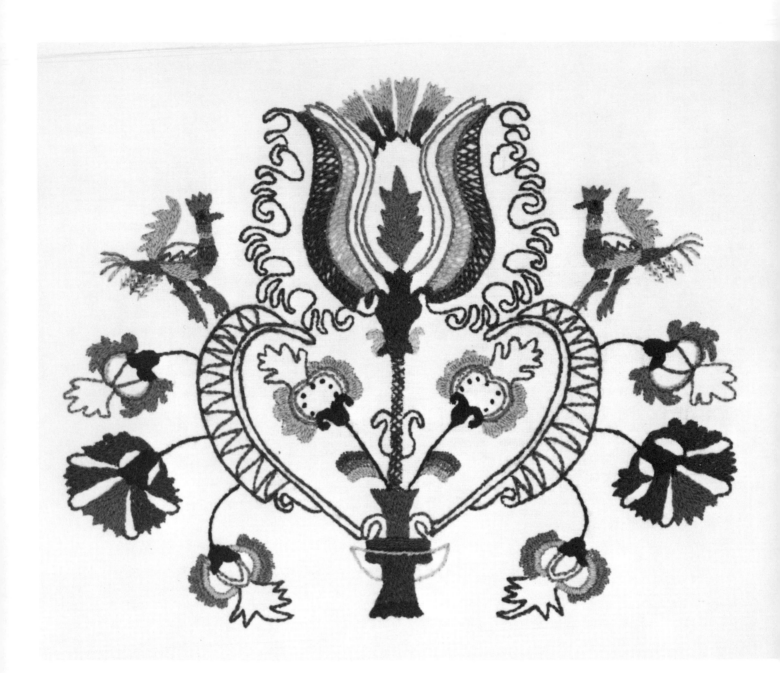

120

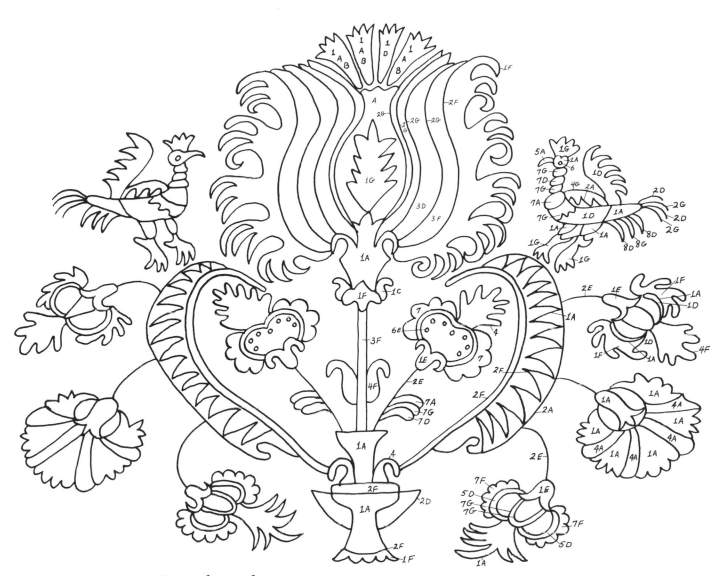

Crewel wool

	Colors		Stitches
A	823	1.	split
B	833	2.	outline
C	873	3.	herringbone
D	417	4.	back
E	715	5.	satin
F	720	6.	French knots
G	725	7.	New England laid
		8.	open fly

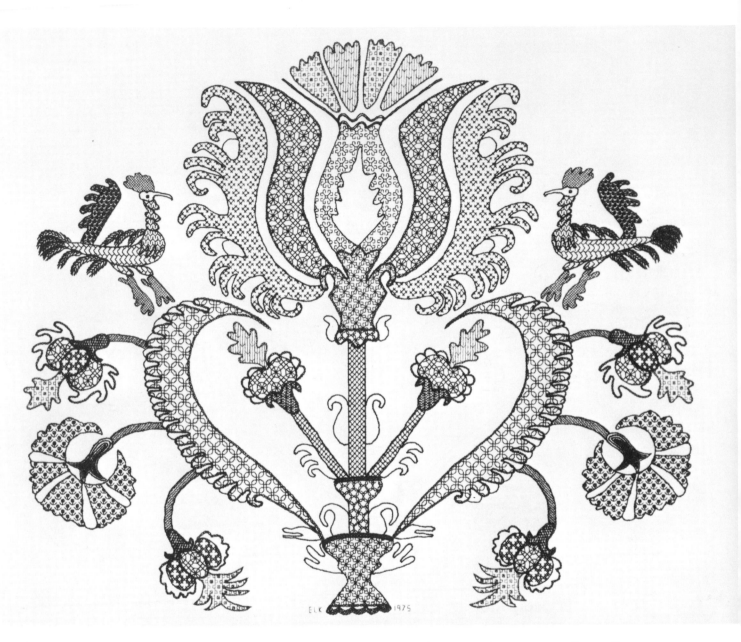

Skyros. Blackwork adaptation of a floral arrangement. The original measures 21″ x 24″. After enlarging it on tissue paper, pin the design in place on the fabric, placing the center of the motif on the grain line. Baste with small stitches. Then, using a contrasting thread, baste the design in small stitches onto the fabric, in this case Hardanger cloth. Tear away the paper and begin to fill in designs. Work all filling stitches first and then outline, with either outline or chain stitch as designated.

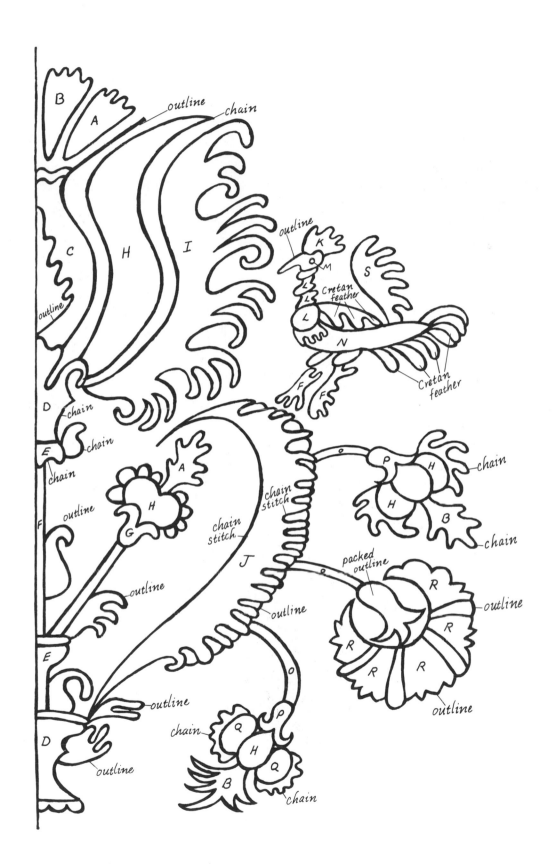

See blackwork stitches on pages 158–161.

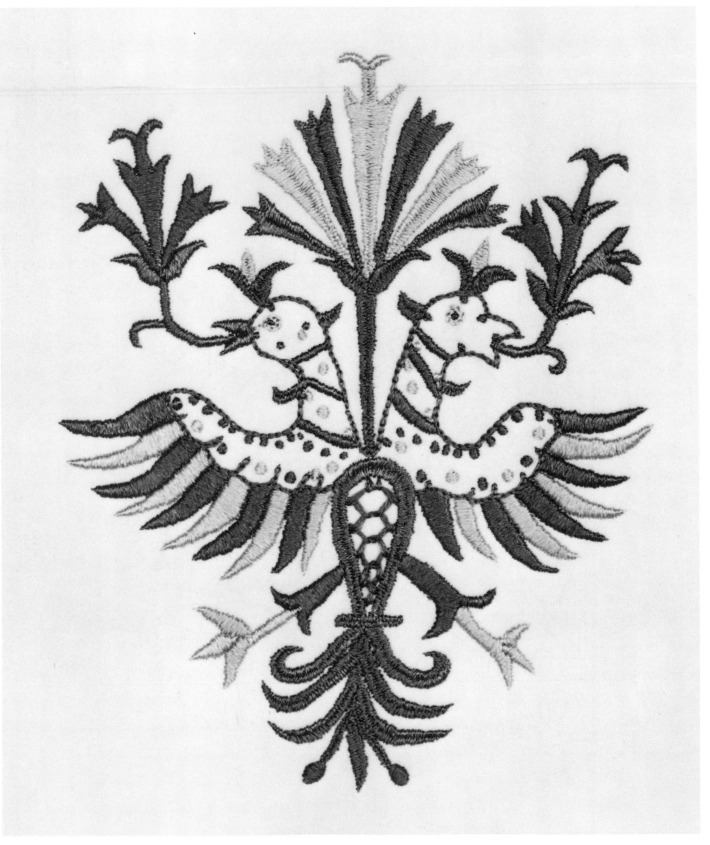

124 Crete. Worked in Pearsall silk on velvet (the type used for oil painting). The velvet was backed with muslin and stretched on a frame. The design was drawn on tissue, pinned in place, and then carefully basted, stitching through the velvet and the muslin. The tissue was ripped off, leaving the outline to work on.

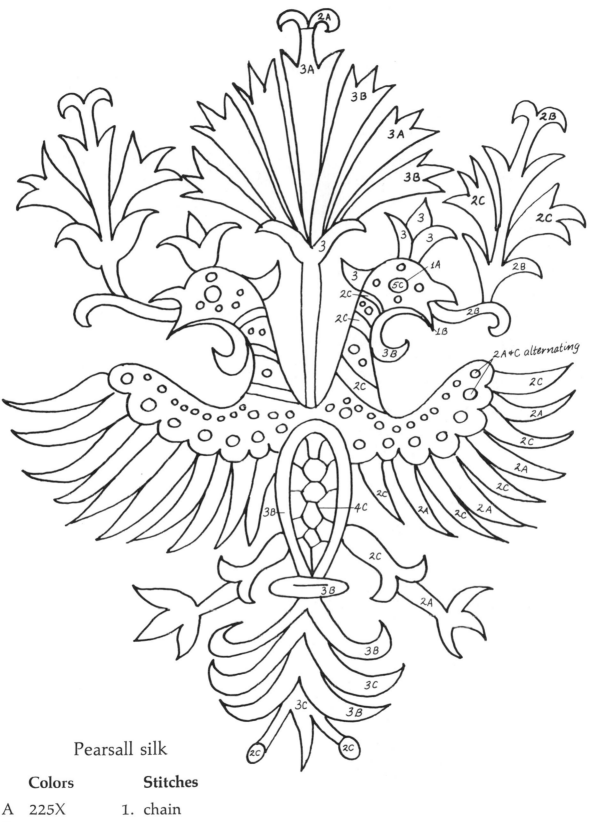

Pearsall silk

	Colors		Stitches
A	225X	1.	chain
B	83	2.	satin
C	189	3.	flat
		4.	Cretan feather
		5.	French knot

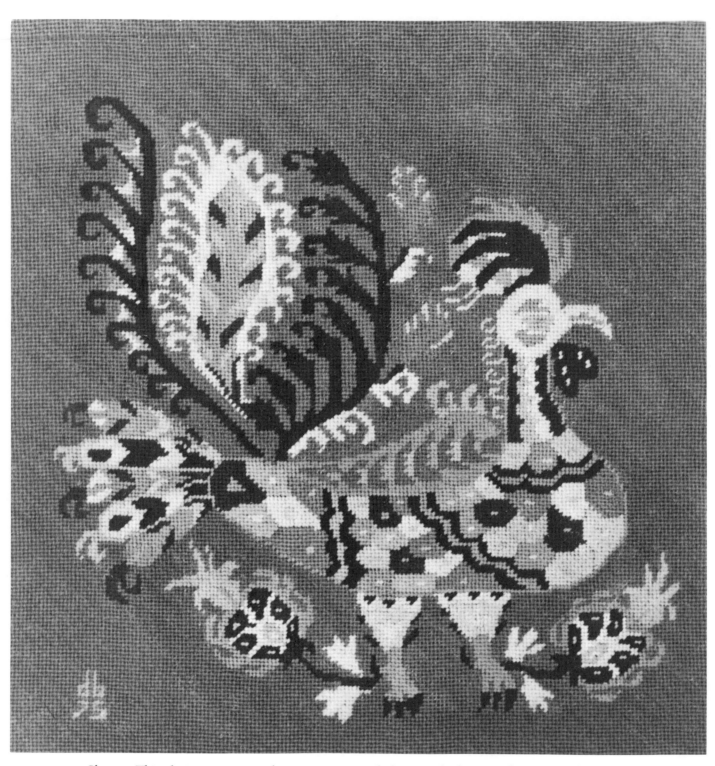

Skyros. This design was traced onto canvas and then worked in mouline. Crewel wool was used for the background.

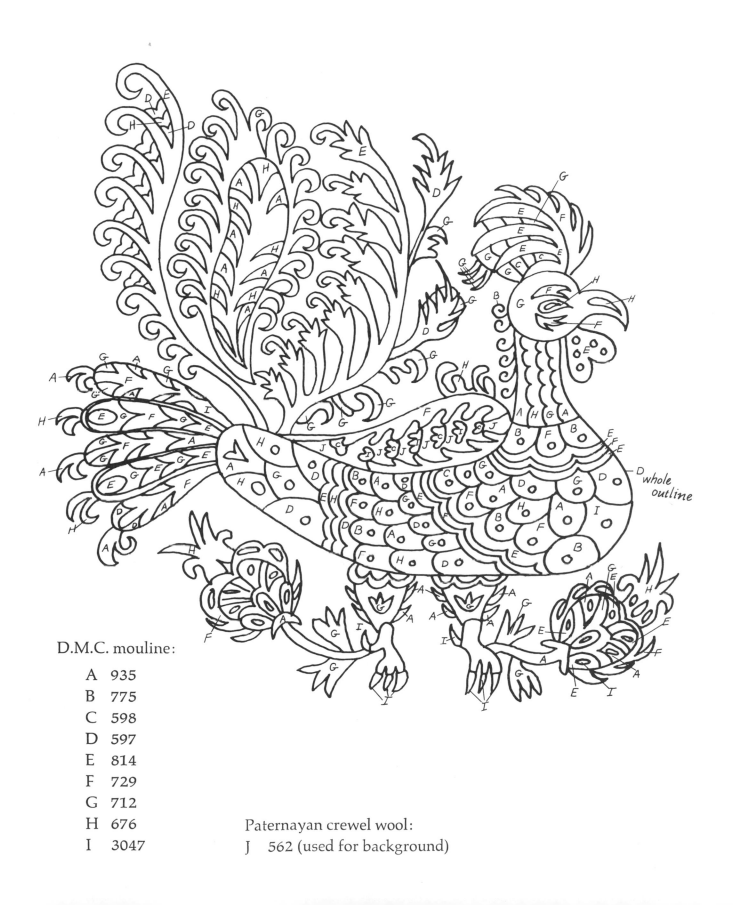

D.M.C. mouline:

A 935
B 775
C 598
D 597
E 814
F 729
G 712
H 676
I 3047

Paternayan crewel wool:

J 562 (used for background)

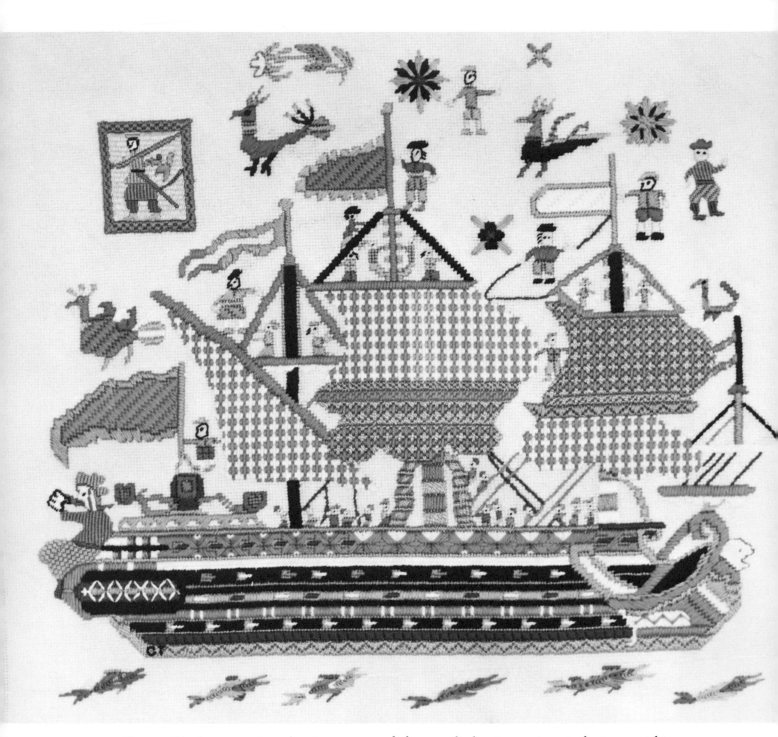

Skyros. The boat was traced onto canvas and then worked using various techniques within the tracing.

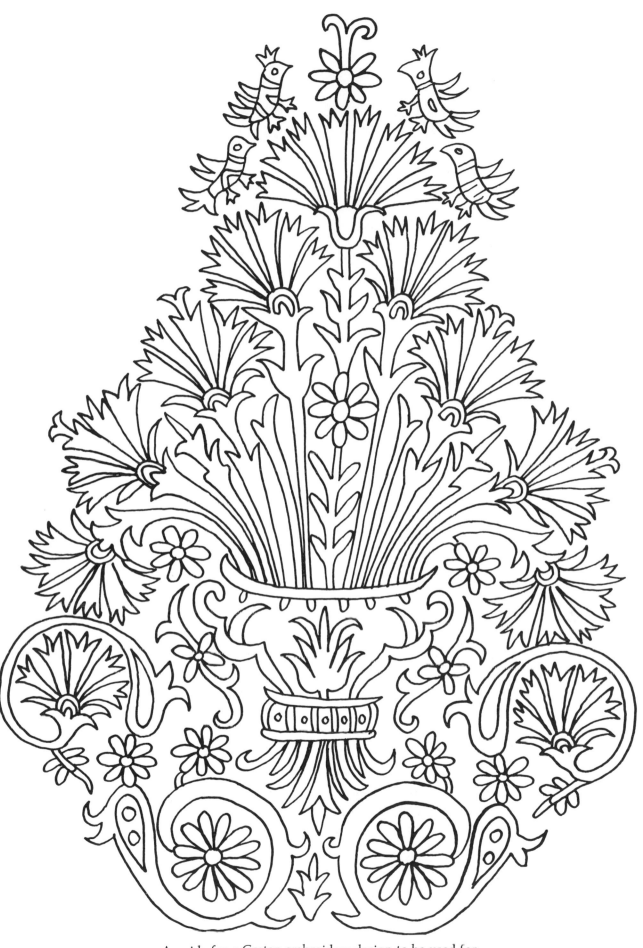

A guide for a Cretan embroidery design to be used for surface embroidery. *Benaki Museum*.

Projects for Children

The children's section of this book came about spontaneously. I had graphed a design for the twelve-year-old daughter of a friend, and after she had worked on it for a day her seven-year-old sister called and asked if I might give her and her other two sisters something to embroider; they had become envious of Susan, who sat working intently. I then proceeded to graph a number of simple designs that I felt the children would enjoy.

The children who worked the projects for this book ranged in age from four and a half to fourteen. The simplicity or complexity of the design was geared to their age as well as to their own ability. Each child chose her own reindeer or "doggie."

As you look through the museum photographs and plates in this book, I am sure you will find all of the children's designs in the original Greek pieces.

The older children worked their designs in the colors used on the Greek pieces. For the younger children we used a different technique. The designs were transferred and outlined on large graph paper. Then the children were given the graph of their choice to color as they wished. Once the coloring was completed, the design was transferred to 5° penelope canvas and the wools were matched to their colors. The children worked their designs in cross-stitch.

For four-year-olds, projects like these could appear to be impossible. However, if you seat them on your lap and show them where the needle should go next, they will be able to work the projects, and their enthusiasm does build up. One word of caution—young children may sit for only ten minutes at a time and do only four stitches, but their bright faces when they ask at a later time, "Can I do my 'broideries' now?" is proof enough of the value of their experience.

Working the background, in this case the tent stitch, is probably the most tedious part for them because of its monotony, so mother's helping hand may be necessary.

Two of the girls designed the borders for their projects. This is indicated under the photograph.

In this book we've used Greek motifs, but these basic principles may be used with any simple designs that can be easily graphed.

The following graphs have been blown up to as large a size as possible so that they will have more eye appeal for the children. We have included colors only for those designs reproduced in the original colors of the museum pieces.

Sifnos

Cross-stitch on 5° 10° penelope.
The small trees were worked on 10°,
therefore a close-up on the right (A)
shows how the smaller motif fits in.
Worked in Persian wool.

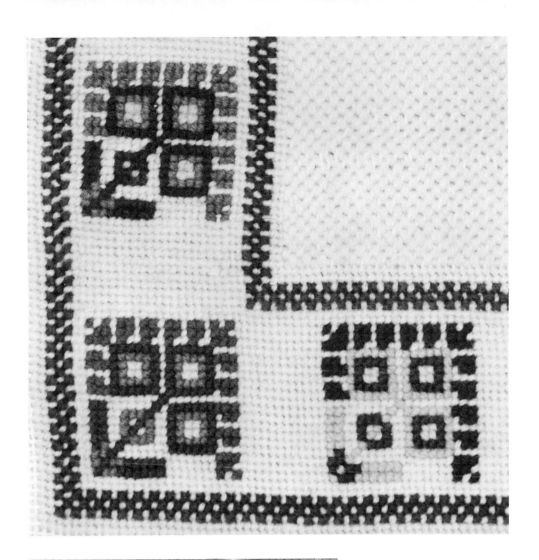

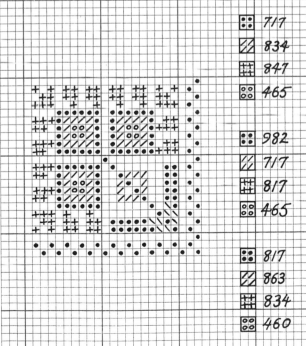

⠿	717
▨	834
⊞	847
⊙⊙	465
⠿	982
▨	717
⊞	817
⊙⊙	465
⠿	817
▨	863
⊞	834
⊙⊙	460

Macedonia. Worked in cross-stitch. Each flower has its own group of colors, which we have included. Crewel wool.

Skyros

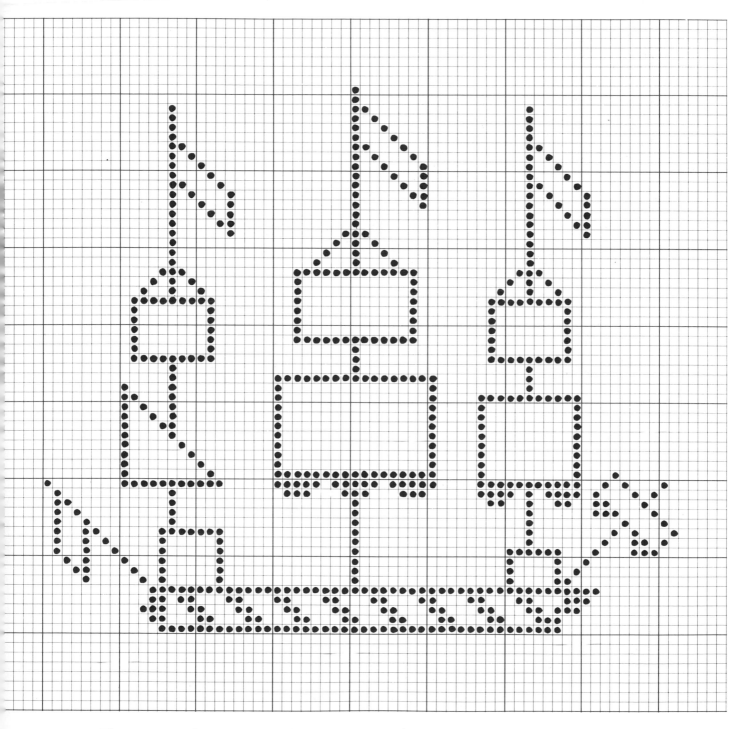

The remaining designs were worked in Persian wools, all of them in
cross-stitch with a half cross background.

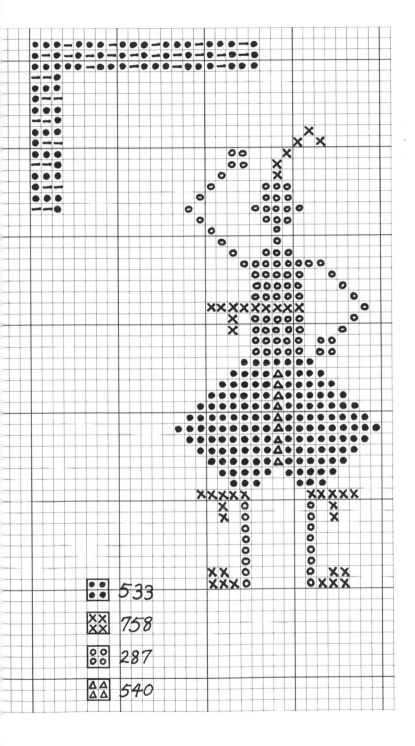

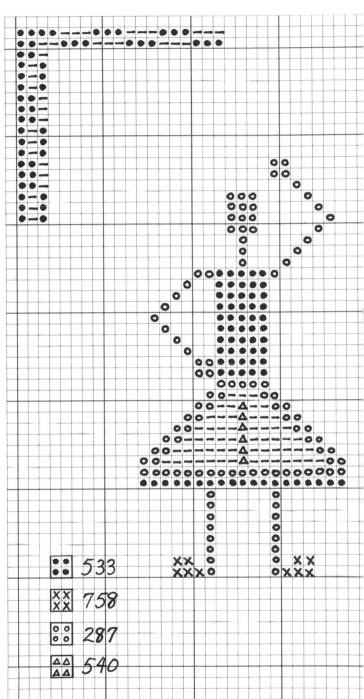

Ionian Islands

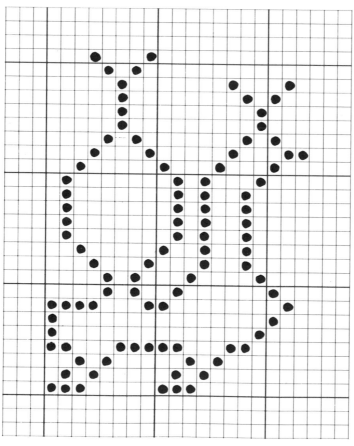

Corfu

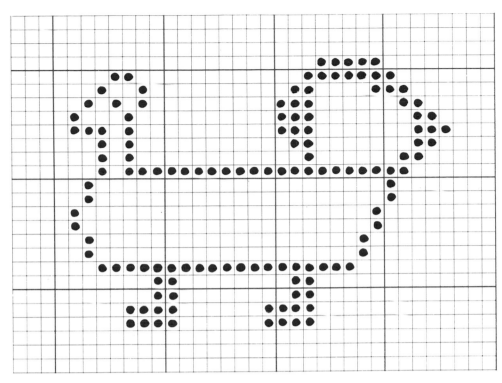

Ionian Islands

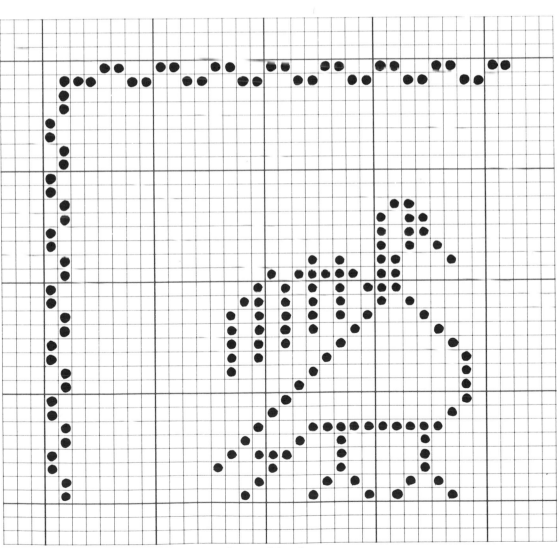

Ionian Islands

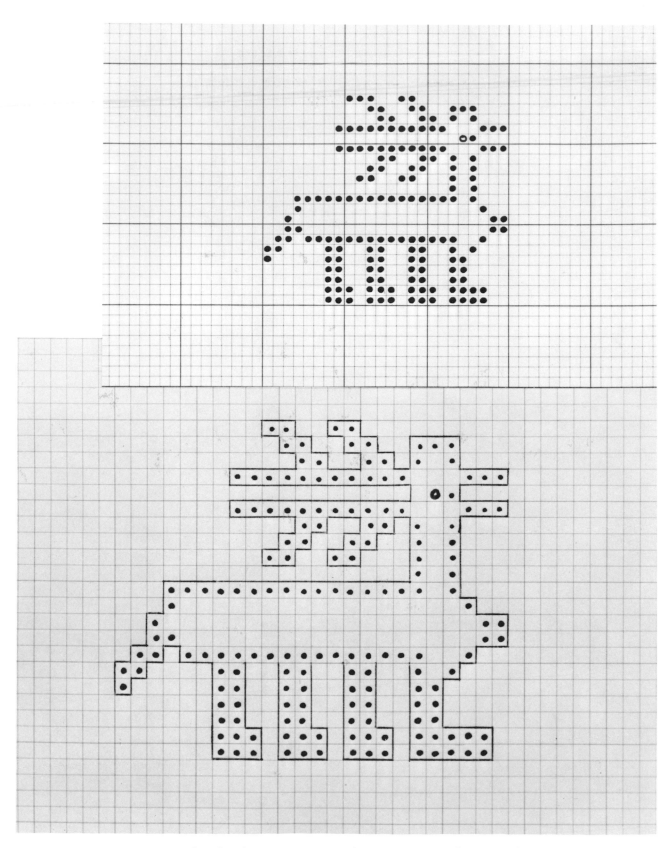

Transfer the design onto graph paper with a large grid.

Have the children color in their favorite colors. Match wools to their colors.

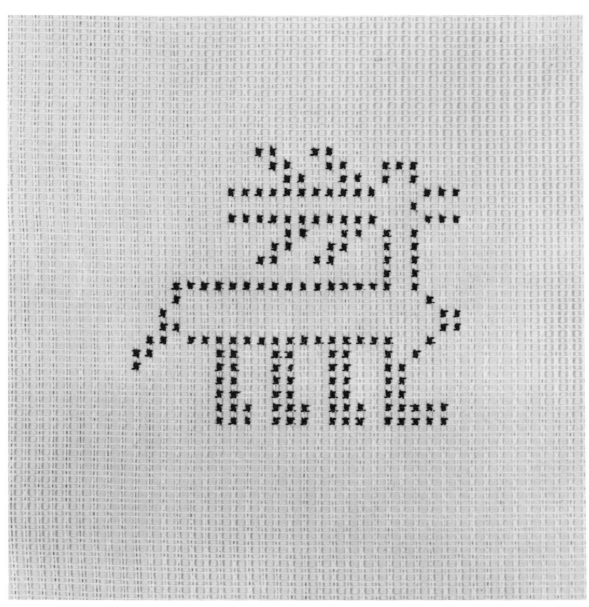

Using an indelible marker, transfer the design onto canvas, placing the dot on the graph paper on each crossing mesh. Tape the edges of the canvas.

Mount the canvas onto a frame.

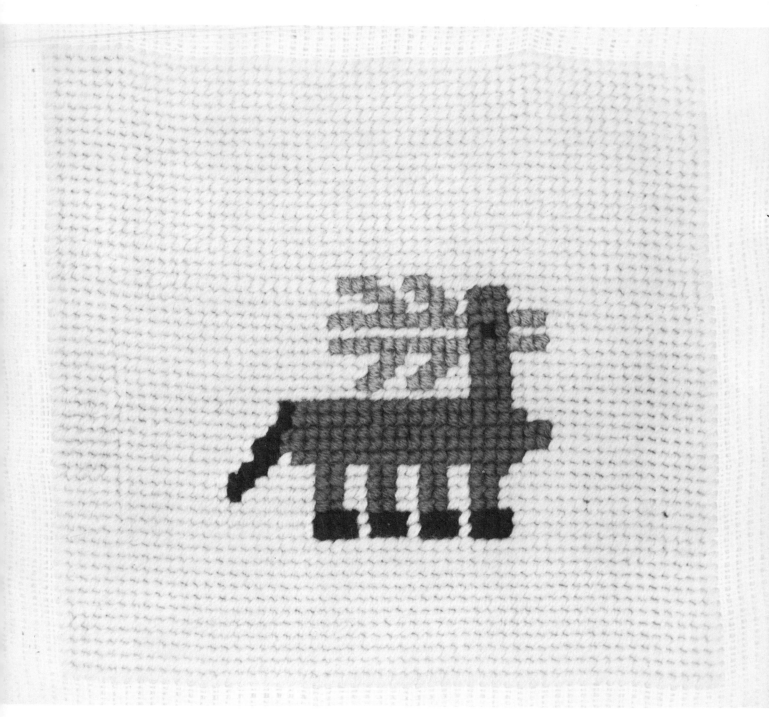

Work and complete the design.

Stitches

Stitches

The stitches diagramed in this section are those that were used to work the projects included in this book, shown in the way they were used. The stitches within each diagram are numbered at each end; number 1 is always the place at which you come up from the back of the fabric or canvas.

CANVAS STITCHES

In all canvas work it is important to remember to come up in an unoccupied hole and go down into an occupied hole in order to avoid a fuzzy look on the surface of the work.

Binding Stitch

Worked with the project wrong side up. The canvas is folded back on itself, leaving one or two canvas threads beyond the embroidery exposed; the seam faces you. Anchor the end of the wool in the carpet being worked on, bring the needle through the first hole so that it points toward you, take a second stitch in that same way in that same hole. Go three holes over and take another stitch, with the needle coming out toward you, and then return to the first hole; proceed in this same manner to hole 5, back to 6, on to hole 7, etc., as shown in the diagram.

Figure B shows the binding stitch as it is seen from above.

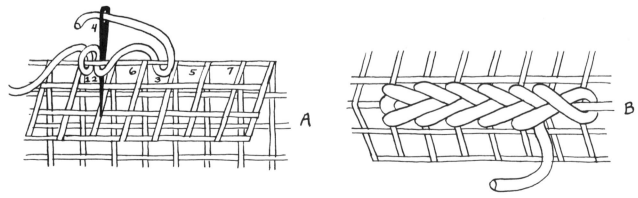

Brick Stitch

Come up at 1, down at 2, up at 3, down at 4, and proceed as numbered.

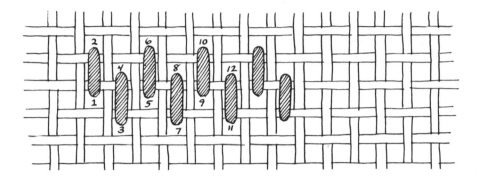

Continental Stitch

Come up at 1, down at 2, up at 3, down at 4, etc. When you reach the end of a row, fasten thread and then come back to the end where you started. Begin again, coming up in an unoccupied hole and down in an occupied hole. Always work in the same direction.

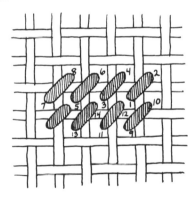

Cross-stitch

When working cross-stitch on canvas it is best to complete one whole stitch at a time before going on to the next one.

When doing cross-stitch in counted-thread embroidery, do all the stitches slanting in one direction completely across the row, and then come back with the slant in the opposite direction.

It makes no difference which way the top of the stitches slant, so long as they all slant consistently in the same direction.

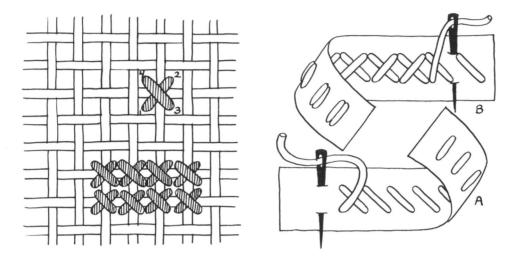

Diagonal Tent Stitch

When working this stitch it is important to be sure that when going up a row the vertical thread of the woven canvas is on top, and when coming down a row the horizontal thread of the canvas is on top.

Since it is difficult to discern where you left off in a row of diagonal tent, if you must stop working for even a short time it is helpful to leave your needle in position for taking the next stitch.

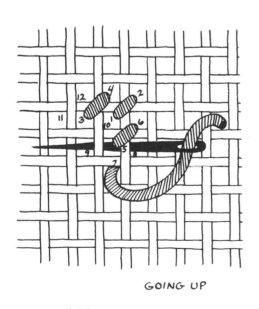

GOING UP

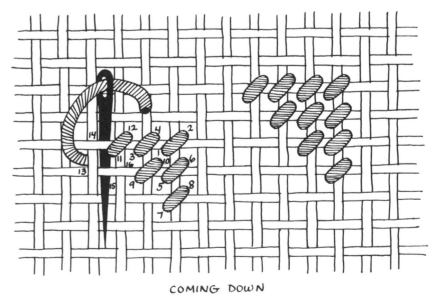

COMING DOWN

146

Diamond Eyelet Stitch

Start the diamond eyelet with number 1 five holes up from the center. Even-numbered stitches go down into the center hole and odd-numbered ones come up from the outer holes, thus avoiding an extremely fuzzy center.

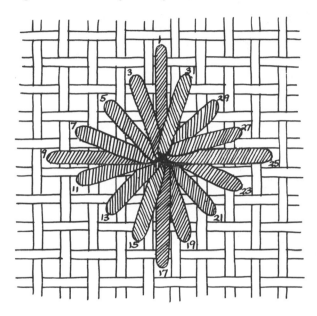

Half Cross-stitch

The half cross-stitch is usually done on penelope canvas because there is no way it can slip. It is always worked from left to right. When one row is completed, the wool is ended and another row is started, again on the left.

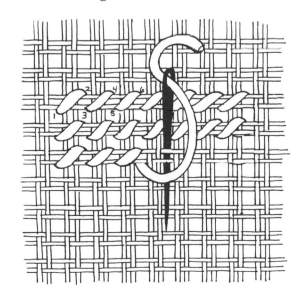

Gobelin Stitch

The gobelin may be straight or slanted, and it may slant up and over any number of threads.

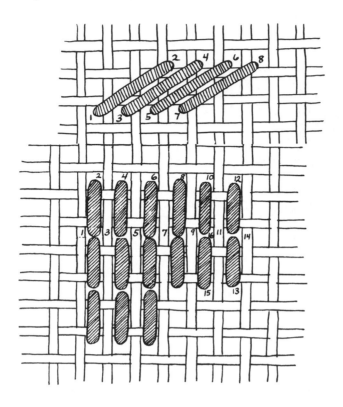

Kalem Stitch

Kalem stitch is actually tent and reverse tent and is worked *vertically*, one row at a time, from left to right.

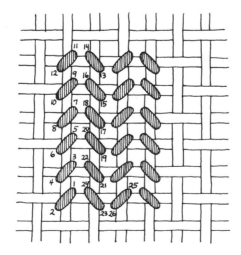

Hungarian Stitch

Each Hungarian stitch is actually made up of three stitches as shown in the numbered black drawing.

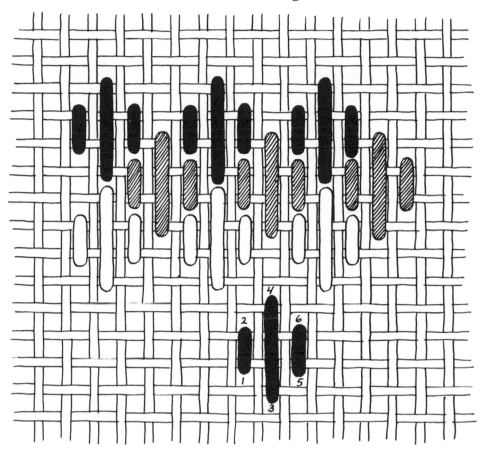

Long-Armed Cross-stitch

The long-armed cross-stitch is made up of two stitches like the regular cross-stitch, the only difference being that one half of the stitch is longer than the other.

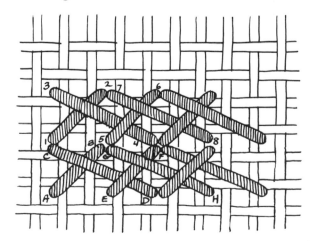

149

Parisian Stitch

Worked with alternating short and long stitches, with short stitches always under long or vice versa.

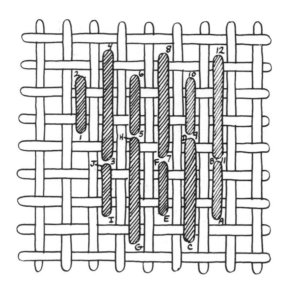

Scotch Stitch

Each unit of stitches produces a square block. When worked in groups, they are often outlined in backstitch.

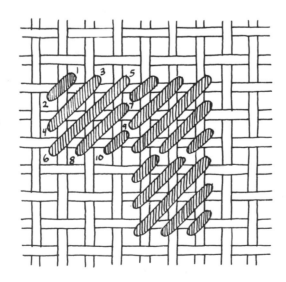

Single Fagot—Drawn Fabric Stitch

Worked down in a diagonal line, always covering four threads at a time. Each stitch is pulled tightly to give an open effect.

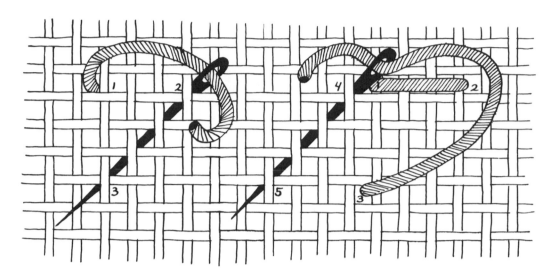

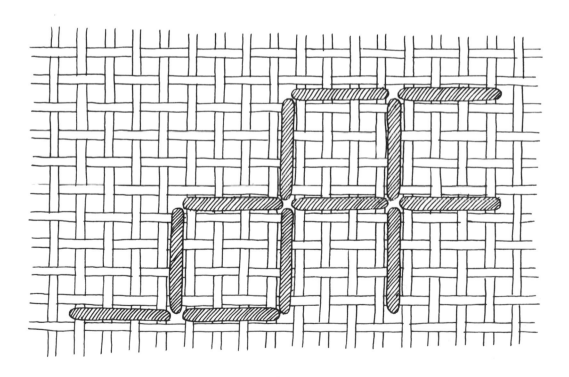

Hemstitching

Used for finishing hems. Usually two threads are removed from the fabric. Baste the hem in place so that it just comes up to the edge of the fabric where the threads have been removed. As the needle goes down into the fabric it picks up part of the hem as well.

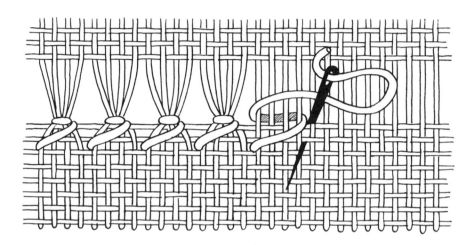

SURFACE STITCHES

Backstitch

Working from right to left, come up at 1, down at 2, up at 3, back into 2 to make 4, then on to 5, etc.

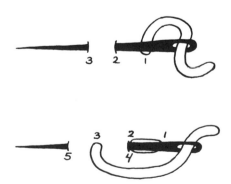

Chain Stitch

Starting at 1, bring the yarn up from under the fabric, and holding the wool with your left thumb, go down (2) in the same hole as 1. Come up at 3, and continue all along the line to be embroidered.

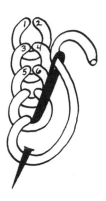

Flat Stitch

Use an imaginary line to guide your stitching. Come up at 1 and down at 2 to the right of the imaginary line, up at 3 which is the same height as 1, down at 4 which is to the left of the imaginary line and slightly lower than 2, up at 5 which is under 1, etc. The back view has an empty surface of fabric between the two rows of thread.

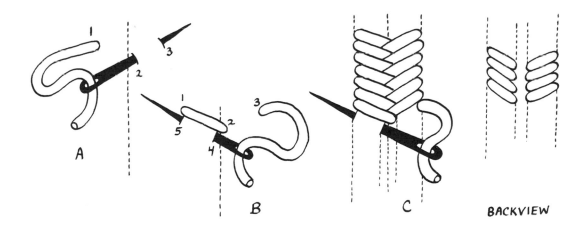

A B C BACKVIEW

153

French Knot

Come up through the fabric at 1 with your needle pointing to the left behind the wool. Wrap the wool once around the needle, hold it taught, and put needle (2) down into material, slightly away from where you came up. Hold onto wool until you have pulled it almost through to the fabric.

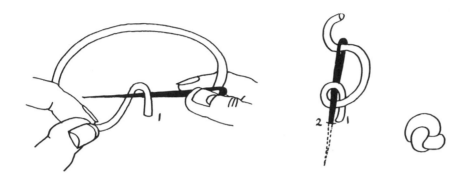

Herringbone Stitch

Come up at 1, go in at 2 and out at 3, in at 4 and out at 5, and continue in the same manner. There are many variations, and stitches may be made very close together, far apart, deep, or shallow, depending upon the desired effect.

The point of the needle is always to the left.

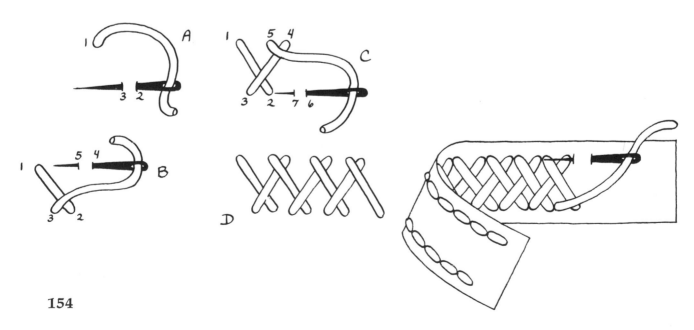

New England Laid Stitch

Work from right to left. Come up at 1, go down at 2, and come up at 3, holding wool to the left with your thumb. Pull wool through, cross over to the left, and go down into fabric at 4 and up at 5. The point of the needle is always toward you.

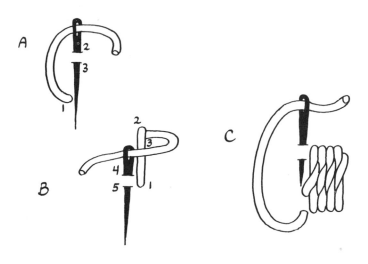

Open Cretan Feather Stitch

Come up at 1, down at 2, up at 3, down at 4, up at 5.

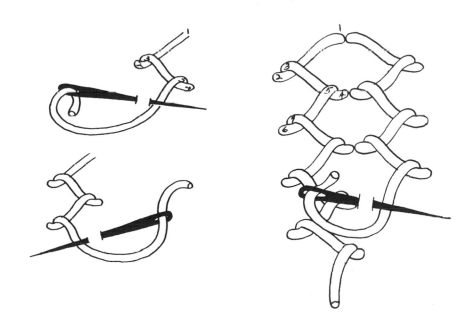

Open Fly Stitch

Come up at 1, hold wool onto fabric with left thumb, go in at 2 and up at 3. Release wool and pull. Go in at 4, up at 5, and repeat.

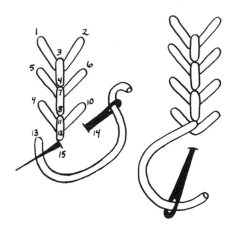

Outline Stitch

Come up at 1, down at 2, up at 3 *halfway between* 1 and 2, down at 4, up at 5 in same hole as 2, etc.

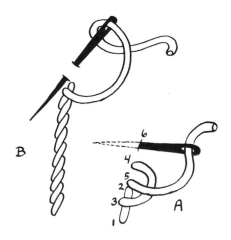

Satin Stitch

May be plain or padded whether it is done on an angle or straight.

Dividing the motif in half, determine an attractive angle. Come up at 1, in at 2, up at 3, in at 4. Continue to the end. Then go back to the center and work in the opposite direction.

To pad satin stitch, split, outline, or backstitch may be used. Come up at 1, in at 2, up at 3, in at 4, etc.

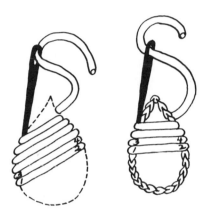

Split Stitch

Split stitch is worked from left to right. Come up at 1, in at 2, up at 3, which is the very middle of both the stitch and the wool.

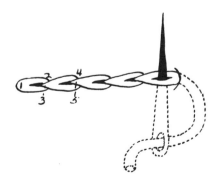

Blackwork stitches

See page 123.

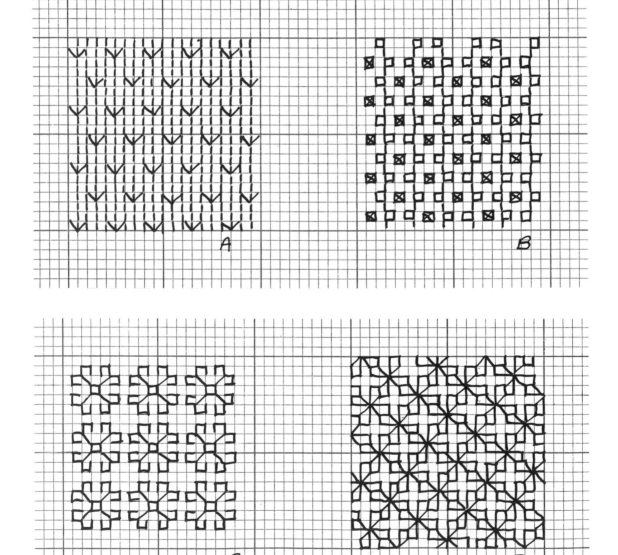

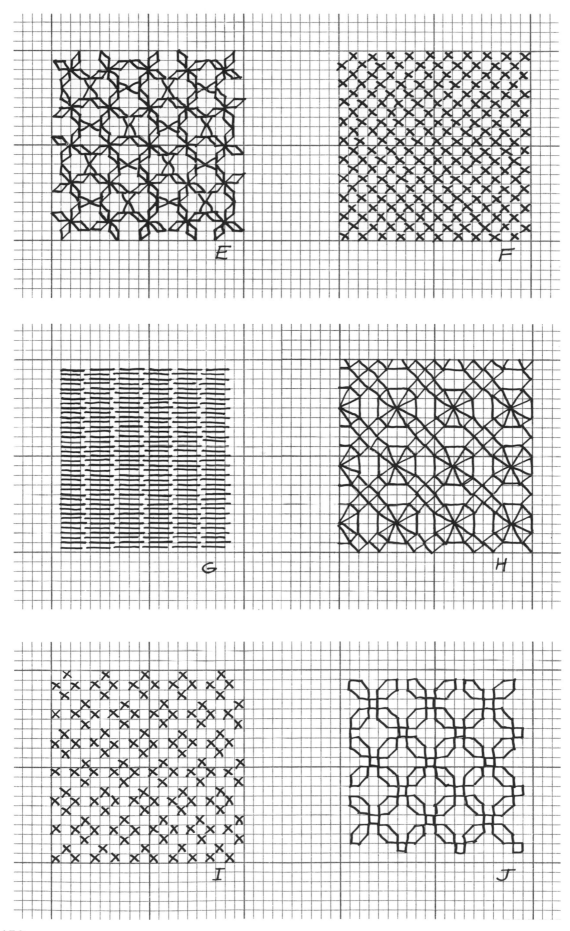

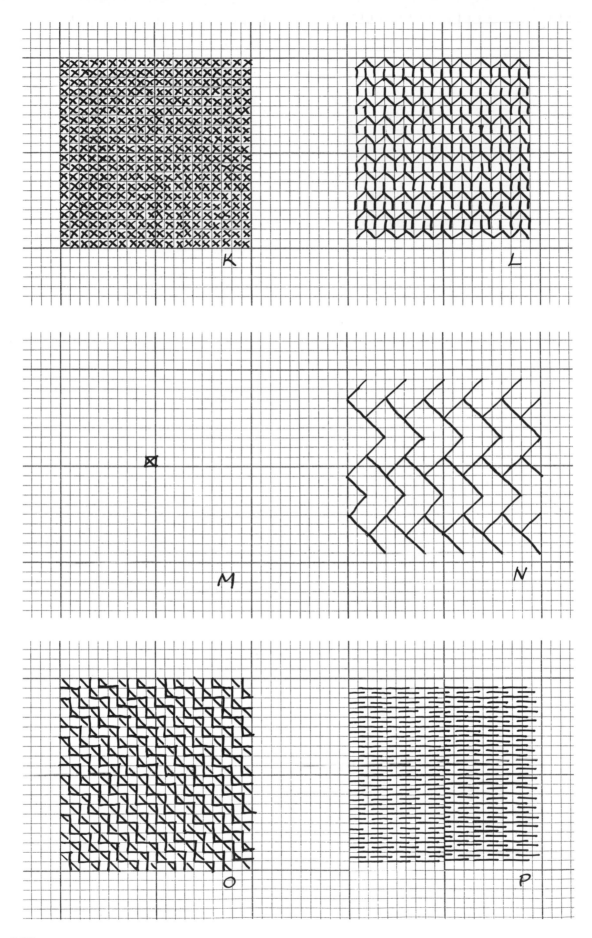

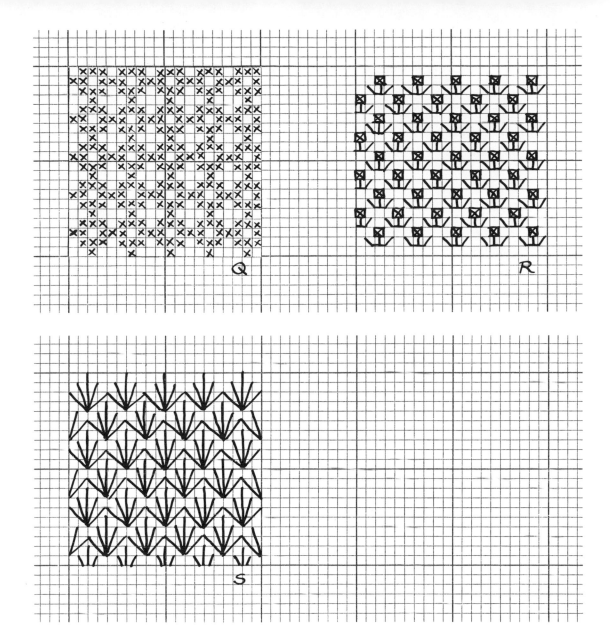

Sources of Materials

Canvas and stitchery supplies including handwoven Greek embroidery fabric
 American Bequest Design
 Wholesale and retail
 Catalogue on request
 36 Oak Street
 Southington, Connecticut 06489
 (203) 628-2649

Finishing and mounting
 Sandra Fitz Gerald
 202 Belleview Avenue
 Southington, Connecticut 06489

Handwoven silks for embroidery
 Lisa Vraillas
 "Argalios"
 9 Phillelinon Street
 Athens, Greece

Handwoven silks for embroidery
 Thrassa
 P. Patron Germanou 25
 Thessalonike, Greece

Handwoven counted-thread embroidery fabric
 Costas Hiras
 11 Nikis Street
 Athens, Greece

Needlework materials, etamine, and a variety of
counted-thread fabrics

Ergohiro
Evangelistrias, 35
Athens, Greece

Menthe
Kapuikarea, 10
Athens, Greece

Kalybiotis
Ermou, 8
Athens, Greece

Notes

Résumé of the History of Greece

1. Steven Runciman, *Byzantine Civilization* (London: Edward Arnold, 1933), p. 11.
2. Philip Sherrard, *Byzantium* (New York: Time, Inc., 1966), p. 31.
3. Ibid.
4. Runciman, *Byzantine Civilization*, p. 27.
5. Sherrard, *Byzantium*, p. 34.
6. James Lees Milne, *Saint Peter's: The Story of St. Peter's Basilica in Rome* (Boston: Little Brown and Co., 1967), p. 63.
7. A. A. Vasiliev, *History of the Byzantine Empire*, vol. 1 (Madison: University of Wisconsin Press, 1958), p. 53.
8. Lord Kinross, *Hagia Sophia: A History of Constantinople* (New York: Newsweek, 1972), p. 23.
9. Ibid.
10. Giuseppe Bovini, *Ravenna* (New York: Harry N. Abrams Inc., 1971), p. 11.
11. Pauline Johnstone, *Bzyantine Tradition in Ecclesiastical Embroideries* (London: Alek Tiranti, 1967), p. 8.
12. Aziz S. Atiya, *Crusade, Commerce and Culture* (Bloomington: Indiana University Press, 1962), p. 49.
13. Steven Runciman, *The Kingdom of Acre and the Later Crusades*, A History of the Crusades, vol. 3 (Cambridge: Cambridge University Press, 1955), p. 123.
14. Ibid., p. 82.
15. William Miller, *The Latins in the Levant* (New York: Barnes and Noble, Inc., 1964), p. 27.
16. C. M. Woodhouse, *The Story of Modern Greece* (London: Faber and Faber, 1968), p. 83.
17. Douglas Dakin, *The Unification of Greece, 1770–1923* (London: Ernest Benn, 1972), p. 9.
18. L. S. Stavrianos, *The Balkans Since 1453* (New York: Holt, Rinehart and Winston, 1958), p. 98.
19. Ibid., p. 114.
20. Ibid., p. 101.
21. Ibid., p. 105.

General Background of Greek Embroidery

1. A. J. B. Wace, "Introduction to Greek Embroideries," *Burlington Fine Arts Club Catalogue of Collection of Old Embroideries of the Greek Islands and Turkey* (London: Burlington Fine Arts Club, 1914), p. xxiv.
2. Pauline Johnstone, *Greek Island Embroideries* (London: Alek Tiranti, 1961), p. 7.
3. A. J. B. Wace and R. M. Dawkins, "Greek Embroideries," *Burlington Magazine*, Vol. 26 (1914), p. 99.
4. Angelika Hadjimichali, Ἑλληνικὴ Λαϊκή Τέχνη Σκύρος (Athens, 1925), p. 103.
5. Philip Argenti, *The Costumes of Chios, Their Development from the Fifteenth to the Twentieth Century* (London: Batsford, 1953), p. 60.
6. Wace, "Introduction to Greek Embroideries," p. xxvi.
7. Argenti, *The Costumes of Chios*, p. 110.
 Mr. Argenti explains that often the "long-armed cross" was referred to by the Greek alphabet letter X or "chi" because of its resemblance to the letter. This might possibly explain the reason for which the long-armed cross is often referred to today as the Greek stitch.
8. Popi Zora, "Colored Embroideries," *Greek Handicraft* (Athens: National Bank of Greece, 1969), p. 162.
 Mrs. Zora states that cross-stitch work, which is one of the oldest types of work done in Greece, is often identified by scholars with ancient Phrygian work.
9. Argenti, *Costumes of Chios*, p. 107.
10. Wace, "Introduction to Greek Embroideries," p. xv.
11. Angelika Hajimichalis, *Patterns of Greek Decorative Art* (Athens: National Organization of Hellenic Handcrafts, 1969), p. 34.
12. Hadjimichali, Ἑλληνικὴ Λαϊκή Τέχνη Σκύρος, p. 126.
13. Wace, "Introduction to Greek Embroideries," p. xix.
14. Zora, *Greek Handcrafts*, p. 284.

Motifs

1. Miller, *The Latins in the Levant*, p. 8.
2. Pauline Johnstone, *A Guide to Greek Island Embroidery* (London: Victoria and Albert Museum, 1972), p. 8.
3. Ibid., p. 6.
4. By the term Levant we refer to the regions of the eastern Mediterranean and Aegean from Greece to Egypt, including Asia Minor, Lebanon, Syria, and Palestine.
5. Royal Horticultural Society, *Dictionary of Gardening*, vol. 4 (Oxford: Clarendon Press, 1956), p. 2161.

6. A. J. B. Wace, Introduction to *Turkish Textiles and Velvets* by Tahsin Oz (1950), p. vii.

7. Constantine Goulimis, *The Wild Flowers of Greece* (Kifisia, Greece: Goulandris Botanical Museum, 1968), p. 6.

8. A. J. B. Wace, *Mediterranean and Near Eastern Embroideries* (London: Haltont Company, 1935), p. 11.

9. Wace, Introduction to *Turkish Textiles and Velvets*, p. vii. In referring to Coptic people, we are referring to Christians who lived along the Nile Valley.

10. Pierre M. du Bourguet, S.J., *The Art of the Copts* (New York: Crown Publishers, Inc., 1967), p. 130.

11. Stilpon Kyriakides, *Two Studies on Modern Greek Folklore* (Thessalonike: Institute for Balkan Studies, 1968), p. 92.

12. Wace, *Mediterranean and Near Eastern Embroideries*, p. 11.

13. Emily Townsend Vermeule, *The Art of the Shaft Graves of Mycenae* (Norman: University of Oklahoma Press, 1975), p. 15.

14. *From the Land of the Scythians, Ancient Treasures from the Museum of the USSR, 3000 B.C.–100 B.C.* (New York: Metropolitan Museum of Art, 1975), plates 3 and 15.

15. F. R. Webber, *Church Symbolism* (Detroit: Gale Research Co., 1971), p. 78.

16. John Doukas, Ὁ Δικέφαλος Ἀετός (Alexandria, Egypt: S. St. Parthenon no. 376, 1952), p. 18.

Patterns and Designs

1. Wace, *Mediterranean and Near Eastern Embroideries*, p. 8.

2. Ibid., p. 7.

3. Zora, "Colored Embroideries," p. 173.

4. Wace, *Mediterranean and Near Eastern Embroideries*, p. 8.

5. Zora, "Colored Embroideries," p. 173.

6. Wace, *Mediterranean and Near Eastern Embroideries*, p. 7.

7. Zora, "Colored Embroideries," p. 173.

8. Ibid., p. 191.

9. Wace, *Mediterranean and Near Eastern Embroideries*, p. 19.

10. Ibid., pp. 7 and 21.

11. Johnstone, *Greek Island Embroideries*, p. 40.

12. Ibid., p. 19.

13. Wace, *Mediterranean and Near Eastern Embroideries*, p. 20.

14. Popi Zora, *Broderies et Ornements du Costume Grec* (Athens: Musée d'Art Populaire Grec, 1966), p. 7.

15. Johnstone, *Greek Island Embroideries*, p. 47.

16. Wace, *Mediterranean and Near Eastern Embroideries*, p. 18.

17. Smithsonian Institution, *Art Treasures of Turkey* (Washington, D.C.: Smithsonian Institution, 1966), p. 108 (plates 202, 203, 205, 206).

18. Wace, *Mediterranean and Near Eastern Embroideries*, p. 18.
19. Smithsonian Institution, *Art Treasures of Turkey*, p. 108.
20. Wace, *Mediterranean and Near Eastern Embroideries*, p. 18.
21. Miller, *The Latins in the Levant*, p. 462.
22. Johnstone, *A Guide to Greek Island Embroidery*, p. 21.
23. Angelika Hadjimichali, *Art Populaire Grec* (Athens, 1931), p. 117.

Bibliography

ABBOT, C. F. *Macedonian Folklore*. Chicago: Institute of Balkan Studies, 1969.

ACKERMAN, DR. PHYLLIS "Textiles of the Islamic Period," *Survey of Persian Art*, vol. 3. Oxford: Oxford University Press, 1939.

ARGENTI, PHILIP PENDELI *The Costumes of Chios, Their Development from the Fifteenth Century to the Twentieth Century*. London: Batsford, 1953.

ATIYA, AZIZ S. *Crusade, Commerce and Culture*. Bloomington: Indiana University Press, 1962.

BAILEY, L. H. *The Standard Cyclopedia of Horticulture*, vols. 1, 3. New York: The Macmillan Co., 1930.

BAKER, MURIEL *The ABC's of Canvas Embroidery*. Sturbridge, Massachusetts: Old Sturbridge Village, 1968.

BAKER, MURIEL *The XYZ's of Canvas Embroidery*. Sturbridge, Massachusetts: Old Sturbridge Village, 1972.

BENAKI MUSEUM *Crete, Dodecanese and Cyclades Embroideries*. Athens, 1966.

BENAKI MUSEUM *Epirus and Ionian Islands Embroideries*. Athens, 1965.

BENAKI MUSEUM *Hellenic National Costumes*, vols. 1, 2. Athens, 1948–54.

BENAKI MUSEUM *Islamic Textiles*. Athens, 1974.

BENAKI MUSEUM *Persian Art in the Benaki Museum*. Athens, 1972.

BENAKI MUSEUM *Pottery of Asia Minor*. Athens, 1969.

BENAKI MUSEUM *Skyros Embroideries*. Athens, 1965.

BOVINI, GIUSEPPE *Ravenna*. New York: Harry N. Abrams Inc., 1971.

CAMPBELL, J. K. *Honour, Family and Patronage*. New York: Oxford University Press, 1964.

CAULFIELD, SOPHIA, AND SAWARD, BLANCHE *The Dictionary of Needlework*. New York: Arno Press, Inc., 1972.

CHRISTIE, ARCHIBALD *Pattern Design. An Introduction to the Study of Formal Ornament*. New York: Dover Publications, Inc., 1969.

COATS, ALICE M. *Flowers and Their Histories*. New York: McGraw-Hill, Inc., 1970.

DAKIN, DOUGLAS *The Unification of Greece, 1770–1923*. London: Ernest Benn, 1972.

D'ALVIELLA, COUNT GOBLET *The Migration of Symbols*. New York: University Books, Inc., 1956.

DOUKAS, JOHN Ὁ Δικέφαλος Ἀετός. Alexandria, Egypt: S. St. Parthenon, no. 376, 1952.

DU BOURGUET, PIERRE M., S.J. *The Art of the Copts*. New York: Crown Publishers, Inc., 1967.

ENTHOVEN, JACQUELINE *The Stitches of Creative Embroidery*. New York: Van Nostrand Reinhold Co., 1964.

FRIEDL, ERNESTINE *Vasilika: A Village in Modern Greece*. New York: Holt, Rinehart and Winston, Inc., 1962.

GENTILES, M. *Turkish and Greek Island Embroideries from the Burton Yost Berry Collection*. Chicago: Art Institute of Chicago, 1964.

GOULIMIS, CONSTANTINE N. *The Wild Flowers of Greece*. Kifisia, Greece: Goulandris Botanical Museum, 1968.

HADJIMICHALI, ANGELIKA Ἠπειρωτική Λαϊκή Τέχνη. Athens, 1930.

HADJIMICHALI, ANGELIKA *Art Populaire Grec*. Athens, 1931.

HADJIMICHALI, ANGELIKA Ἑλληνικὴ Λαϊκή Τεχνη Σκύρος. Athens, 1925.

HAJIMICHALIS, ANGELICA *Patterns of Greek Decorative Art*. Athens: National Organization of Hellenic Handcrafts, 1969.

HANLEY, HOPE *Needlepoint Rugs*. New York: Charles Scribner's Sons, 1971.

HAUSER, WALTER "Greek Island Embroideries." *Metropolitan Museum of Art Bulletin*, April 1943, p. 254.

JOBES, GERTRUDE *Dictionary of Mythology, Folklore and Symbols*. New York: Scarecrow Press, Inc., 1962.

JOHNSTONE, PAULINE *The Byzantine Tradition in Ecclesiastical Embroideries*. London: Alek Tiranti, 1967.

JOHNSTONE, PAULINE *Greek Island Embroideries*. London: Alek Tiranti, 1961.

JOHNSTONE, PAULINE *A Guide to Greek Island Embroidery*. London: Victoria and Albert Museum, 1972.

KINROSS, LORD *Hagia Sophia: A History of Constantinople*. New York: Newsweek, 1972.

KOUSOULAS, D. GEORGE *Modern Greece: Profile of a Nation*. New York: Charles Scribner's Sons, 1974.

KYRIAKIDES, STILPON P. *Two Studies on Modern Greek Folklore*. Thessalonike: Institute for Balkan Studies, 1968.

LUKENS, MARIE G. *Islamic Art*. New York: Metropolitan Museum of Art, 1965.

METROPOLITAN MUSEUM OF ART *From the Land of the Scythians, Ancient Treasures from the Museum of the USSR, 3000 B.C.–100 B.C.* New York: Metropolitan Museum of Art, 1975.

MILLER, WILLIAM *The Latins in the Levant*. New York: Barnes and Noble, Inc., 1964.

OZ, TAHSIN *Turkish Textiles and Velvets*. Ankara, 1950.

PAPANTONIOU, IOANNA Ἑλληνικές Φορεσιές I. Athens, 1973.

PAPANTONIOU, IOANNA Ἑλληνικές Φορεσιές II. Athens, 1974.

PESEL, LOUISA F. "Cretan Embroidery," *Burlington Magazine*, Vol. 10 (1906), pp. 155–156.

PESEL, LOUISA F. "The Embroideries of the Aegean," *Burlington Magazine*, Vol. 10 (1907), p. 230.

PESEL, LOUISA F. "The So-Called 'Janina' Embroideries," *Burlington Magazine*, Vol. 11 (1907), pp. 32–39.

PESEL, LOUISA F. *Stitches from Eastern Embroideries*, 1913.

RICE, DAVID TALBOT *Art of the Byzantine Era*. Frederick A. Praeger, Inc., 1963.

ROYAL HORTICULTURAL SOCIETY *Dictionary of Gardening*, 2nd ed. Oxford: Clarendon Press, 1956.

RUNCIMAN, STEVEN *Byzantine Civilization*. London: Edward Arnold, 1933.

RUNCIMAN, STEVEN *The Fall of Constantinople, 1453*. London: Cambridge University Press, 1965.

RUNCIMAN, STEVEN *The Kingdom of Acre and the Later Crusades*. A History of the Crusades, vol. 3. Cambridge: Cambridge University Press, 1955.

ST. CLAIR, ALEXANDRINE N. *The Image of the Turk in Europe*. New York: Metropolitan Museum of Art, 1973.

SHERRARD, PHILIP *Byzantium*. New York: Time, Inc., 1966.

SMITHSONIAN INSTITUTION *Art Treasures of Turkey*. Washington, D.C.: Smithsonian Institution, 1966.

STAVRIANOS, L. S. *The Balkans Since 1453*. New York: Holt, Rinehart and Winston, 1958.

TARSOULI, ATHENA *Dodekanesa*, 3 vols. Athens: 1930.

THOMAS, MARY *Dictionary of Embroidery Stitches*. New York: Gramercy, 1935.

VASILIEV, A. A. *History of the Byzantine Empire*, 2 vols. Madison: University of Wisconsin Press, 1971.

VERMEULE, EMILY TOWNSEND *The Art of the Shaft Graves of Mycenae*. Norman: University of Oklahoma Press, 1975.

VOLBACH, W. FRITZ *Early Decorative Textiles*. New York: Paul Hamlyn, 1969.

WACE, A. J. B. "Introduction to Greek Embroideries," *Burlington Fine Arts Club Catalogue of Collection of Old Embroideries of the Greek Islands and Turkey*. London: Burlington Fine Arts Club, 1914.

WACE, A. J. B. *Mediterranean and Near Eastern Embroideries*. London: Haltont Company, 1935.

WACE, A. J. B., AND DAWKINS, R. M. "Greek Embroideries." *Burlington Magazine*, vol. 26 (1914), pp. 49, 99–107.

WEBBER, F. R. *Church Symbolism*. Detroit: Gale Research Co., 1971.

WILSON, ERICA *Erica Wilson's Embroidery Book*. New York: Charles Scribner's Sons, 1973.

WOODHOUSE, C. M. *The Story of Modern Greece*. London: Faber and Faber, 1968.

ZORA, POPI *Broderies et Ornements du Costume Grec*. Athens: Musée d'Art Populaire Grec, 1966.

ZORA, POPI "Colored Embroideries," *Greek Handicraft*. Athens: National Bank of Greece, 1969.

———— Catalogue: Mediterranean Embroideries Lent by Professor A. J. B. Wace, Liverpool Public Museums, England, 1956.

Geographical Index

Index of Stitches